RAJASTHAN

HOUSES AND MEN

© 2007, Contrasto Due srl
via degli Scialoia, 3
00196 Rome
www.contrastobooks.com

Original spanish edition © 2007 Lunwerg Editores
Photographs and drawings © 2007 Tito Dalmau
Texts © 2007 the Authors
Graphic design: Tito Dalmau and Lunwerg team

Publisher: Alessandra Mauro
Editing: Suleima Autore, Ludovica Coazzin
Translations: Richard Rees
Technical layout: Angelo Rinna

ISBN 978-88-6965-062-8

Distribution:
Thames and Hudson
www.thamesandhudson.co.uk

For USA and Canada only:
Consortium Book Sales & Distribution
www.cbsd.com

TITO DALMAU

RAJASTHAN

HOUSES AND MEN

Texts

MAKA ABRAHAM

contrasto

TO OUR SONS MAX AND SARA

FOREWORD

ENRIQUE VILA-MATAS

An old Hindu in an ancient Cathar cloister, on the outskirts of the city of Soria. This was many years ago. He transfixed me with a single gaze and then walked out of the cloister. His gesture held something very special for me. Perhaps he wanted to tell me something, though I've never known what. He saw me and my destiny. At least, that's what I've always believed. Maybe he was saying 'one day you'll go to India'.

The years have gone by and I still haven't been to what for me is a strange, remote, almost inaccessible country. Nevertheless, Tito Dalmau's magnificent photographs have undeniably brought me closer to that distant, mystifying land. My friend has focused on the sparsely populated state of Rajasthan, a name with echoes of legend and of great sonorous elegance, the former Rajputana. Hunting down its houses and its people a camera, fired with emotion, has striven to capture the disturbing beauty of abject poverty, apparently so closely associated in time with the poetry of the patina of decay that seems to take possession of everything. Dalmau's is, indeed, a deeply moved camera, though working in stringent alliance with the ice-cold disposition of the viewfinder: an imperturbable camera, though tremendously sensitive to aesthetic greatness. The squalid walls of certain façades, exquisite though essentially ragged clothes and all-pervading refuse are endowed with grandeur in the clean photographs of the artist, who has managed judiciously to measure out that permanent feeling you get in Rajasthan that however many difficulties its people have to face, they do so with a spirit of resignation and an unbending refusal to dramatise their situation. Dalmau's photographs stand at this spiritual level, and the artist has succeeded in merging with the psychical landscape of that radiant yet semi-deserted Rajasthan.

Initially, as I was pondering over this foreword and after having taken an unexpected crash course on the theme of Rajasthan, I thought I might pour everything I'd learnt into a work of fiction and pose as a connoisseur of that part of India. After all, an enjoyable several-hours-long conversation with Tito Dalmau in a Barcelona hotel, a close reading of Maka Abraham's texts on those distant landscapes, long consultations of various dictionaries, a dream of Rajasthan – Hindu of Soria included –, sessions of browsing through books by Michaux, Pasolini and Tabucchi and, above all, a prolonged, minute examination of the admirable photographs contained in this book had converted me, after two days' intense work, into someone who overnight could easily pass himself off as an expert on Hindu lands, a traveller perfectly familiar with certain virtues of ancient, legendary Rajputana.

Furthermore, a short time previously I'd read the biography of Louis de Rougemont, a writer regarded as the first stationary traveller of modern times, and it was my total fascination for his captivatingly motionless journeys – at the end of the nineteenth century he convinced thousands of *Wide World* readers that he had travelled everywhere from Congo to India, even to the North Pole, and was equally well known wherever he'd been – that led me for a moment to consider imitating him.

In the end, however, common sense prevailed and I decided to renounce my make-believe story about beautiful Rajasthan in favour of the truth, in other words, of the powerful impression these photographs by Dalmau have made on me. Indeed, so compelling is this impression that I would sincerely advise the reader of my foreword to waste no time in closely examining the photographs in the book. I know that Hindus tend invariably to hold back their emotions so that everything becomes denser, but here I would be inclined not to recommend this attitude, quite the contrary: I would exhort readers to go in search of the first image and, moreover, to approach it with an open mind so that everything becomes charged with an original meaning. The world is pure illusion; everything in it is devoid of meaning. And for this reason I believe that one should approach Dalmau's photographic drifts with a single initial idea of non-contamination and no other. Only in this way, free from any preface or prejudice, can we endow what we see with a personal meaning, a unique, original meaning to this collection of fleeting human gestures and mysterious, stunning architecture.

Let's go straight to the original meaning of the pictures and, after their epiphany, then and only then turn to the words and enumerations, the historical circumstances, the geographical notes, the necessary references to the pathetic contrast between disturbing beauty and poverty, the information about the strange landscape and about a society which has been governed by a hierarchical order from time immemorial. Let it be after the photographical epiphany that Maka Abraham's skilful hand provides us with all the data about reality that will bring us back into the world, almost like a necessary calm, a restorative calm after the impact of the photographic tension between forms and colours, between graceful gestures and the desert, between the explosion of life and nothingness, between the repeatedly restored house and the permanent patina of use. Let this data come after the furious gale of highly colourful imagery and of Hindu mysteries lost in time; let it come after we have contemplated that exquisite tissue of mirror-like mansions and the silently patient men and women we see in the photographs, forming in the background the only true, overwhelming image of ourselves.

Tito Dalmau is a portraitist loyal to terrible beauty, one of photography's greats. It only remains for me to wish that one day the old man of Soria will come back and take me with him, at last, to his Hindu landscape. And that Tito and Maka, who have accompanied me so often in time, will accompany me there also, as they have already done through this book. A Hindu denouement to bring so many stories of the *Eixample* to an end.

E.V-M

RAJASTHAN

HOUSES AND MEN

MAKA ABRAHAM

Let us begin with the sounds of a name – Rajasthan or Rajputana, as it was formerly called – and the power with which the hypnotic cadences of a few syllables manage to convey the promise of mysteries as old as time. The myriad faces of tradition have shaped the mirror in which this child of the desert has always contemplated itself, bewitched by the force of an image that goes back thousands of years. The Thar Desert covers three fifths of Rajasthan's territory. From ancient times until the beginning of the nineteenth century it was the natural route traversed by all the migratory peoples, invading armies and trade caravans bearing silk and spices that penetrated the Indian subcontinent from the northwest. That explains its cultural wealth and variety. Within the vast expanse of this arid landscape, periodically swept by terrible sandstorms, a rich mixture of stratified, overlapping or even rival subcultures – nomads, semi-nomads, farmers, urban dwellers – coexist and interact, woven into the beauty of a gigantic and wonderful tapestry.

Magnificent yet terrible beauty, when one takes a deeper look into the real meaning of why these forms of life have remained unchanged, as if trapped in a time warp. This most unusual survival of form is inextricably linked to the endurance of a caste system which strives to keep society divided and well ordered, with everything forever in its place. A complex order based on religious notions that designate what is 'pure' and separate it from what is 'impure', focusing on every possible human activity, ritualizing every aspect of daily life, which has been there for around four thousand years. It is true that the caste system relates only to Hinduism, and that there are other religions – Muslim, Jain, Christian, Buddhist –, but the vast majority of the population is Hindu. If there is anywhere in the world where one can anytime, everywhere, measure the power of what is regarded as 'sacred' to design the lives of men, then that place is India. And nowhere is this truer than in the desperately poor and conservative lands of Rajasthan, whose people staunchly resist the temptation to renounce ancestral norms and practices that clash violently with the expectations and requirements of a modern lay state.

There are no half tones in the Thar Desert, where everything the eye rests upon either explodes with life or else constitutes the very image of emptiness; where everything that is not endless wastes of sand, or broken limestone and dry, dusty shrubs, is an astounding mixture of breathtaking colours. As if the exuberance of these explosions of colour were conceived as a spiritual antidote against the deprivation imposed by the harshness of the natural environment, in these endless horizons, where barefoot peasant women – who work from dawn to dusk chopping stones with which to repair highways, or walk mile after mile with gallons of water in shiny brass pots balanced on their heads, or carry mountainous loads of fodder for their famished herds – move with infinite grace, like queens wrapped in splendid arrays of bright colours, silhouetted against the monochrome aridity of the landscape. Wonderful displays of colour that continue when the desert recedes at the gentle slopes of the

Aravalli Range, where the first patches of green gradually thicken and become dark forests: bold colours like the high-pitched voices of an ancestral tongue that flows through old pink, blue, white and gold cities that spring up like mirages in the middle of nowhere, of nothing.

In this context nothing, 'the void', is a concept associated with the absence of water. A nothing which in Rajasthan is doubly eloquent, since it is poised against the bustle and the colour of the crowds of people and animals, and the piles of flowers and fruit and vegetables, which create an interplay with the colours of the old city walls.

———————————

From the very beginning, man has had to discover a means of constructing a life for himself and his group wherever chance or necessity took him; for this he had to learn how to 'inhabit' the territory in a way that would allow him to survive in it; to find ways of protecting himself, inventing gods and culture as a means of domesticating it – and domesticating himself in the process – in order to become a native of that landscape. He had to refuse chaos by ordering the universe, thereby finding a place in it for himself. His home, the main symbol of what man has constructed, is invariably and everywhere a metaphor of his culture.

Man builds houses not only for shelter, but also to define and show himself to others. In this sense, the architecture he produces is the best indicator of how he perceives his world. Architecture which is a measure of the complexity, the maturity and the health of a given society; architecture which serves to interpret the nature of the relationships established between the inhabitants of a specific environment; architecture which remains frozen in time, a visible object after other cultural phenomena have either become extinct or else evolved into other unrecognizable forms. Architecture which allows us to directly observe the difference as well as the lasting relation between what there was and what there is at present.

In Rajasthan, the state with India's lowest population index, the transition between inhabited and uninhabited areas is sudden and subject to the availability of water. There is a permanent lack of water, and its abundance is associated with joy and wellbeing. By permanently inhabited areas we mean the magnificent cities that were once the fortified capitals and strongholds of the Rajput kingdoms, as alive today as they were then. The feudal Rajput monarchs – maharajahs, rajas, maharanas, raos – were scions of the Kshatriya warrior caste, and conflict was their element. Until the nineteenth century they were constantly warring with each other, squabbling over wells, waterholes and slighted princesses, competing for the taxes, when not the booty, they extorted from the great silk-route caravans that crossed their lands. The tributes they exacted from their subjects were also a great source of wealth. They amassed enormous fortunes. A large part of these fortunes went to build fabulous fortified cities, with palaces, temples, artificial lakes, and enormous, amazingly deep step wells called *bahoris*, incredibly elaborate constructions that resemble inverted empty buildings below the ground. Cities like Jaipur, Udaipur, Jodhpur, Jaisalmer, or Bikaner dominate the history of Rajasthan. There is also lovely Bundi, with the most fascinating palace of all, that due to dynastic quarrels has not kept apace with the others, and remains rooted in its dreamy past. Or tiny Pushkar, the holy city of Brahma, where thousands

of pilgrims come each year to purify themselves in the waters of its sacred lake. There are also magnificent dead cities, ancient capitals like Amber and Chittorgarh, now only inhabited by the ghosts of a glorious past kept alive through oral tradition. There are deserted forts like fists of stone looming over craggy cliffs; and the formerly prosperous merchant towns of Shekhawati, full of crumbling, abandoned mansions that are literally covered in frescoes. Along the main roads there are also a few relatively medium-sized towns inhabited by farmers who lead a more or less precarious existence. And then there are the beautiful little desert villages – clusters of small, almost windowless, mud houses designed to keep out the heat and the cold, inside low-walled enclosures around tiny painted courtyards that somehow manage to eke out a living on the limits of subsistence.

If in the Western world the 'limit of subsistence' is a concept, in India it is a tangible reality that may be stretched to unbelievable lengths. On the fringes of the fabled cities that the maharajas built stand the dwellings of the nomadic subgroups who are the very image of the lack of almost everything: the colourful patchwork tents of the Banjara goatherds; the squalid camps of the Lohar blacksmiths, doomed to travel with their families from town to town on bullock carts, making a living from their ancient craft. Even more precarious are the shacks made of scraps which the Kalbeliya gypsies use for shelter at night, when not sleeping out in the open, on the outskirts of the towns, where the men make a few coins as snake charmers, and their women – reputedly the most beautiful in the world – as street dancers. All except the Lohar, who claim to be descendants of Rajput blacksmiths who lost their home and their honour when Chittorgarh fell in the sixteenth century, are casteless. Caste, no matter how low, means that one has certain ancestral rights that go with the prohibitions. Modern India has given them rights, but tradition does not recognize them.

It may be rather incongruous to talk of the dramatic encounter between monumentality and extreme poverty in terms of the visual beauty which this contradiction generates. But that troubling paradox is the very essence of Rajasthan today, where the eye of the beholder is bewitched by the tension between the forms and all the colours and a thousand fleeting gestures which, in fact, are a mere reflection of the inescapable differences and distances that are sanctified by tradition. A tradition that goes back four thousand years to the sacred texts of the Brahmins who arrived with the first wave of Indo-Europeans, perhaps already carrying the basic structure of the caste system which eventually spread throughout the vast Indian subcontinent. Its origins are uncertain, going so far back in time that they are still a matter of guesswork. All the silk-gloved efforts that the Mogul emperors before and after Aurangzab made to deactivate the monolithic weight of that tradition were immediately quashed. In the end, they had no alternative but to compromise with what was already there, and be content with imprinting their exquisite culture in the arts. The British – who never actually conquered Rajputana, although eventually they came to manage the princes and hold political power in their name – were likewise unable to make any breaches in the strength of the caste system. Most of the social reform laws passed by the modern lay state of India have failed in much the same way. The customs of Rajasthan persist, even today, and the vast majority of the population identifies with its myths to such an extent that they refuse to renounce the rules of the ancient game in which they are trapped, who knows whether for better or for worse.

———————————

With the images that illustrate this book, architect and photographer Tito Dalmau leads us gently through the fascinating scenario of the different forms of the inhabited landscape in Rajasthan. The contrasts hold the key to something less tangible: the collective memory of a society that has always been deeply hierarchic. A hierarchy that in the present book is expressed through architecture, constituting a sort of secret language understood and shared by the very diverse groups that inhabit the landscape separately, subdivided, forever accepting difference as part of an order that stands above the individual.

Traditionally, in Rajasthan the house is conceived as home for the extended family: married sons continue to live with their wives and children in the paternal home, whereas daughters are exported to their husbands' families. This is still true today, even among the urban middle classes.

The image of 'the house' is possibly what best indicates how this social order functions and best illustrates the strategies tradition employs to outlive modernity and remain unchanged. Hence the fact that the photographs in this book focus on architectural forms rather than on the handsome faces of the people who inhabit these lands.

M.A.

JAIPUR

Jaipur, though ancient, is relatively new in comparison with other cities of Rajasthan. It was founded in 1727 by Sawai Jai Singh II, sovereign of Amber, who needed a new, larger, capital. Designed by Bengali architect Vidyadar Chacravati, it was planned in accordance with the ancient Vedic Vaastu Shastra texts, which stipulate that cities must conform to one of the thirty-two possible *mandala* models to enable their inhabitants to meld into the harmony of the cosmos. The magic diagram Chacravati chose was transformed, in the space of eight years, into a beautiful reticular city with an urban layout of big arcaded avenues subdivided by plazas into sectors or *padas*, each of which, corresponding to a different part of Brahma's body, was assigned to a specific caste or sub-caste. It seems that the magical properties of the *mandala* soon took effect, for the city prospered and, after the decline of the Mogul Empire, it became a flourishing centre for merchants, bankers, jewellers and the like, and later still, after India had become independent and unified, the political and economic capital of the recently created State of Rajasthan. Still today, and still observing Shastra precepts, the bazaars and residential districts of the city are arranged in strict accordance with caste and métier distinction: the Brahmins in the north, the Rajputs or Kshatriyas in the east, the Vaishyas in the south and the Shudras in the west. Subsequent growth of the city, which though initially more or less well regulated has degenerated into the urbanistic chaos of the last few decades, gradually formed fringes around certain sectors of the magic diagram of the old city, the 'pink city', although it has never managed to penetrate it. The old walled city, with its huge roundabouts and arcaded avenues characterised by prodigious architectural forms and bustling bazaars, rather more gap-toothed though still wearing reddish-toned makeup and essentially intact, continues to be the nerve centre of Jaipur.

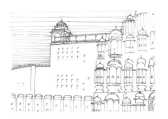

THE HAWA MAHAL

Hawa Mahal means 'palace of the winds'. This extraordinary building, a prodigy of cross ventilation, dates from 1799 and stands in the west wing of the City Palace in Jaipur, where the maharaja still resides today. Conceived as a great mask in order to observe everything going on outside without being seen, it consists of a complex honeycomb of 593 delicately sculpted stone lattice windows and balconies overlooking the street. It originally served to relieve the tedium of strict seclusion which the ladies of the court were obliged to observe in the *zenana* – women's quarters or harem. Invisibly ensconced inside the Hawa Mahal, they could contemplate all the goings-on in the street below and, hidden behind the lattices, everything that occurred in the open dependencies of the palace courtyard.

THE JANTAR MANTAR OBSERVATORY

Part of the Jaipur Palace City complex, this extraordinary landscaped precinct features the apparently whimsical forms – somewhere between sculptural and technical – of eighteen huge stone buildings, which in actual fact are highly sophisticated calculating instruments. Constructed between 1728 and 1734, this fanciful 'toy' was the brainchild of Sawai Jai Singh II, the founder of Jaipur and not only an acclaimed statesman and warlord but also a great astronomer and mathematician. The instruments are built in such a way that the shadows that fall onto their meticulously calibrated surfaces indicate the position and movement of the stars and constellations with such mathematical precision that they may predict, among many other phenomena, the arrival and even the intensity of the monsoons.

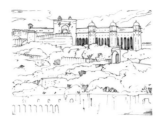

AMBER

On the summit of one of the crests surrounding Jaipur, the fortress-palace of Amber – what remains of the ancient Rajput Kachwaha capital (1037-1720) which Sawai Jai Singh II abandoned when he founded Jaipur – is reflected like a mirage in the waters of Lake Maota, when the monsoons permit. Since little is left of what there once was, we are inevitably overwhelmed by the sumptuousness of what we may still contemplate behind the blind walls of a gigantic, pale-stone fort which rises like an eagle's nest amidst the dark crenellated profiles of walls that meander interminably over the surrounding mountainsides. The fortress interior is a labyrinthine succession of gardens and patios that become increasingly hermetic and elevated, surrounded by hypostyle halls, temples and palaces with their corresponding dependencies. The strong links that united Amber with the Mogul court may still be seen in the architecture which, though clearly Rajput, is tinged with details that denote the assimilation of Islamic elements.

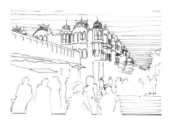

PUSHKAR

Pushkar, a tiny city in a narrow green valley surrounded by the dunes of the desert, makes its living from a lake venerated throughout India, to which all devout Hindus worthy of the name must make at least one pilgrimage in their lives, beside which stands the only temple devoted exclusively to the worship of Brahma. Besides this, it has also around five hundred temples dedicated to a multitude of divinities. White temples connected to the water of the lake by the fifty-two *ghats* (flights of stairs) that surround it, which at certain times of the day, when the women spread out the veils in which they wrap themselves after their purifying bath, are transformed into a feast of colours. Once a year, at full moon in the month of Kartika, which generally falls in November, all those who immerse their bodies in the holy lake are cleansed of their sins. During the days preceding this ceremony, thousands of devotees come from all over India, and the already narrow, sinuous streets of Pushkar transform into a veritable human swarm. The pilgrims are joined by the hordes of stock-breeders and dealers who come to the camel fair – the most important in the whole of Asia – which takes place at the same time of year, and camp with their families and animals on the sandy outskirts of the city.

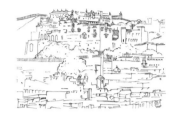

BUNDI

Bundi, in the mountainous region lying southeast of Jaipur, was once the capital of a powerful kingdom. Today it is a small, peaceful walled city, almost a village, watched over by the mighty fourteenth-century Taragarh fortress. In the shadow of the fort stand the towering walls crowned by domes and pavilions of a thoroughly captivating abandoned palace in the purest Rajput style which, paradoxically enough, was built between the sixteenth and seventeenth centuries, by which time Bundi had become allied with the Moguls. In the opinion of Scottish historian and orientalist James Tod, author of *Annals and Antiquities of Rajasthan* (1829), this palace is 'perhaps the most impressive in the whole of India'.

Having its own lake, Bundi never lacks water. Equally suggestive of abundance is the height of the entrances to the houses and the pavements on the steeply sloping main street, which project over the road in anticipation of the floods that rush down once a year when the sluice gates of the great Taragarh step wells are opened for the 'water ceremony'. And yet the city centre is also full of huge step wells. The Raniji ki Baori, a genuine water palace 151 feet deep, is just one of the 21 wells Queen Nathavati ordered to be built in the seventeenth century. For in Rajasthan, a state permanently obsessed with water, building a well for the community was regarded as an act of true piety.

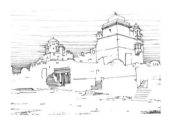

CHITTAURGARH

Built on an enormous cliff that soars abruptly up from the plain, the fortress of Chittaurgarh occupies a surface area of 692 acres at a height of 590.5 feet. For eight centuries it was the capital of Mewar and the valiant Sisodya clan until, in 1568, it fell to the Mogul Akbar.

The feats of Chittorgarh, still acclaimed in song by the strolling bards of Rajasthan, epitomise the code of honour of the Rajputs.

Three times in its history it was besieged, and on all three occasions, in view of the inevitable outcome, the 'glorious defeat' was opted for. *Jauhar*, the collective suicide ritual, was decreed. Having spent the night in preparation, intoning chants, at dawn the following day the women and children sacrificed themselves on a gigantic funeral pyre just before the men, dressed in the saffron-coloured tunics of martyrdom, made their last charge on horseback to certain death. The last *jauhar* took place in 1568, when Chittorgarh fell to the Mogul Akbar.

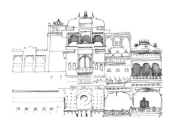

UDAIPUR

Udaipur is a placid white city that surveys the waters of several lakes and captures the reflection of a horizon of palaces, temples and *ghats* that succeed one another beneath the exquisite outline of a gigantic pale-coloured stone palace. It is bigger than it looks. The capital of Mewar, the fertile mountainous woodland region in southeast Rajasthan, has a more ethereal, amiable air than its desert counterparts. Nonetheless, its history is marked by wars. Mewar, which never made pacts with nor married its princesses to the Moguls, is identified with the Sisodya, a lineage that dates back to 568 and continues with the present-day maharaja. In 1559, Udai Singh, seeing that his capital Chittor, or Chittorgarh, was destined to fall to Akbar, founded a new one in Udaipur. When his son Pratap Singh finally managed to expel the Moguls, the city prospered, palaces were built everywhere and the arts flourished until in 1736 the city was attacked by the Mahrattas, who did not cease to rob and pillage until Udaipur was left in ruins towards the end of the eighteenth century. Eventually its people were forced reluctantly to accept the aid and protection of the British early in the nineteenth century. When India became independent, the city became part of the new state of Rajasthan.

Udaipur's City Palace is the largest complex of its kind in Rajasthan. Work began on its construction in 1559 and in the three following centuries it was extended at least three times. Eleven buildings were erected by the same number of maharajas, each one linked to the others by a labyrinth of narrow passageways to delude invading enemy forces.

FROM UDAIPUR TO JODHPUR

The fortress of Kumbalgarh, which stands on a plateau amidst narrow valleys with dense woods on the western spurs of the Aravalli mountains, is the most spectacular of the thirty-two forts that warrior king Rana Kumbha built in the Mewar region between 1433 and 1468. Its approximately 22.5 miles of 23-foot thick walls reinforced by huge bastions entirely encompass the plateau's perimeter. Its interior contained wells and reservoirs, pasture land and cultivated fields, and some 300 temples and palaces, of which fewer than ten remain. Today, only a few families of peasant farmers live behind its colossal walls.

Not far from here stands the Adinatha temple of Rajakpur in a clearing in the mountain forests. This is the biggest and most complex Jain temple in the whole of India, its twenty-nine halls occupying a surface area of 46,285 square feet. It was built by a wealthy Jain merchant, one of the Rana of Mewar's ministers, and work on its construction was completed in 1439.

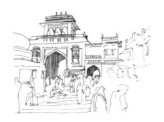

JODHPUR

The origins of Jodhpur date back to 1459, when the overlord Rao Jodha of the Rathore dynasty laid the city's foundations. Since then it has been the capital of the 'land of death', the immense region of Marwar, a rich oasis in the midst of this arid desert area. The 'old city' is encompassed by walls, or at least by what remains of them, and in its centre, on a craggy cliff top that entirely dominates the surrounding terrain, stands the imposing fortress of Mehrangarh.

The compact urban layout of the city meanders and flows in narrow streets over the uneven site, climbing up the mountainsides and forming terraces that culminate at the base of the fort. The districts still correspond to the metiers of their inhabitants, that is, to the castes. The most characteristic traits of the traditional architecture of Rajasthan – the richly sculpted stone façades with *jarokhas* (galleries) and exquisite patios – are here often tainted with indigo or else whitewashed. Indigo, which traditionally denoted the house of a Brahman, has become widespread in Jodhpur, by virtue of which it is known as 'the blue city'.

Unlike Jaipur, fruit of meticulous prior planning conceived for eternity by a governor, Jodhpur is the result of five hundred years of experimentation with forms and materials, of growth, transformations and improvements carried out by a closely-knit society who strove to settle effectively on difficult terrain.

UMAID BHAWAN AND THE LOHARS

The colossal Umaid Bhawan palace in Jodhpur was designed by H.V. Manchester as the residence of maharaja Jaswant Singh and built between 1927 and 1944. With its 347 rooms, it was one of the world's biggest private homes. And although the current maharaja still lives here, the palace has been partially converted into a luxury hotel.

In the foreground stands the squalid Lohar encampment with the mass of Umaid Bhawan providing the backdrop. The Lohars are a community of blacksmiths who together with their families wander from town to town on carts drawn by bullocks, eking out a living by practising their trade. According to legend, they are descendents of the last blacksmiths of Chittorgarh, who when the fortress fell swore they would never again sleep under a roof until they could return to their former home.

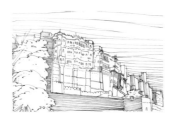

THE FORT OF MEHRANGARH

In 1459, the same year in which the city was founded, work began on the construction of what is possibly Rajasthan's most formidable citadel, on top of a 410-foot-high promontory. Mehrangarh is a kind of closed fist composed of layer after layer of sinuous walls, penetration of which was possible only by following a steep, tortuous itinerary that took in seven successive monumental gates and led to the fortress's very core. This was the *zenana* – the harem –, Mehrangarh's most secluded area.

Here, as in many of the most ancient palaces, the visitor is struck by the small dimensions of the maharaja's quarters in comparison to those of his wives. The explanation for this lies in the Rajput nobility's devotion to the profession of arms. The maharajas of the heroic period spent most of their time engaged in interminable military campaigns; consequently, the true palace occupants were the women, particularly when we bear in mind, moreover, that the *purdah* custom made it compulsory for wives to live secluded in the *zenana*. Indeed, it is said that they would leave the harem only to die beside their husbands on the funeral pyre.

The wall beside the Loha Pol – the Iron Gate – features the imprints of fifteen small hands. These belonged to the fifteen queens who in 1843 walked out of the fort to throw themselves onto the funeral pyre of maharaja Man Singh, thereby defying the law the British had enacted in 1829 to ban this practice, known as *sati*.

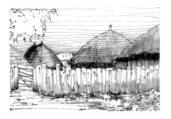

FROM JODHPUR TO JAISALMER

Only thorn bushes and the odd *khejri* tree relieve the monotonous alternation between dunes and stony desert that lines the military road – the only one there is – between Jodhpur and Jaisalmer. Occasionally, a certain distance away, small clusters of circular huts appear, whose straw roofs are so integrated into the surrounding landscape that they are practically invisible. These are the *jhompas*. Certain characteristics of life in the desert produce forms which, although the materials may vary, reappear time after time. The *jhompas*, built mostly of mud, remain circular even when made of stone, which abounds in the area near Jodhpur. The nucleus of the *jhompa* is the patio, which shelters the occupants from the heat, sand and curious onlookers and constitutes the centre of family life, even in the *dhani*, the most primitive form of settlement.

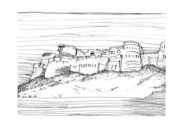

JAISALMER

At the limits of the Thar Desert, still surviving centuries of accumulated history like an impossible sandcastle lost in the midst of an absolutely desolate landscape, the legendary city-fortress of Jaisalmer still accommodates thousands of inhabitants behind its golden defence walls. Founded in 1156 at a strategic point on the Silk Road by Rao Jaisal, a Rajput prince of the Bhatti clan, the city soon began to prosper by assaulting and extorting money from the camel trains that made the journey from central Asia to the emporiums of Delhi to the east and Gudjarat in the south. Jaisalmer flourished, engaged in warfare and was often besieged, since the Sultanate of Delhi retaliated with punishment campaigns that on at least two occasions ended in the ritual suicide termed *jauhar*. The city's rapacious princes continued to fill their coffers by engaging in ruthless plunder for a few centuries more, until in 1570 the daughter of one of them was married to the Mogul Emperor Akbar. Halfway through the seventeenth century, they acknowledged the sovereignty of Delhi, hostilities ceased and, thanks to its strategic location, Jaisalmer embarked on a new, more respectable, trading career, accumulating even more wealth than in its days of banditry.

Remote, though sheltered by its formidable walls, Jaisalmer attracted what became a wealthy community of merchants and bankers – most of whom were Jains – who regardless of the costs involved built magnificent temples and, above all, innumerable houses and urban mansions or *havelis*, using the same yellow sandstone from which the fort is built. In the narrow streets of Jaisalmer, lined by exquisite honey-coloured façades that ventilate the interior of the buildings by means of *jarokhas* and lattices as delicate as lace, sculpted by the Silavat community of stonemasons, desert urban architecture reached its heights of refinement. The fact that all the buildings, even the most sumptuous *havelis*, are tall and adjoin their neighbours on either side is to minimise exposure to sunlight and compensate for the dearth of available building land. This practice increases the importance of the patios and the flat roofs, on which the occupants traditionally slept and continue to sleep on warm summer nights.

In the nineteenth century, the rise of maritime trade and, by extension, of the port of Bombay sounded the death knoll for the overland Silk Road and marked the disappearance of the camel trains that had provided Jaisalmer with its wealth. Decline was therefore inevitable. Today, the city's strategic importance is of a military nature, by virtue of its proximity to the border with Pakistan.

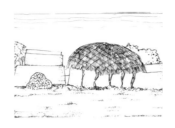

VILLAGES OF JAISALMER

The district of Jaisalmer is the second largest in the whole of India, and the least populated.

In the desert, settlements are very small: clusters of houses rather than villages. The intense heat, frequent sandstorms and the lack of materials have invariably determined forms of habitat. In Sam, the houses are like tiny clay fortresses that meld with the colour of the desert. Rectangular rooms arranged around a patio form a hermetic complex sheltered from the sand that piles up outside. The motifs painted around the openings onto the patio break the monotony of the materials and the landscape.

Khuri is a village somewhat larger than Sam, although the forms of its houses are identical.

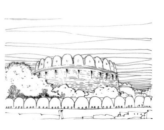

BIKANER

Bikaner is a dusty desert city that stands rather isolated in the extreme northwest of Rajasthan. It was founded in 1488 by the Rajput Rao Bika, son of Rao Jodha, the founder of Jodhpur. After years of perpetual confrontations with the tribes of the desert in order to gain control of the region, in the following century Bikaner had to face the army of the all-powerful Mogul Akbar, to whom it succumbed, although the Emperor failed to secure the fort. Indeed, the fort of Junagarh, built on the lowlands unlike all the other strongholds of Rajasthan, has never fallen into enemy hands. This colossal mass of red sandstone over half a mile in circumference still occupies what is the centre of the city.

After the military defeat, the peace treaty signed with the Mogul allowed Bikaner to take advantage of its strategic location, thanks to which it soon became a prosperous stopover for camel trains, as the opulence of its *havelis* and temples attests. However, with the advent of the railway and the rise of the great ports of Calcutta and Bombay, the city and the region suffered the same fate as other caravan-train centres.

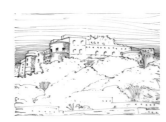

THE DISTRICT OF ALWAR

East of Jaipur lies the region or district of Alwar, where the Kingdom of Biratnagar flourished until 1500 BC. The youngest of the Rajput states, today it is a somewhat backward, rather forgotten region.

The city of Alwar was founded around the year 1000 at a point where the lowlands of Delhi and the Aravalli mountains meet. It was much coveted and disputed over by the Rajputs, the Moguls, the Patanas and the Jats of Bharatpur until in the eighteenth century Pratap Singh, a minor Rajput chief, conquered it and kept the neighbouring states at bay until his heir, Bakhtawar Singh, struck an alliance with the British in 1803 and Alwar was born as an independent state. Its maharajas were ostentatious and extravagant and built above their means. Today Alwar is a modest agrarian and artisan city whose Vinay Vilas royal palace – a variegated synthesis of Rajput and Mogul, festooned with arches and balconies, with Bengal pavilions and eaves – has been transformed into a branch office of the Inland Revenue. A few miles from the city stands Vijay Mandir, a gigantic late Indo-Islamic palace which Jai Singh (1857-1933) built on the shores of a lake. Belonging to the current maharaja, its 105 rooms are in a state of thorough neglect.

The district is a remote fertile region of mountains and extensive fields cultivated by farmers who live in small hamlets and villages dominated by the fortresses that once protected them. In Sariska, which was formerly the maharaja of Alwar's game reserve, there are still tigers and ruined temples among the undergrowth. Near Sariska stands Kesroli, a small fourteenth-century fort which the Rajputs, the Moguls, the Jats and the Ranawats fought over. Its seven towers dominate a great plain of cultivated fields worked by the peasant farming families from the village that hugs its base.

31 miles from Sariska are the ruins of the city of Bhangarh, built early in the eighteenth century by the Raja Madho Singh, brother of the celebrated Man Singh of Amber. It once had a total of ten thousand homesteads and legend has it that the city had to be abandoned because an evil sorcerer put a curse on it. Indeed, the local farmers believe that it is still cursed.

East of Alwar and north of Bharatpur, in a vast Mogul-style garden in the small walled city of Deeg, there is an extraordinary palace complex built from pale yellow sandstone and constructed halfway through the eighteenth century by the Raja Suraj Mahl of Bharatpur. Deeg was the second capital of the Jat state of Bharatpur and the Jat dynasty was of peasant, not Rajput, origin. The main palace, Gopal Bhawan, which combines Rajput and Mogul architectural traits, is said to be one of the finest and best proportioned in the whole of India. The palace complex includes two water cisterns with *ghats* at either end of the garden.

SHEKHAWATI

The region of Shekhawati lies in the semi-desert steppes between Delhi, Jaipur and Bikaner. Here there are no big cities but rather a chain of small ones, the most important being Nawalgarh, Mandawa, Fatehpur, Dundlod, Sardarshahr, Jhunjhunu, Churu, Laxmangarh and Bissau. Though now somewhat neglected, they nonetheless preserve an astonishing heritage of magnificent *havelis*, festooned with frescoes and built between the eighteenth and early twentieth centuries by Marwari merchants who had emigrated from Calcutta and Bombay.

These urban mansions feature one of the world's greatest concentrations of mural paintings, a socio-cultural phenomenon unique to this region.

The presence of small communities of merchants in the region dates back to the time when it was one more among the caravan routes from Delhi to the coast of Gudjarat. The cost of the conflicts that were unleashed with the fall of the Mogul empire forced Jaipur and Bikaner to increase their tariffs, which led to the rise of Shekhawati, a corridor between the two kingdoms and divided into small fiefs governed by interrelated Rajput barons, who levied lower taxes. The trade boom induced a substantial number of Banyas (the merchant caste) to move to this area, where they prospered and began to build, though still under the shadow of the Rajput lords. The economy flourished until the advent of the railway put an end to this trade route to the small Gudjarati harbours in favour of the great ports of Bombay and Calcutta, which would become capital of the new colonial commerce. Given the threat of imminent ruin that this change implied, the traders of Shekhawati moved above all to increasingly prosperous Calcutta, where thanks to their skill as middlemen they amassed great fortunes. They lived frugally, however, sending the lion's share of their profits to their families in Shekhawati, entrusting them with the construction of temples, *baoris* (step wells) and sumptuous mansions as tokens of their success and new status in their native lands. By 1820 the Banyas had come to thoroughly eclipse the Rajputs in Shekhawati, and the two rivalled each other in the construction of havelis, which became increasingly bigger and more elaborate as the century unfolded.

Some of these *havelis* are of colossal dimensions: four or five storeys high and with up to four patios. Both the inside and outside wall faces were profusely decorated with mural paintings, with subject matter ranging from religion to customs, some combined with commonly-held truisms about the West and the wonders of progress interpreted Indian-style.

Today, these splendid *havelis* are a threatened heritage. Either empty or semi-abandoned, they are often the victims of vandalism and many have been despoiled of architectural elements – such as *jarokhas* or columns – which end up in European antique dealers' establishments.

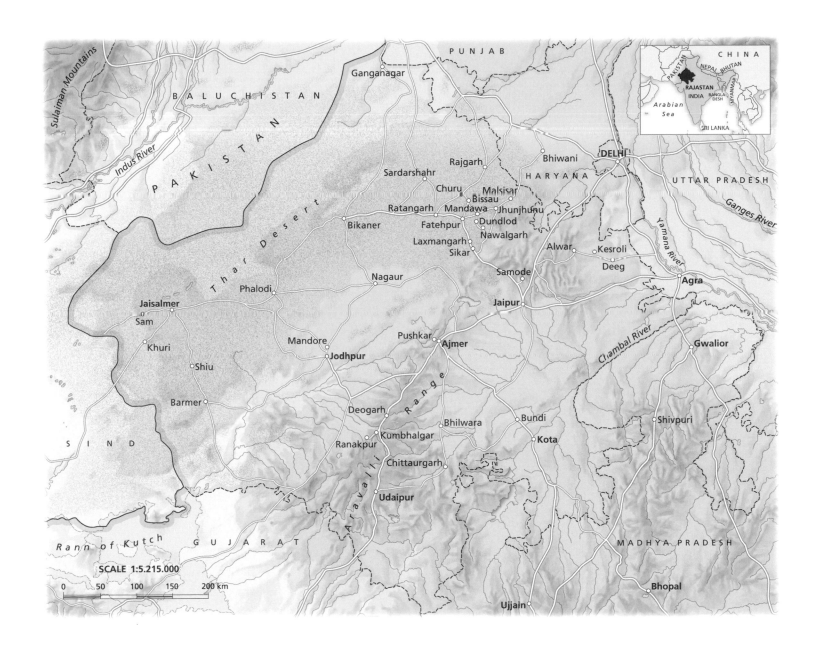

Sulaiman Mountains

Indus River

BALUCHISTAN

PAKISTAN

PUNJAB

Ganganagar

CHINA

PAKISTAN

NEPAL BHUTAN

RAJASTAN

INDIA BANGLA DESH

MYANMAR

Arabian Sea

SRI LANKA

Bhiwani

DELHI

HARYANA

UTTAR PRADESH

Rajgarh

Sardarshahr

Churu Malsisar

Bissau

Ratangarh Mandawa Jhunjhunu

Bikaner Fatehpur Dundlod

Laxmangarh Nawalgarh

Sikar

Samode

Alwar Kesroli

Deeg

Ganges River

Yamana River

Thar Desert

Nagaur

Phalodi

Jaipur

Agra

Jaisalmer

Sam

Mandore

Pushkar Ajmer

Khuri

Jodhpur

Chambal River

Gwalior

Shiu

Deogarh

Bhilwara Bundi

Shivpuri

Barmer

Aravalli Range

Ranakpur Kumbhalgar

Kota

SIND

Chittaurgarh

Udaipur

Rann of Kutch GUJARAT

MADHYA PRADESH

SCALE 1:5.215.000

Bhopal

0 50 100 150 200 km

Ujjain

JAIPUR

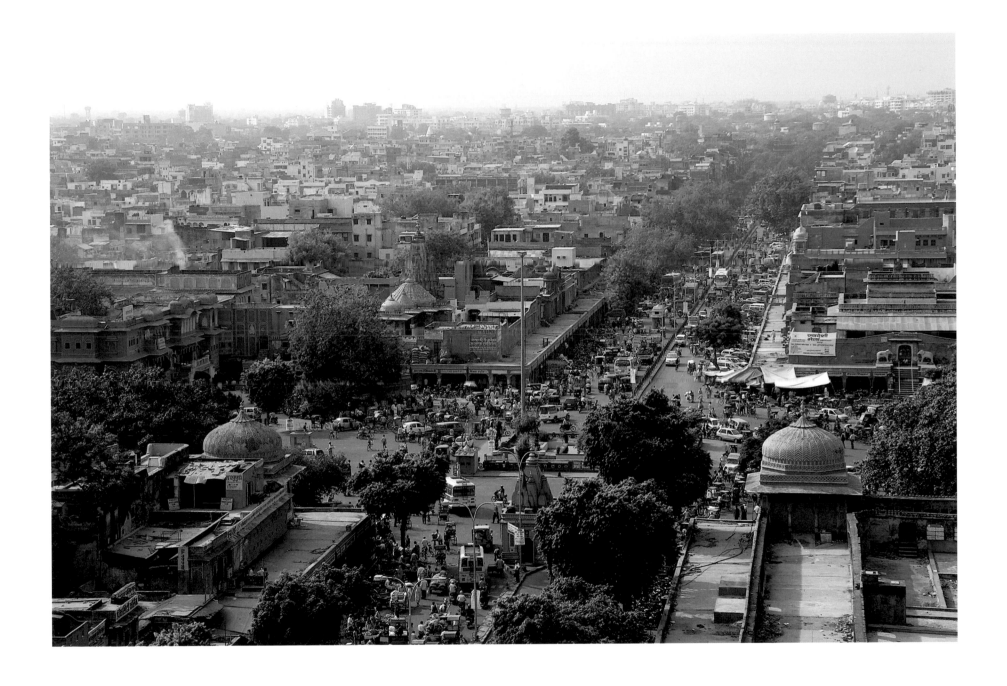

Chhoti Chaupar.

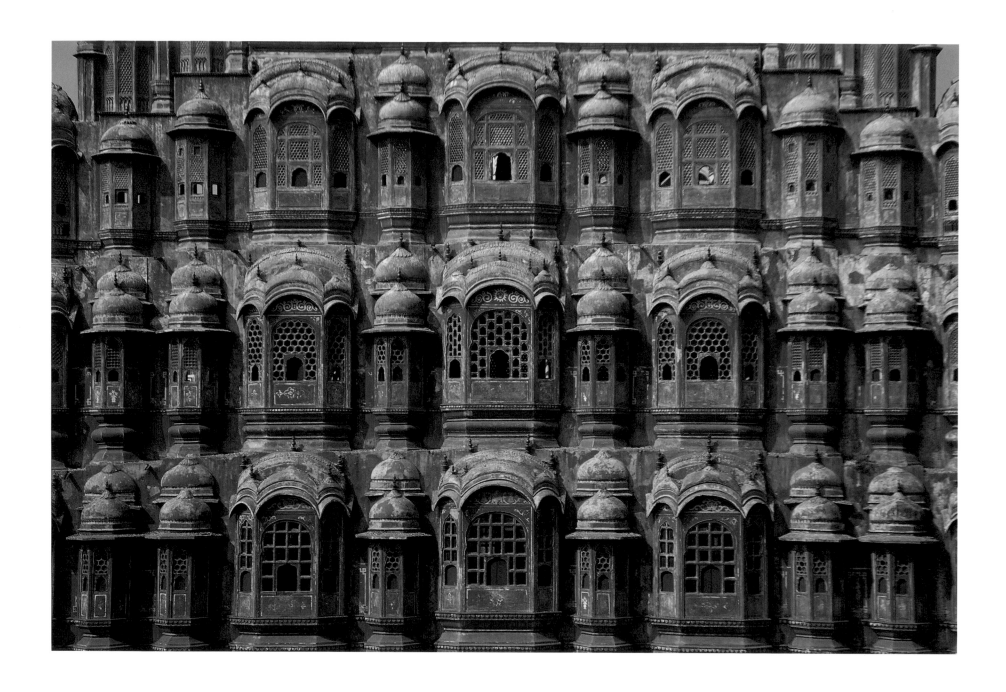

Hawa Mahal or the Palace of the Winds.

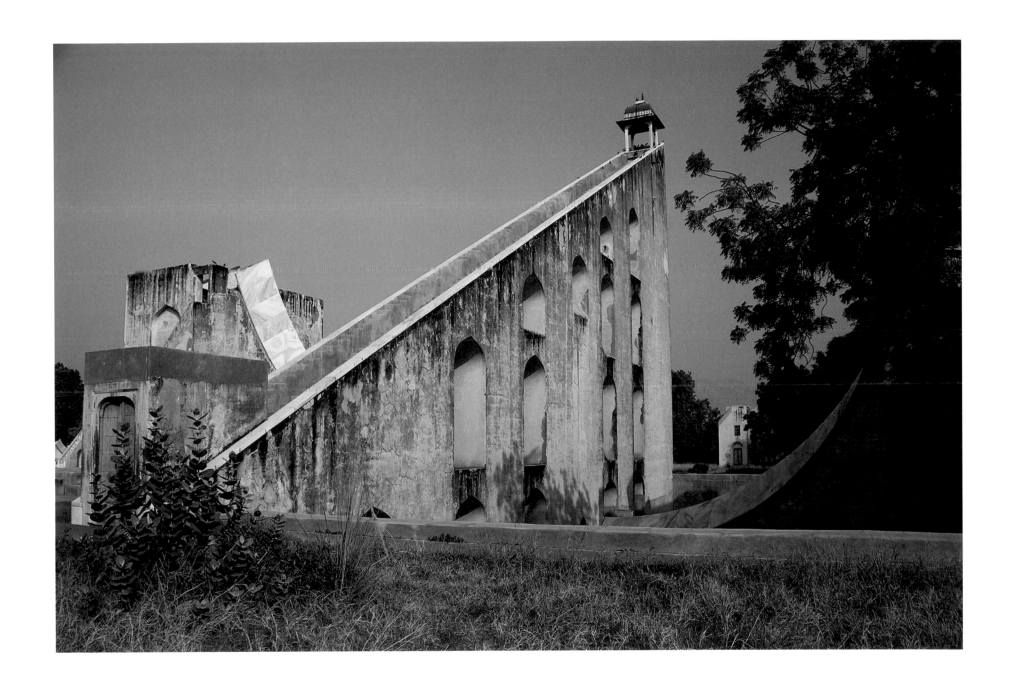

The Jantar Mantar observatory. Brihat Samrat Yantra or the Great Sundial.

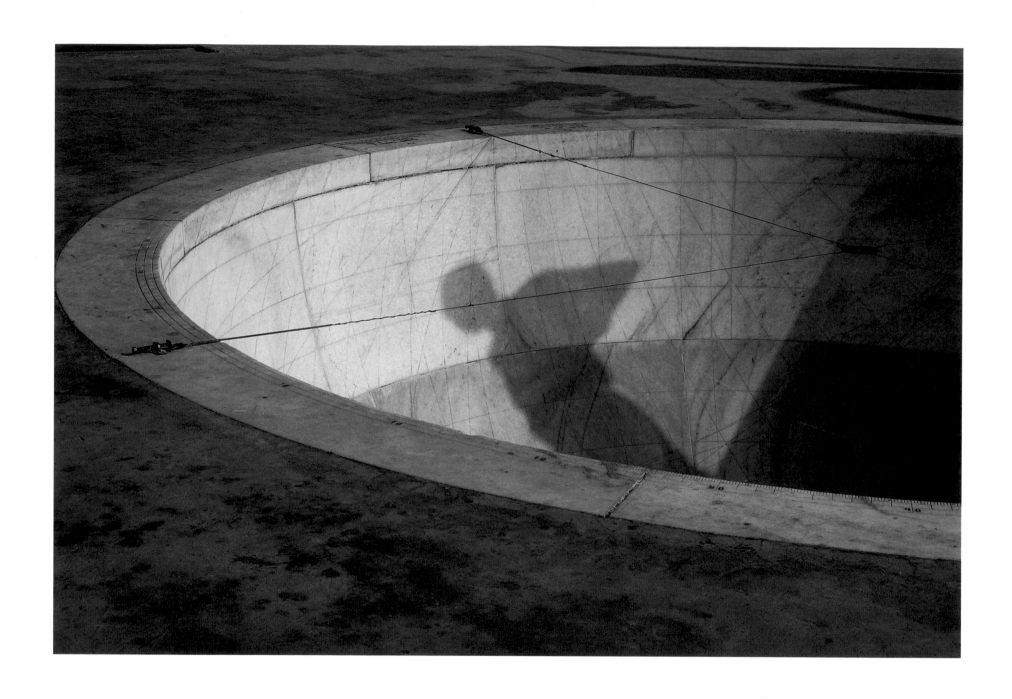

Jantar Mantar. A measuring instrument.

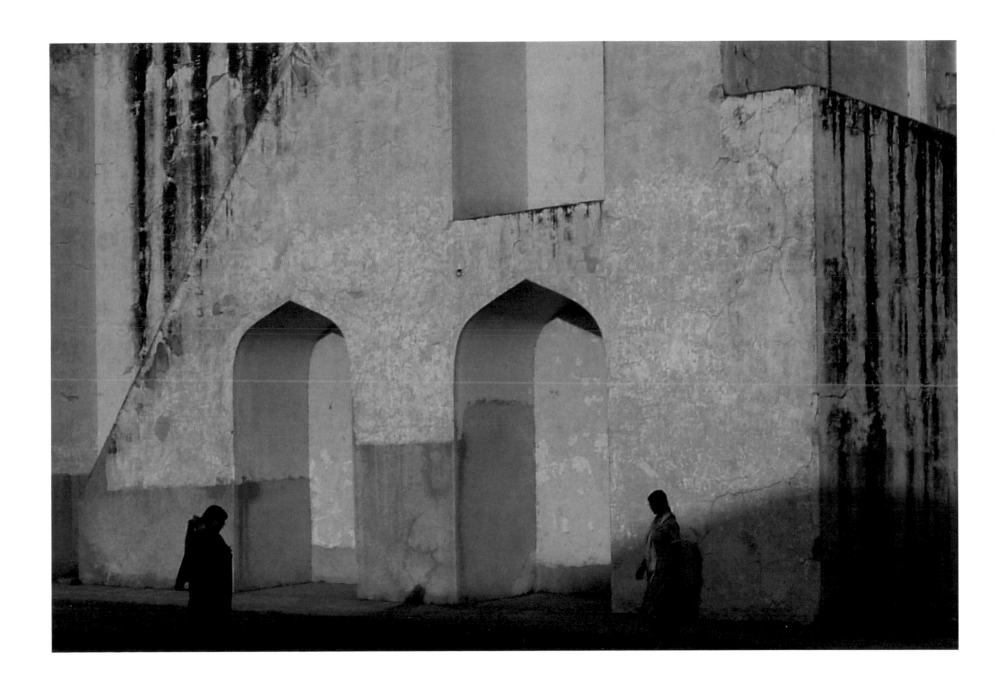

Base of the Samrat Yantra.

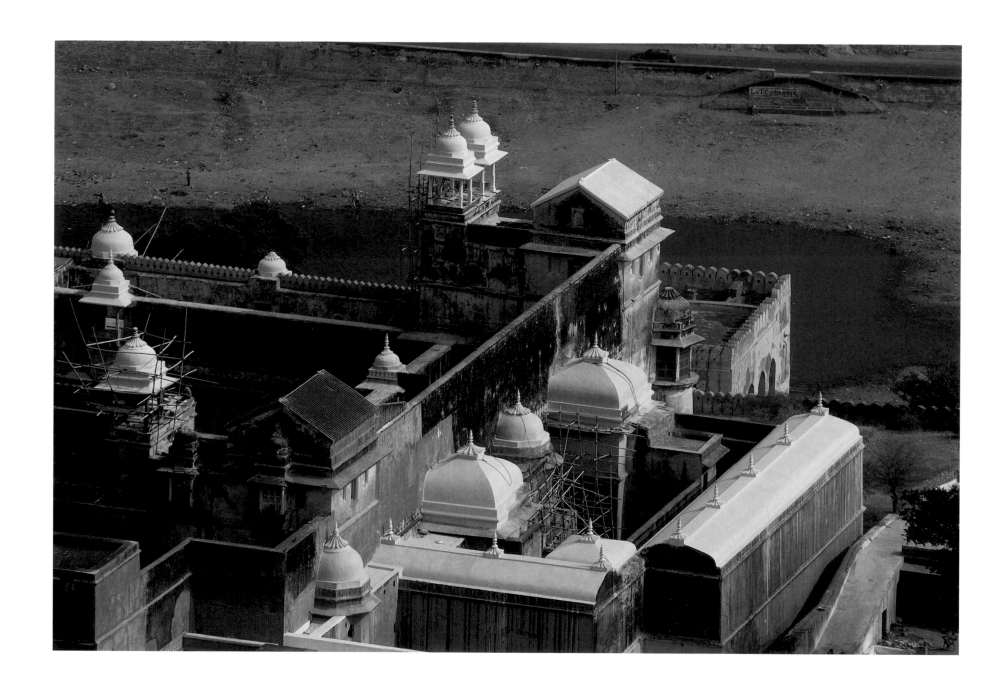

Outskirts of Jaipur. Amber Palace from Fort Jaigarh.

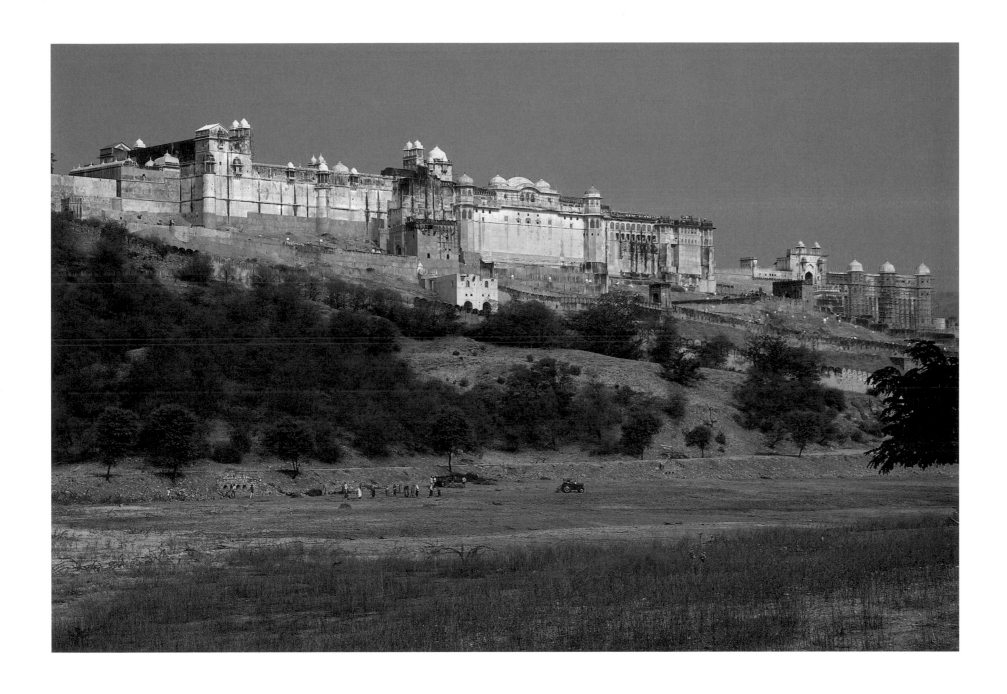

Outskirts of Jaipur. Amber and dried-up Lake Maota, October 2006.

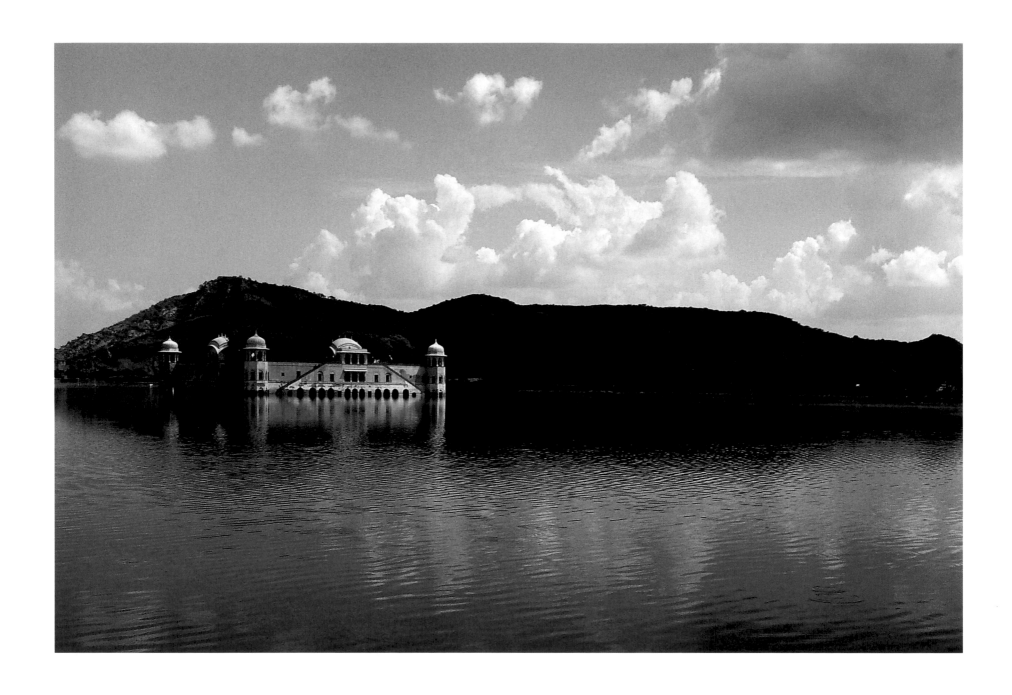

Outskirts of Jaipur. Jal Mahal or the Water Palace on Lake Man Sagar, September 2005.

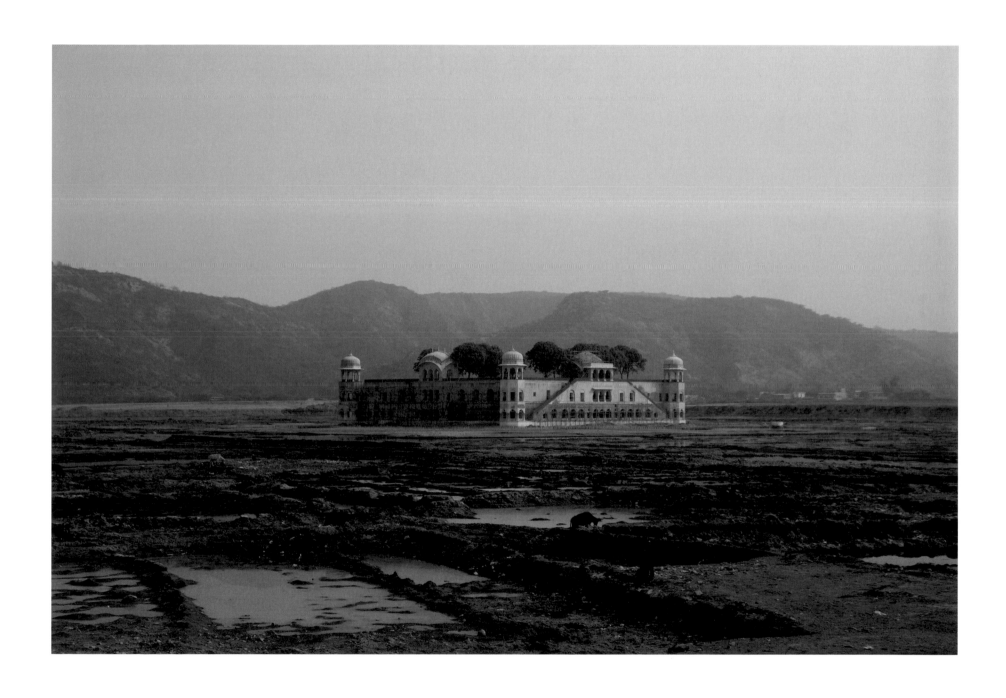

Outskirts of Jaipur. Jal Mahal and the dried up lake, October 2006.

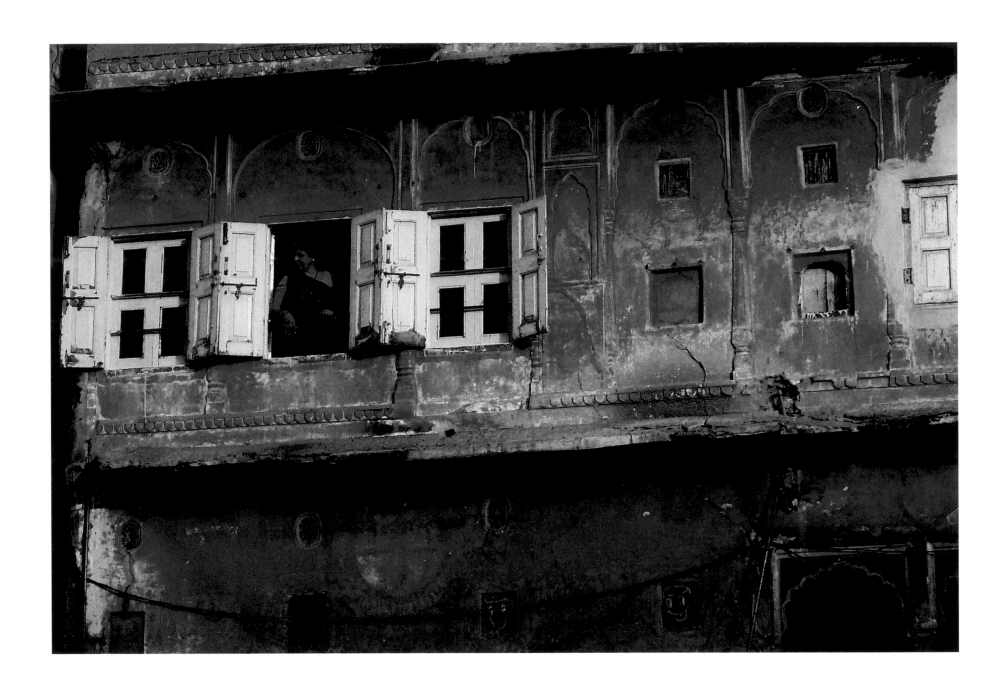

Façade overlooking the bazaars.

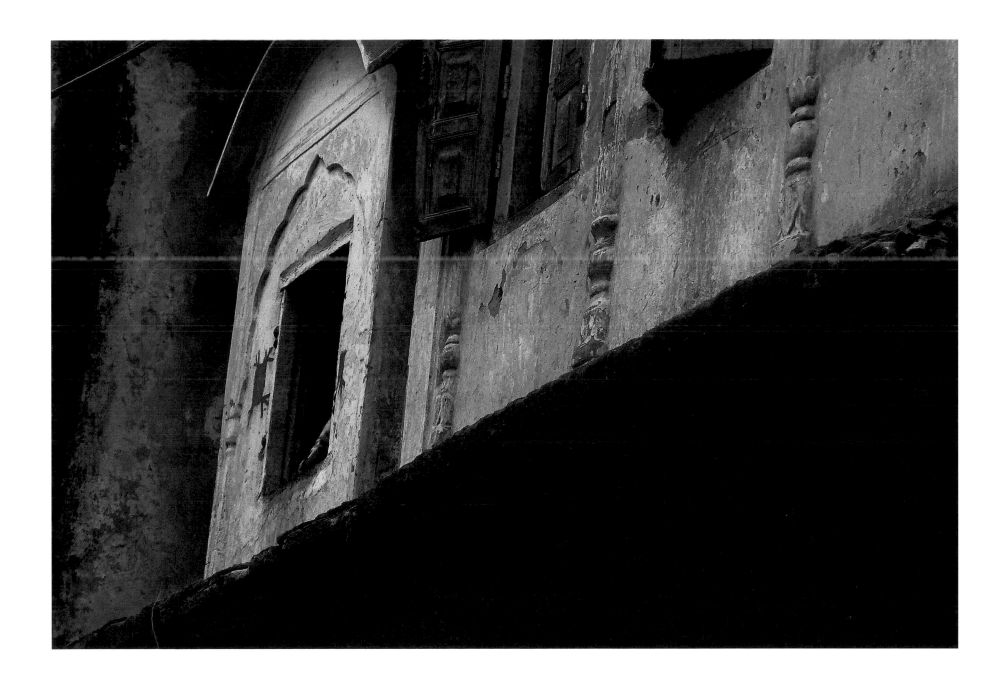

Façade in the old quarter.

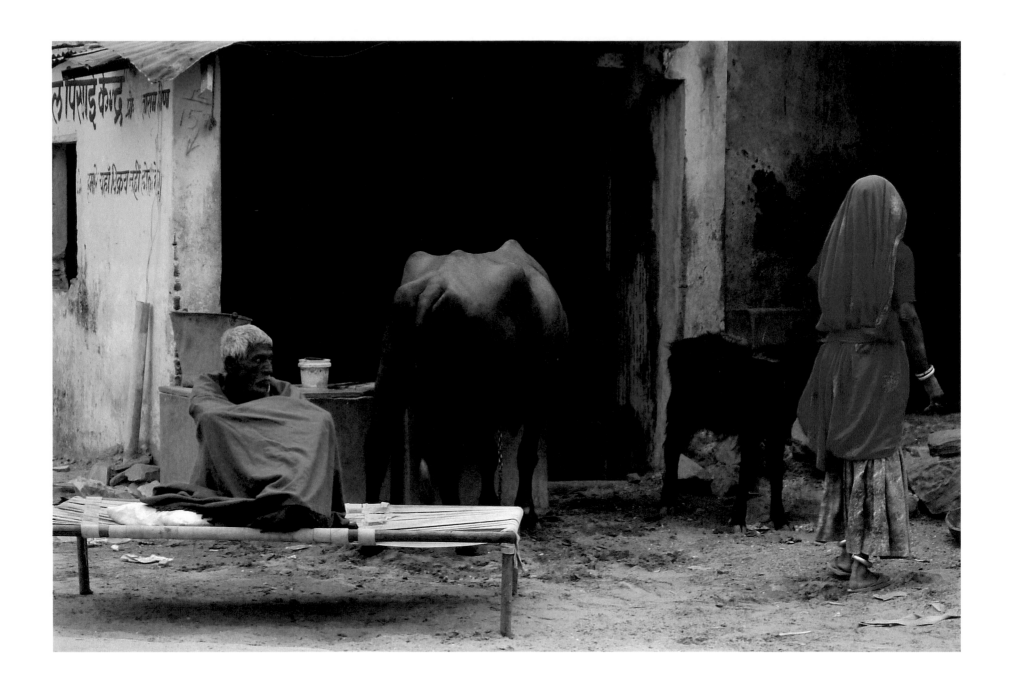

Purana Basti Street.

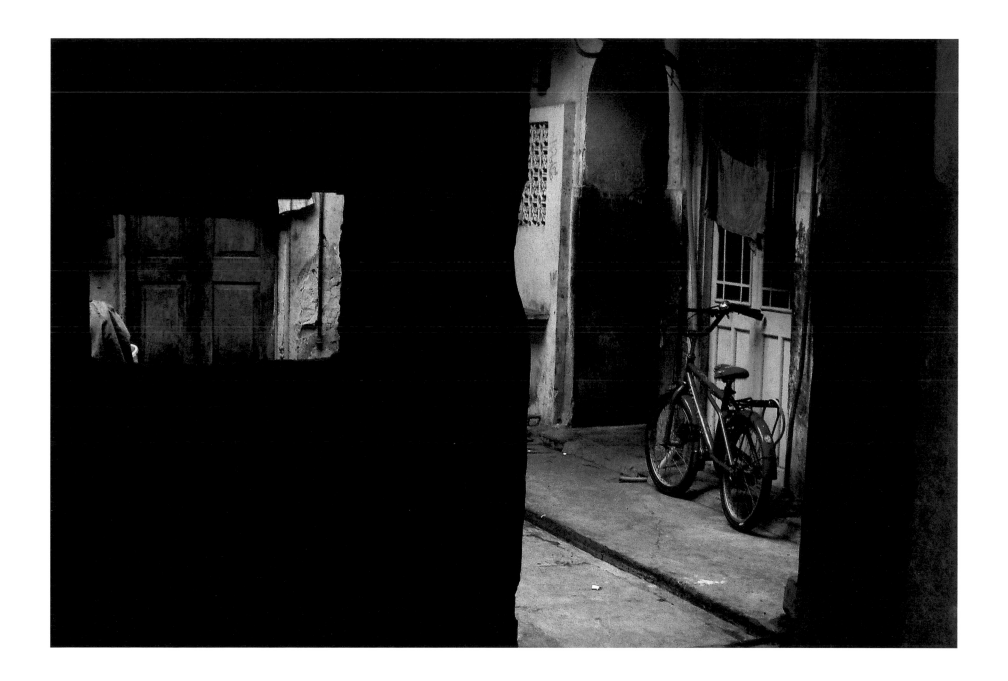

Patio.

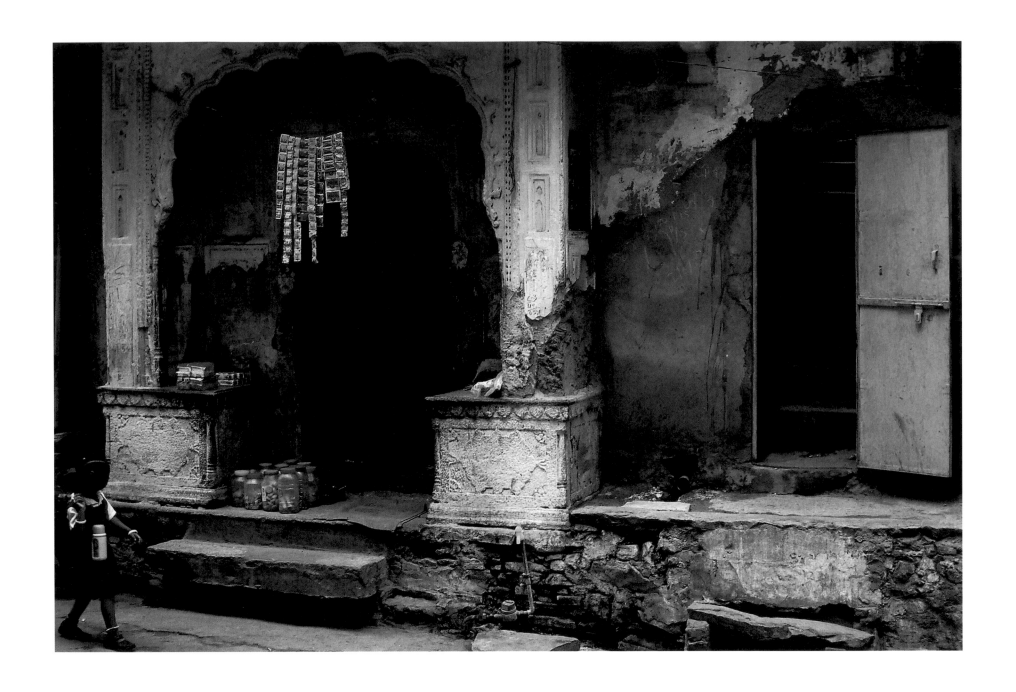

A sweet shop.

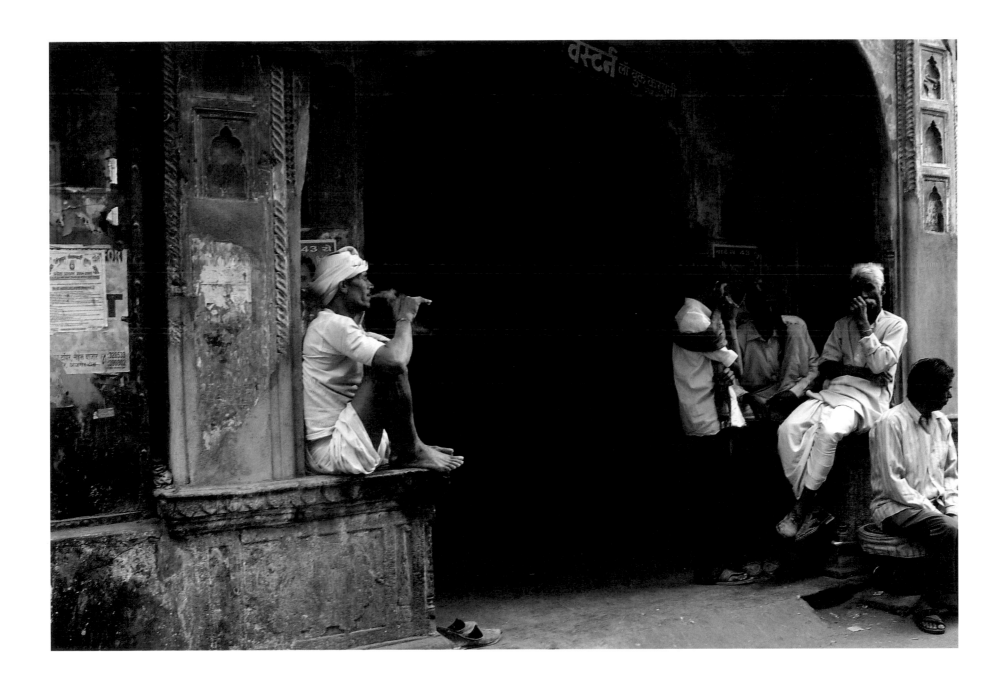

Eternal rest.

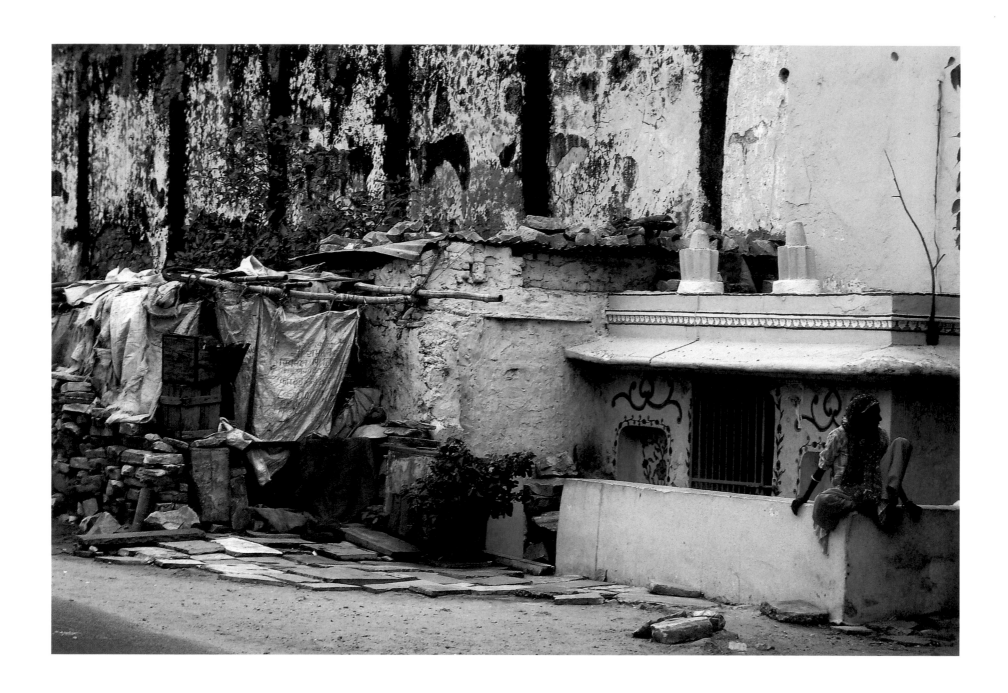

A house adjoining the walls.

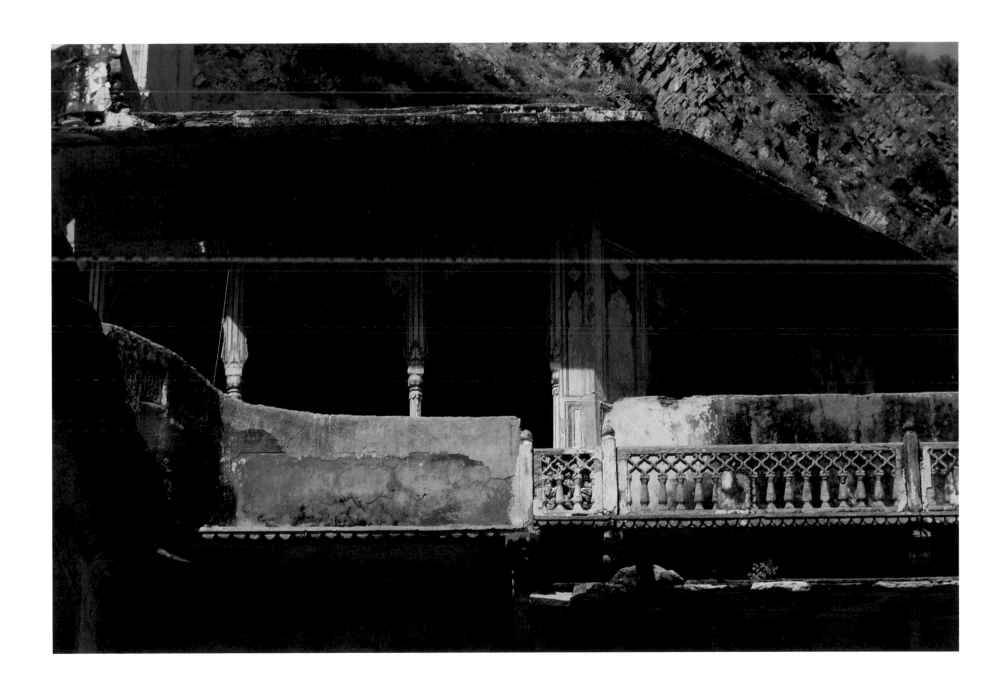

Outskirts of Jaipur. Building adjoining the temple of Galta.

PUSHKAR

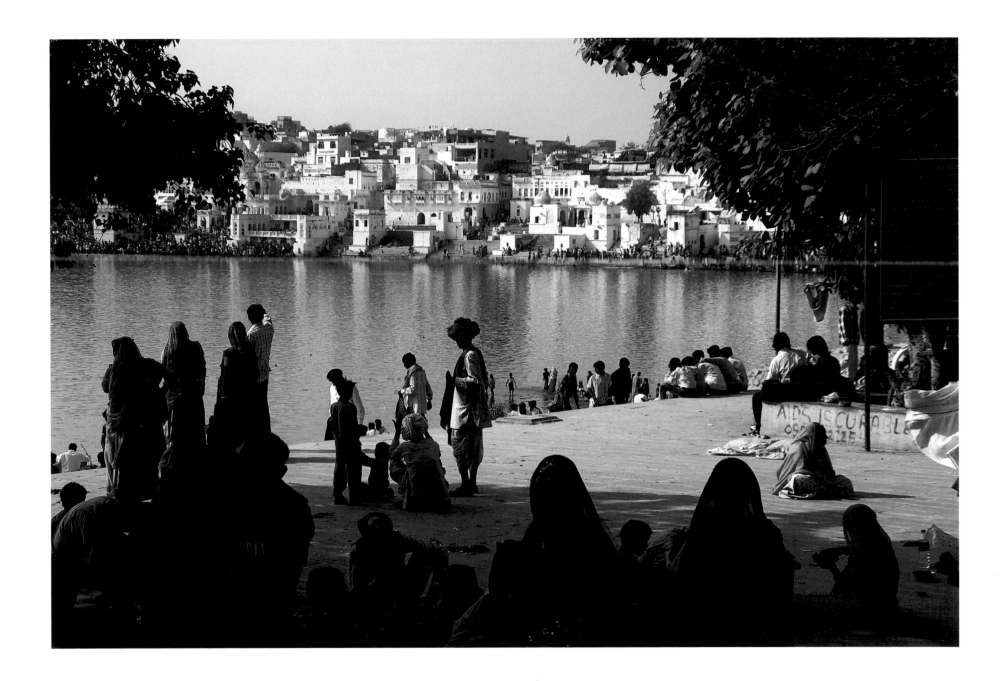

The sacred lake.

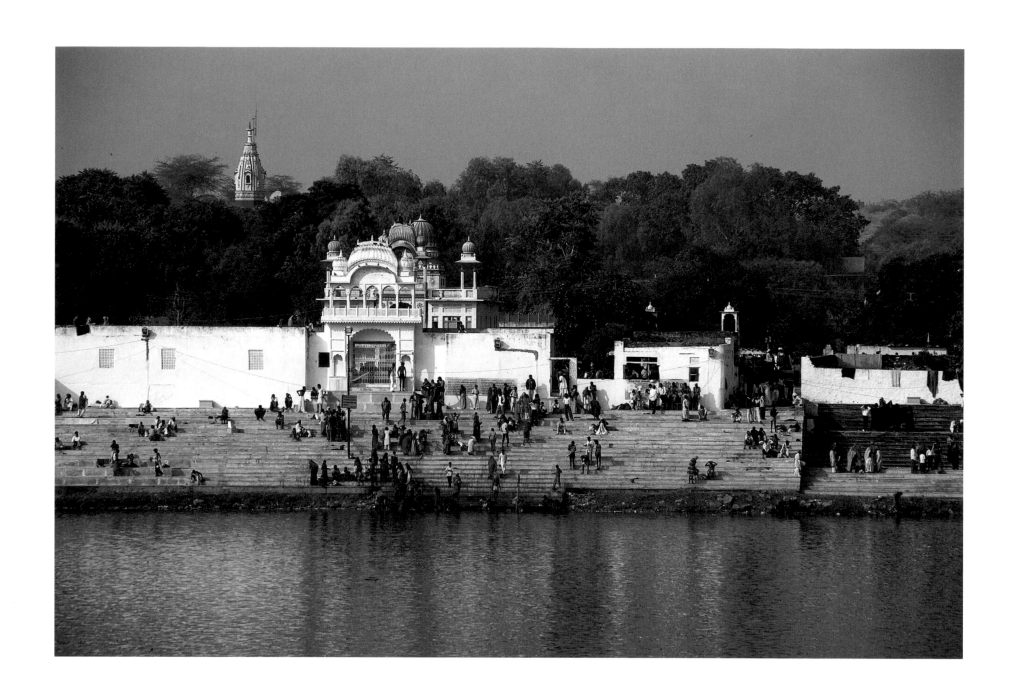

One of the numerous *ghats* or flights of steps.

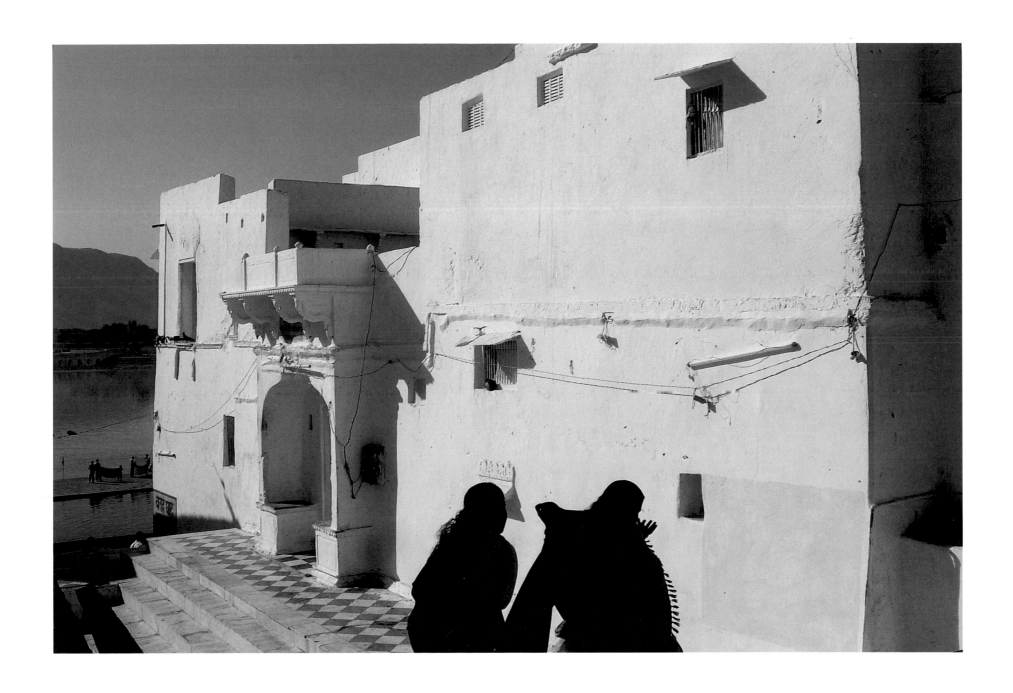

Street leading to a *ghat*.

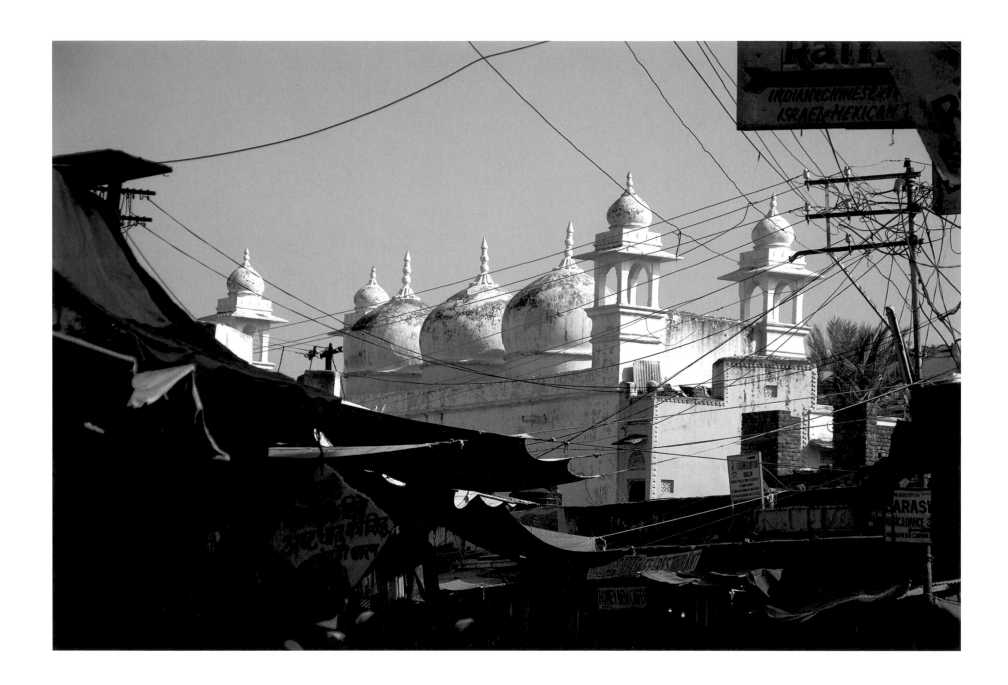

The main bazaar.

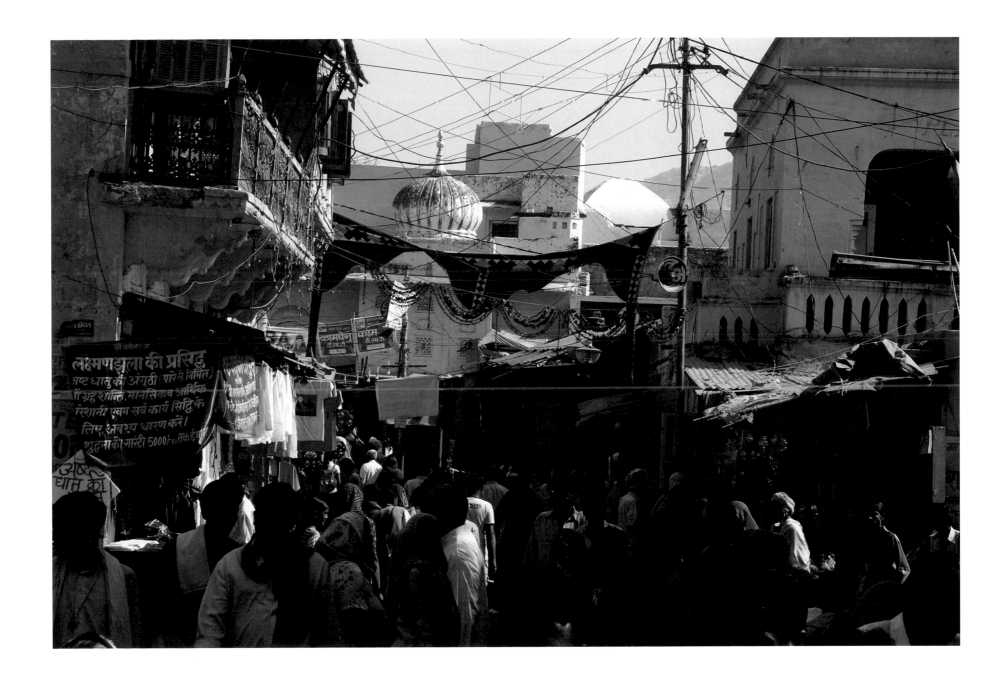

Bazaar.

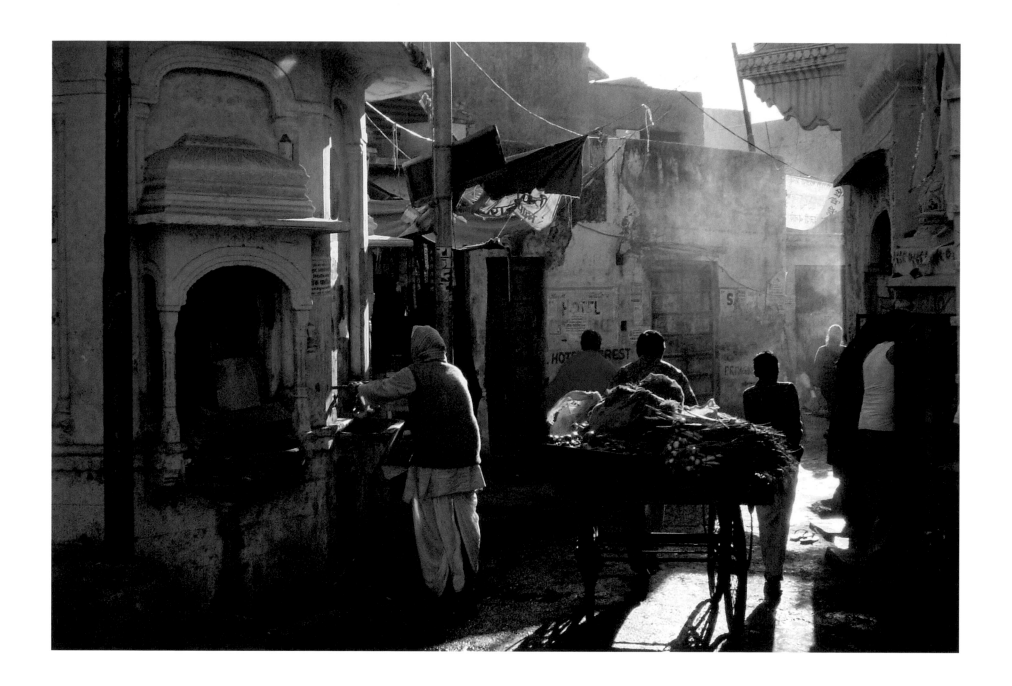

Fountain.

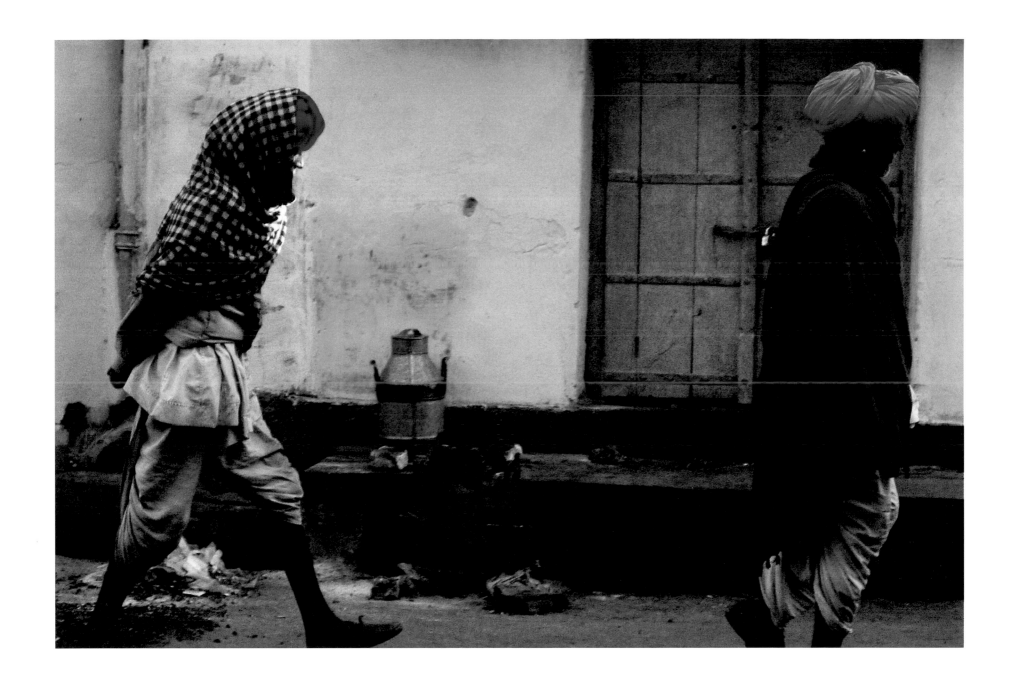

On the way to the temple.

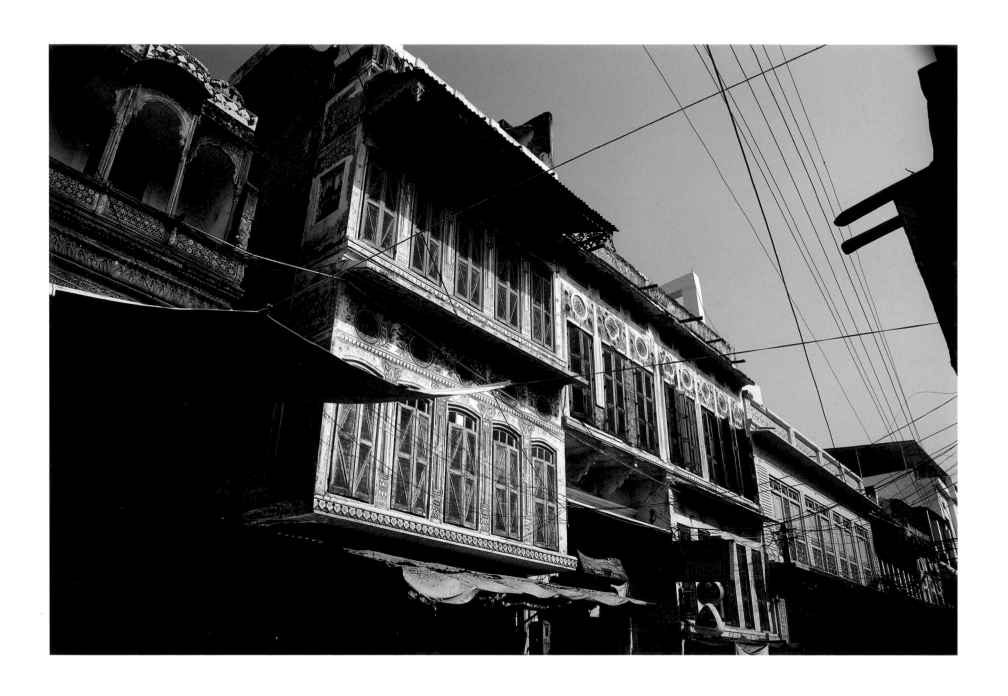

Pushkar. Façades on Sadar Bazaar Road.

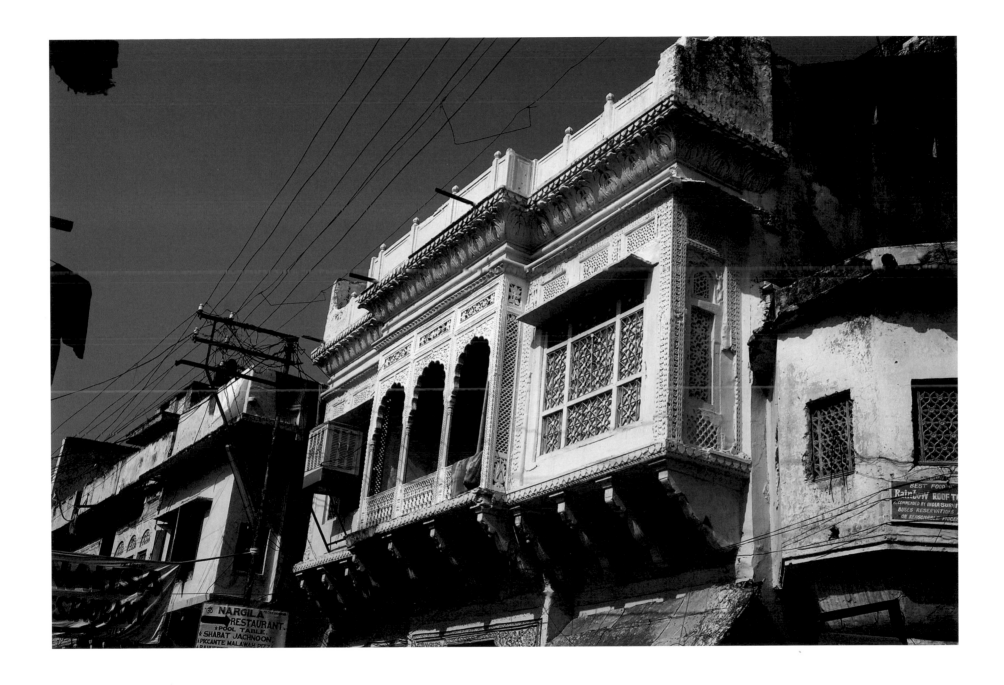

Pushkar. Façades on Sadar Bazaar Road.

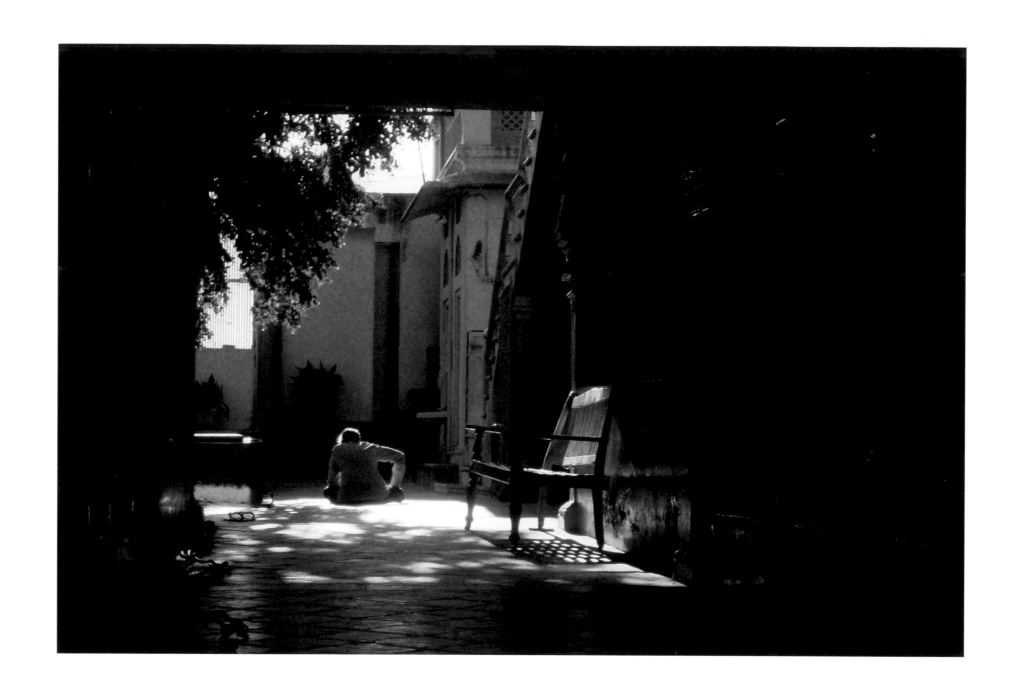

Inner patio.

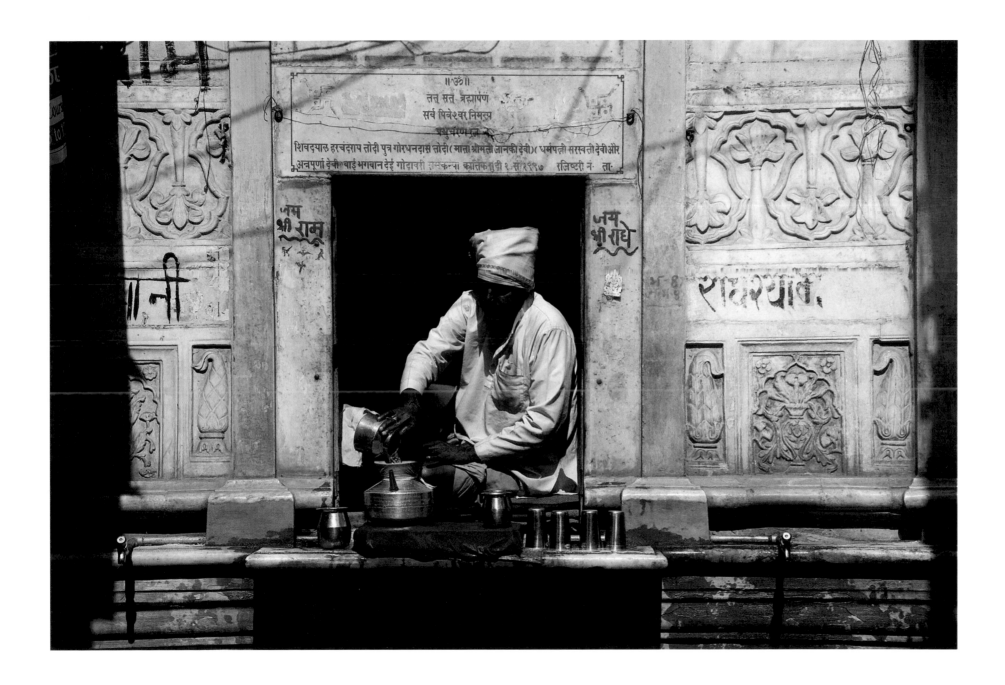

The water seller's house.

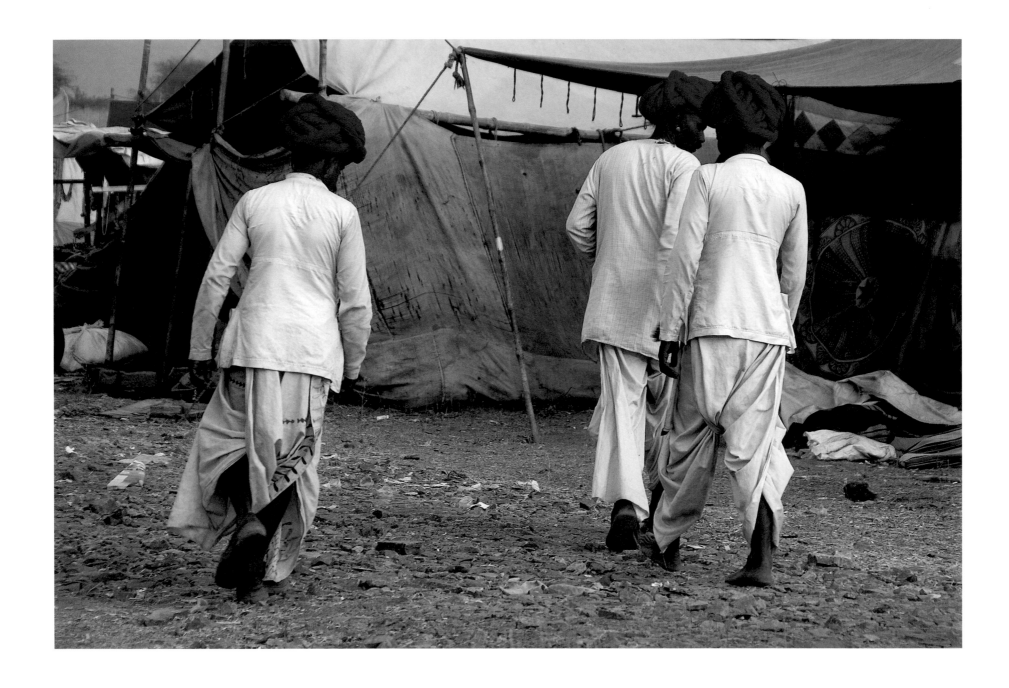

Rabaris at Pushkar fair.

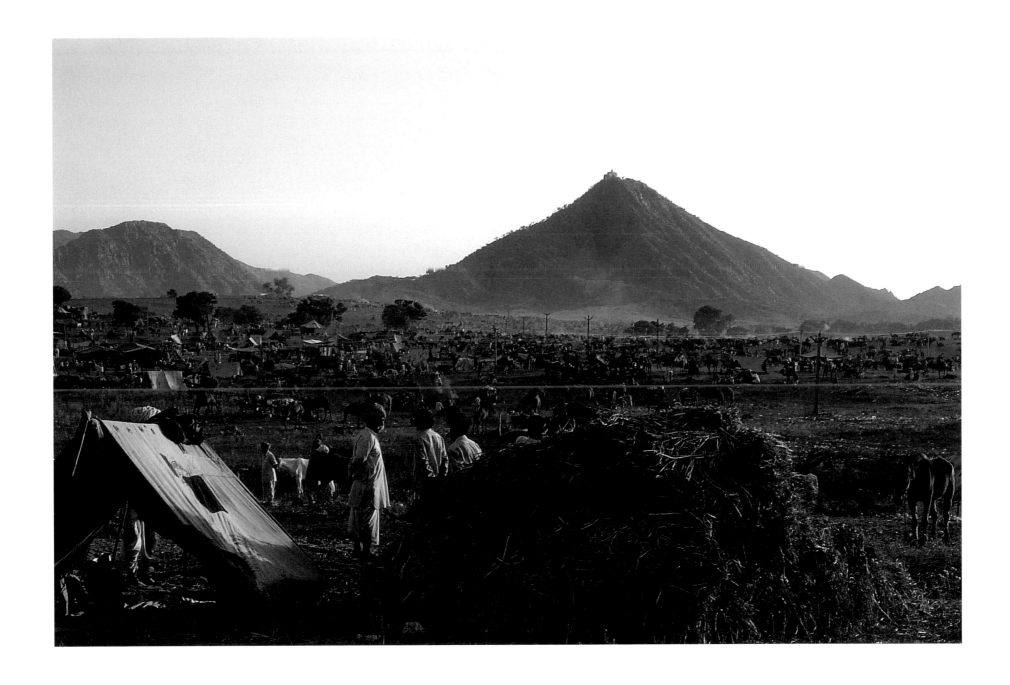

Pushkar fair.

BUNDI

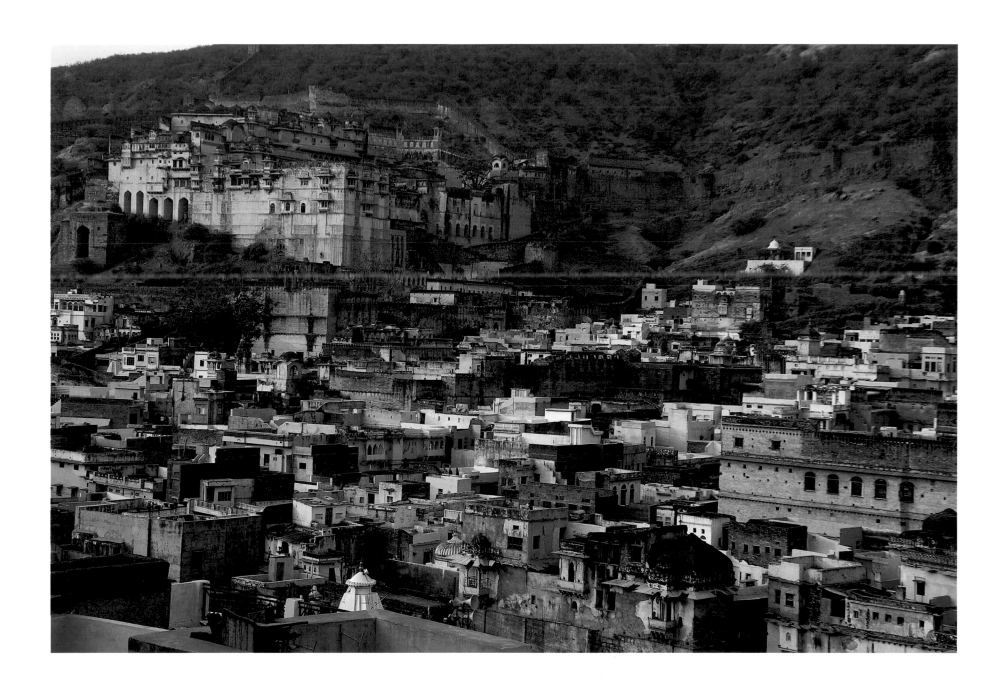

The palace and the city.

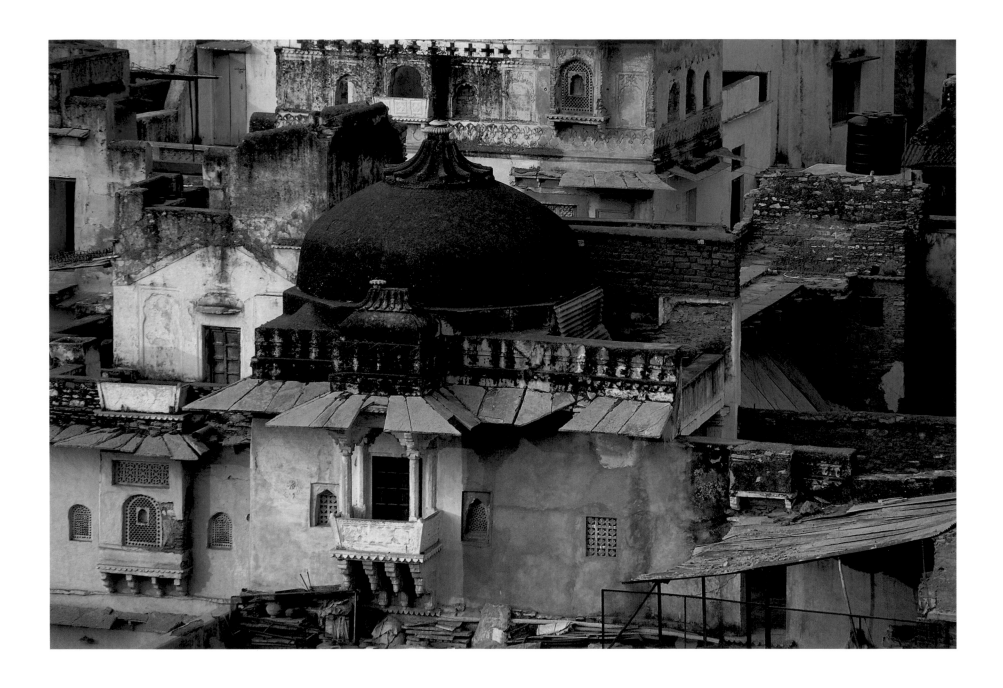

Flat and sloping roofs.

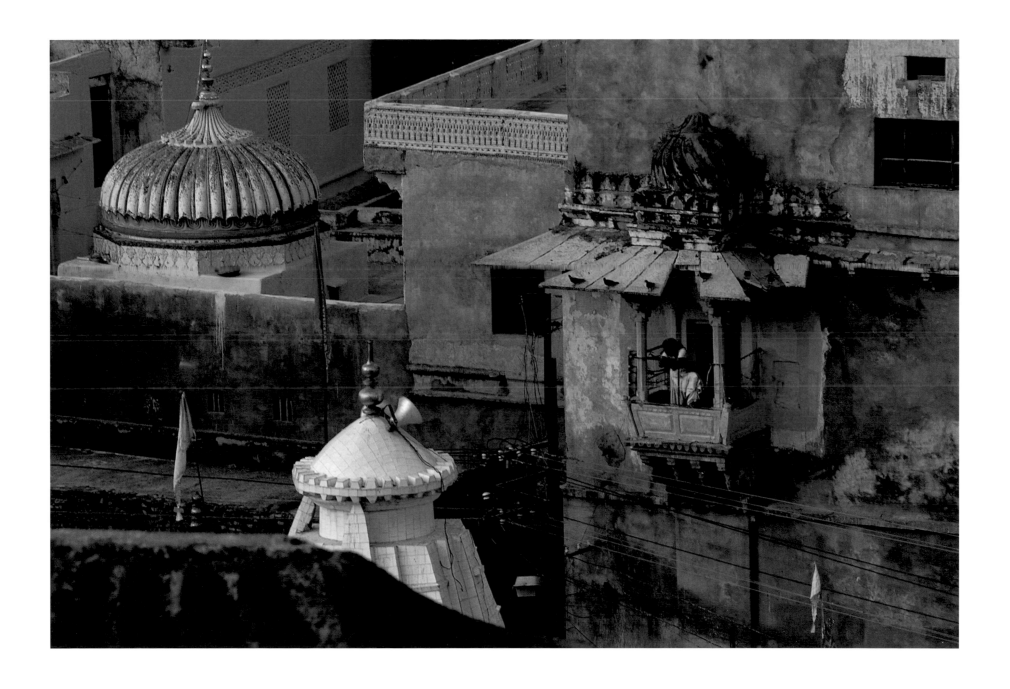

Flat, sloping and circular roofs.

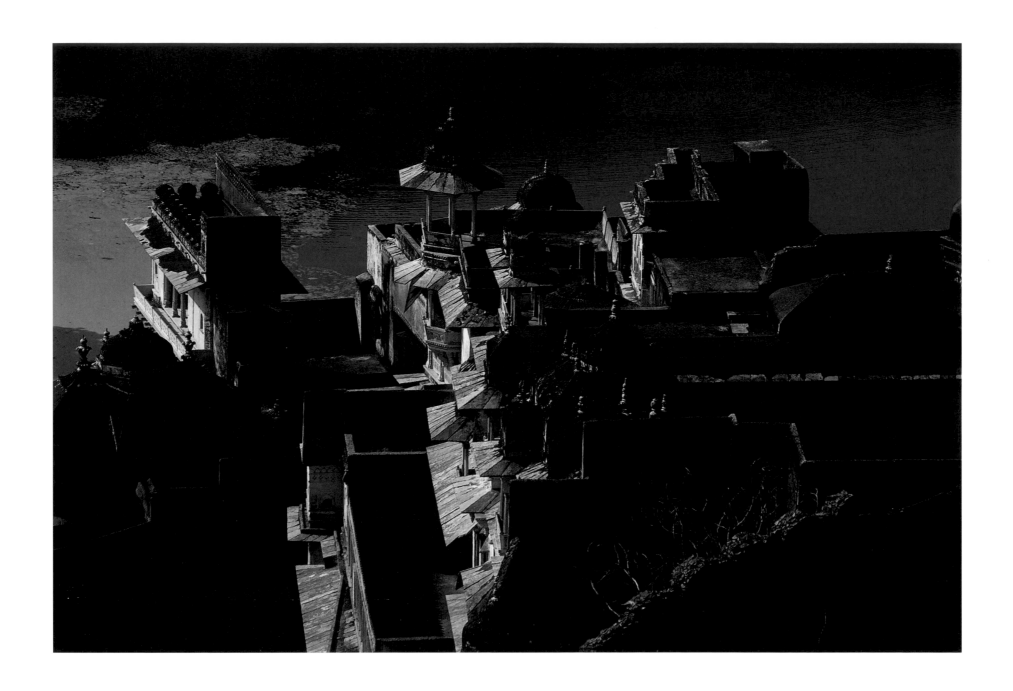

Bundi Palace from Fort Taragarh.

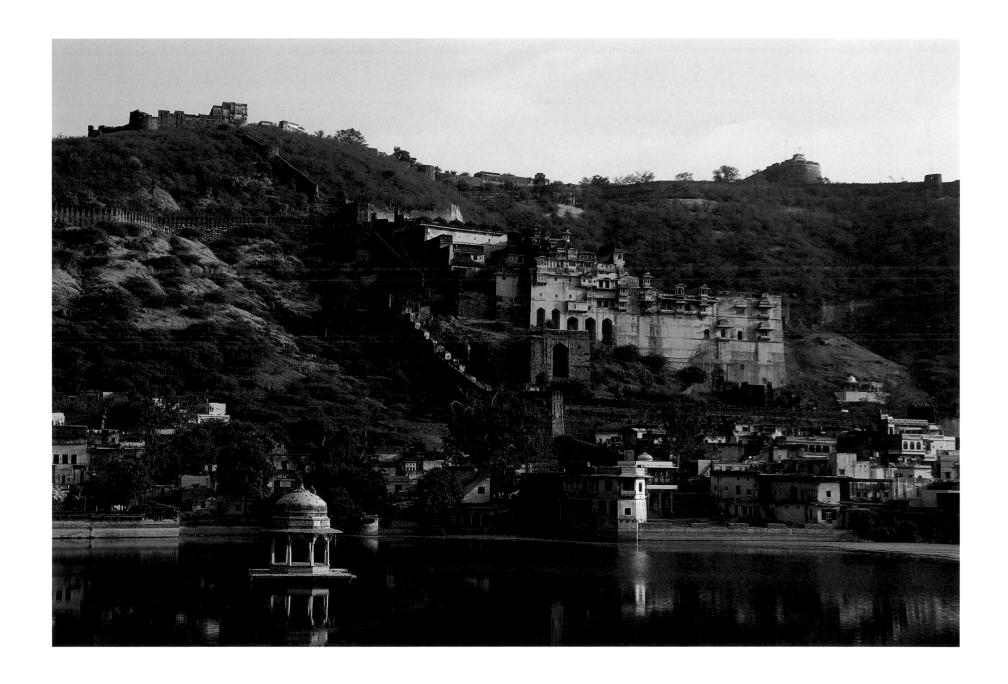

Lake Nawal Sagar.

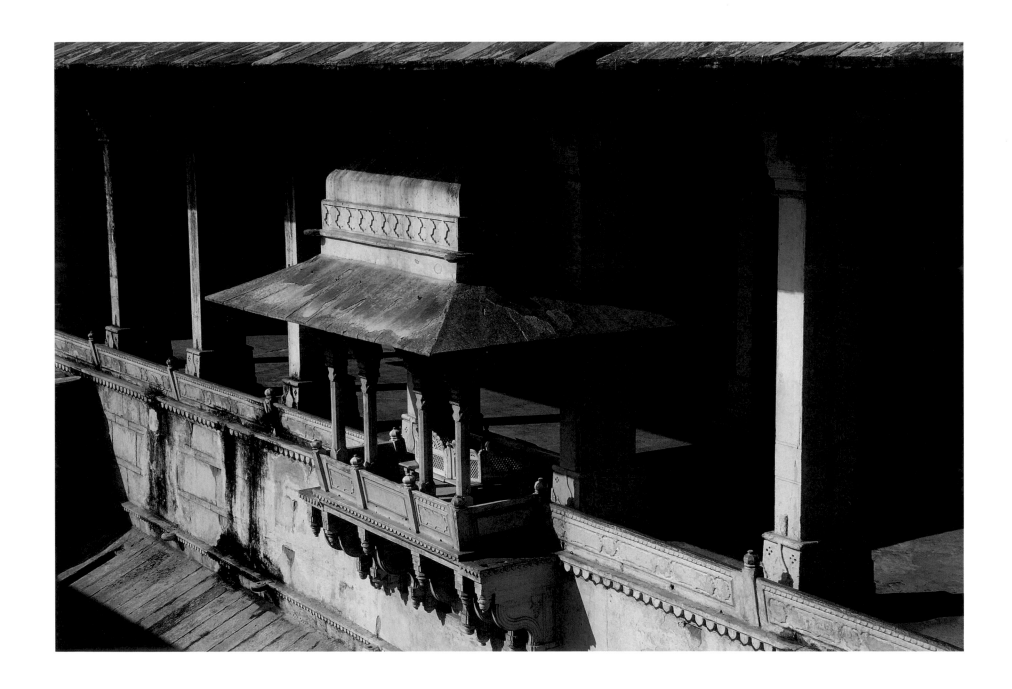

Bundi Palace. The receptions box.

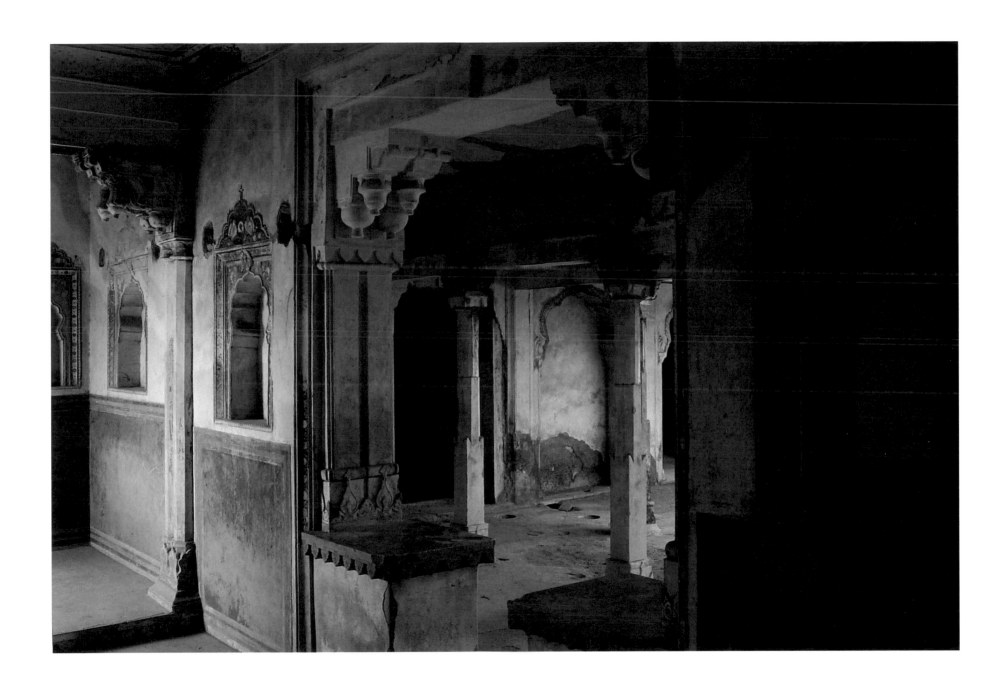

Bundi Palace. The queen's quarters.

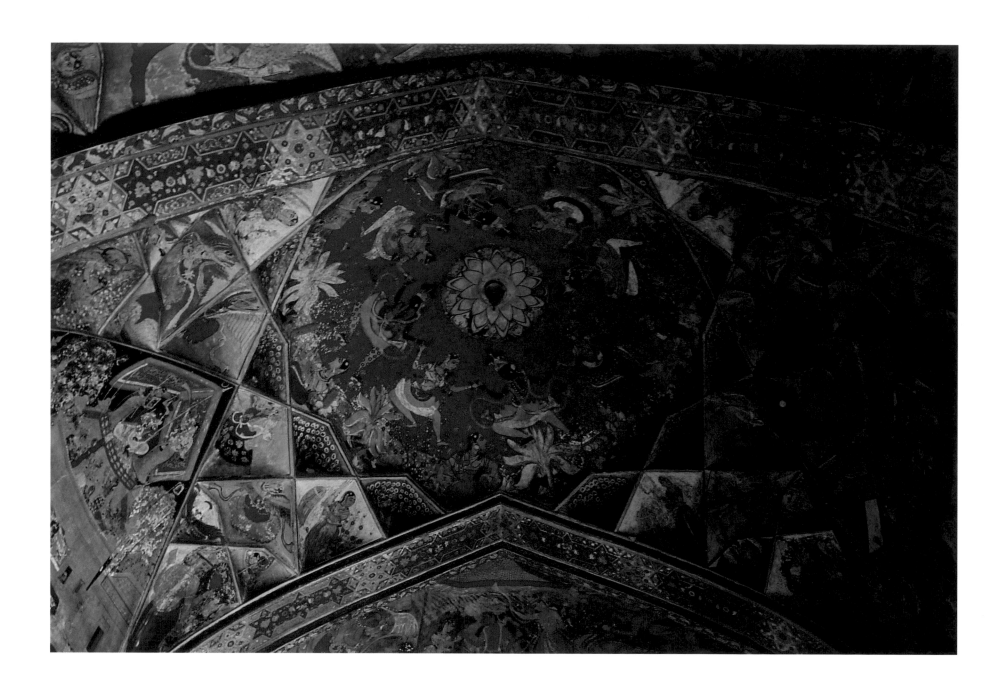

Bundi Palace. Vault over one of the halls.

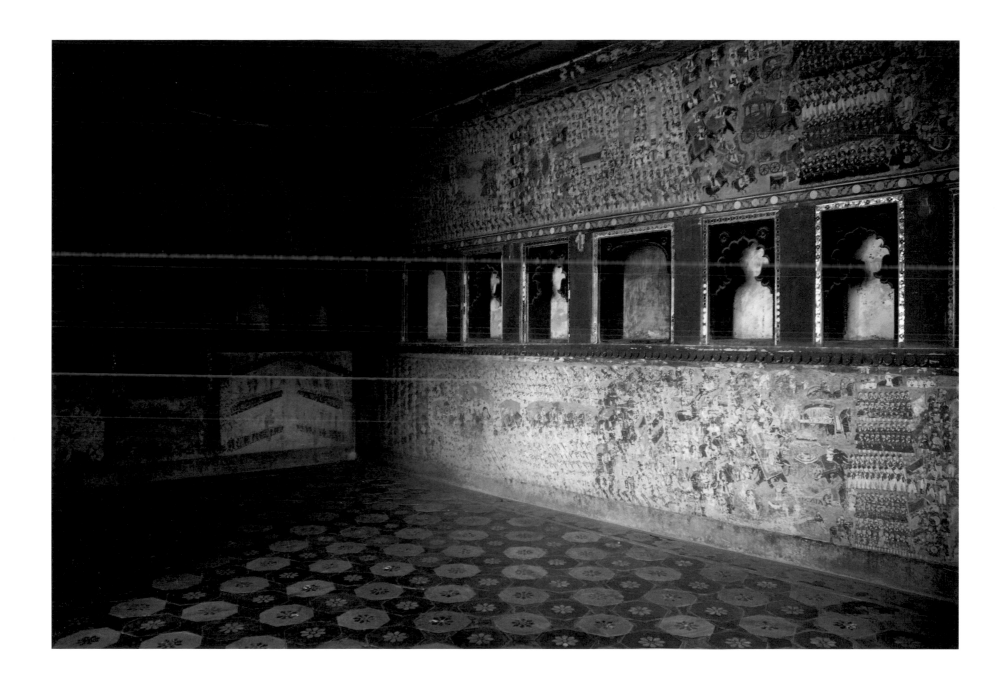

A hall in Bundi Palace.

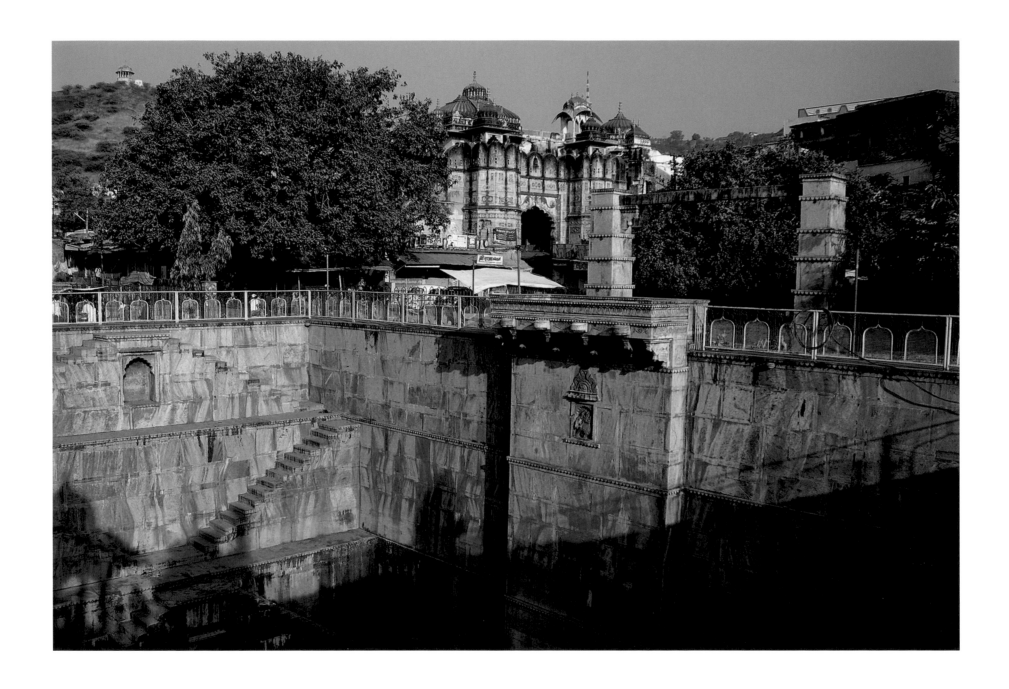

Bundi. Bahori Nagar Sagar Kund.

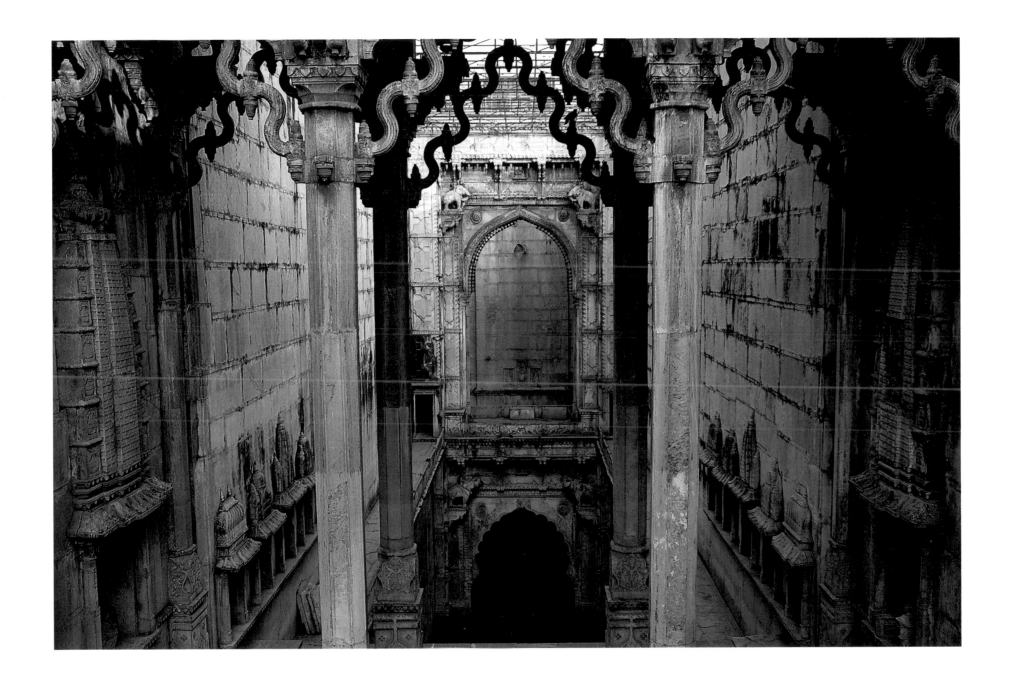

Bundi. Raniji Ki Bahori.

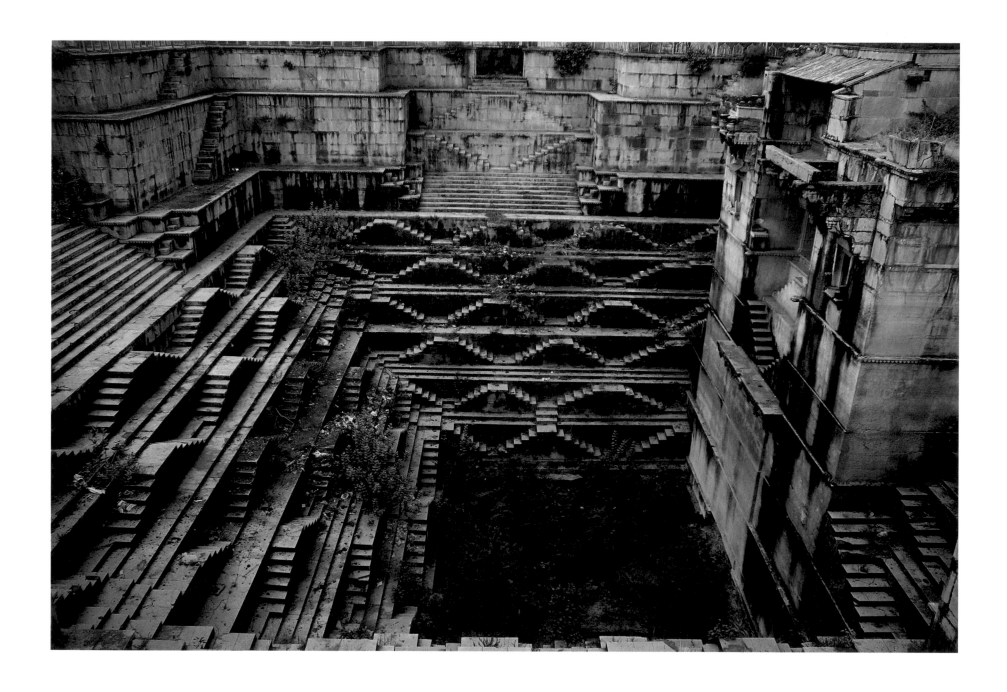

Bundi. Sabirna Dha Ka Kund Bahori.

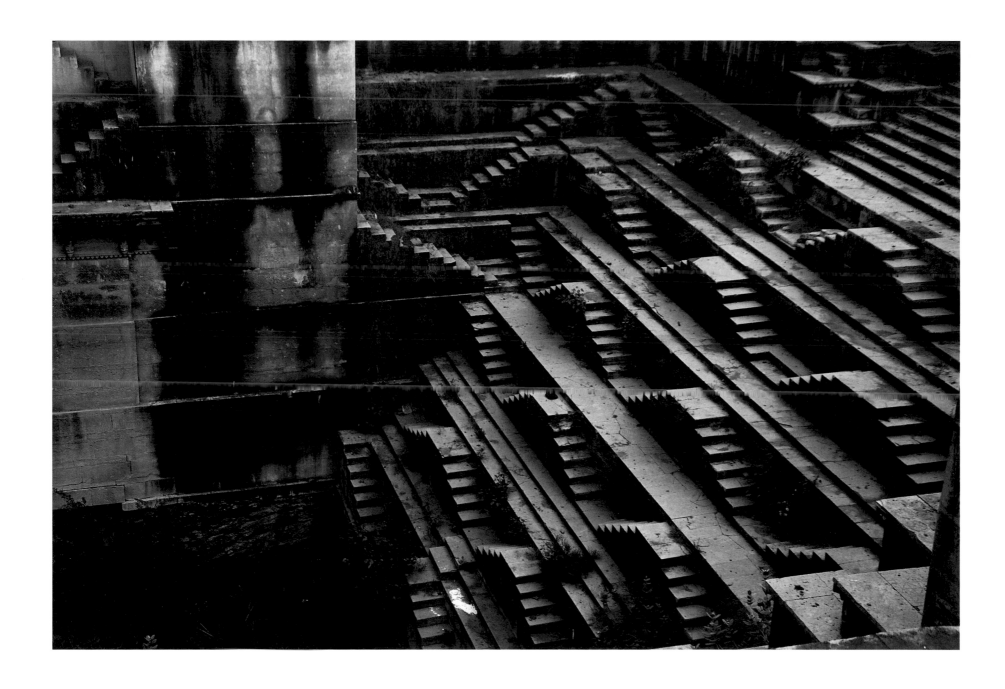

Bundi. Sabirna Dha Ka Kund Bahori.

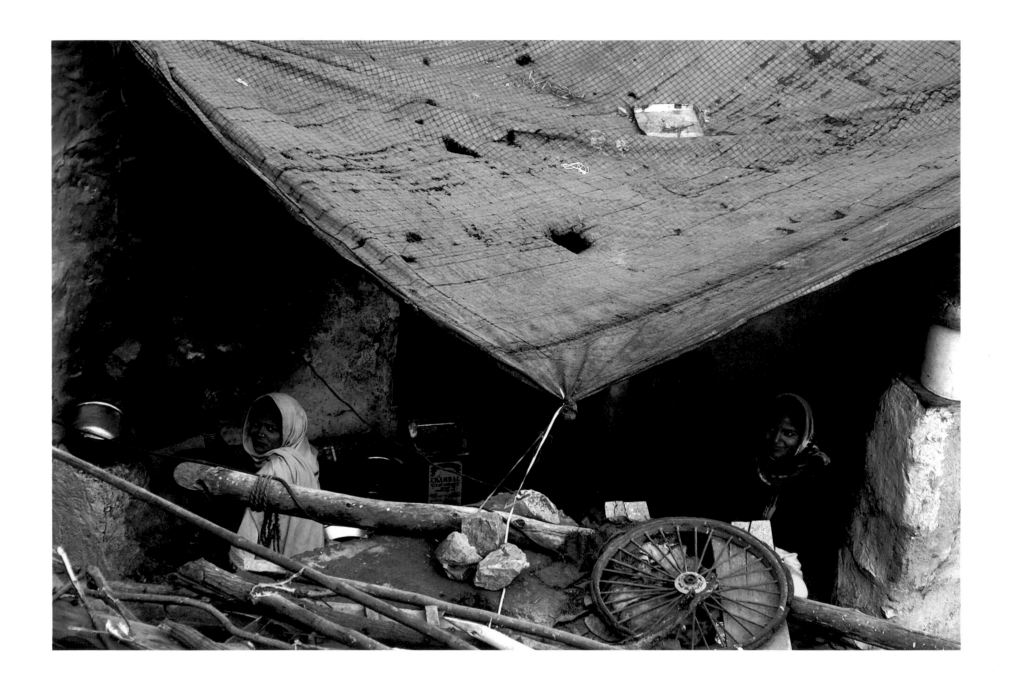

Preparing a meal.

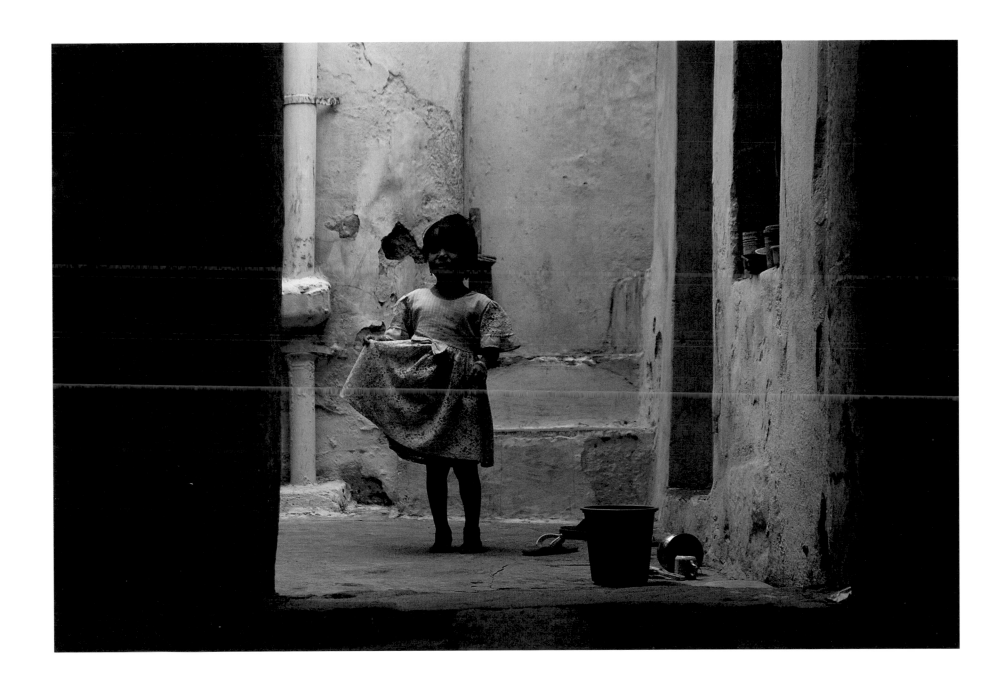

The little girl and the patio.

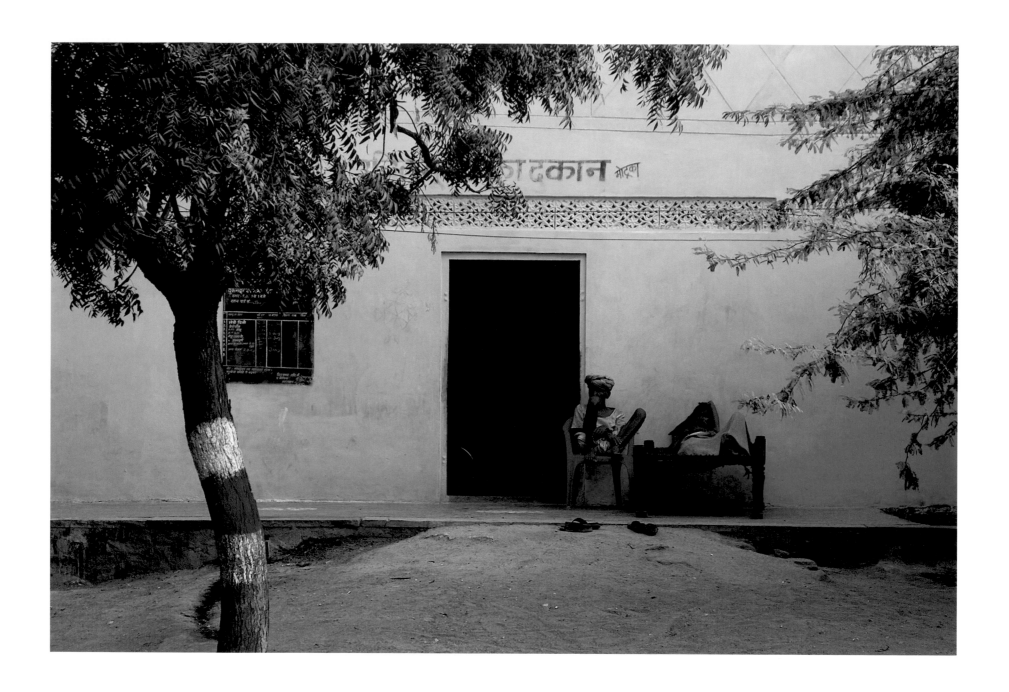

On the way from Bundi to Jaipur.

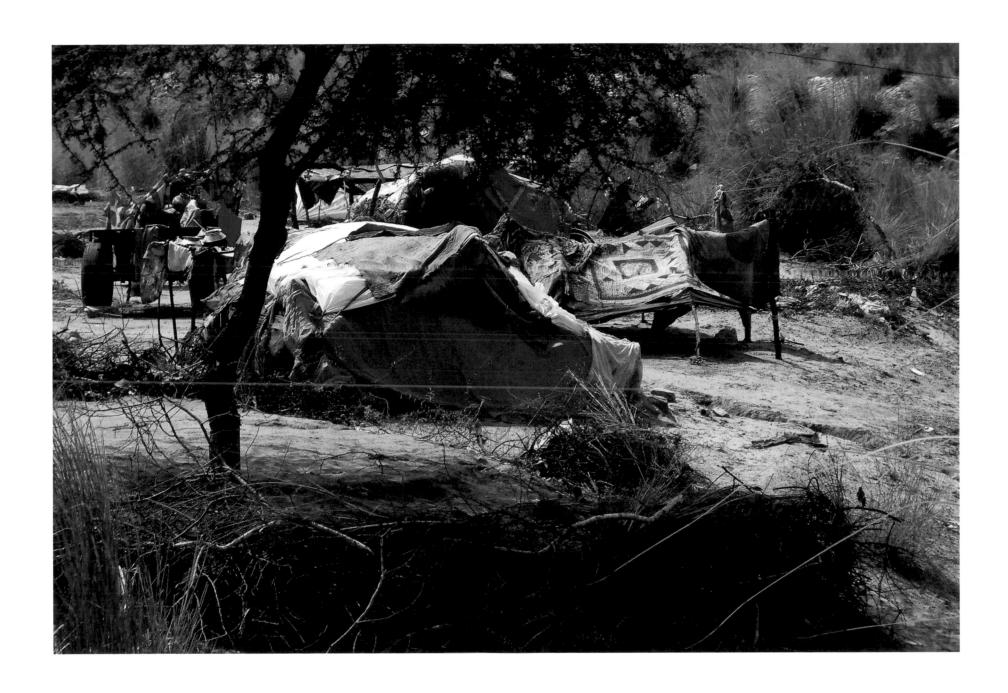

Outskirts of Bundi. Banjara gypsy camp.

CHITTAURGARH

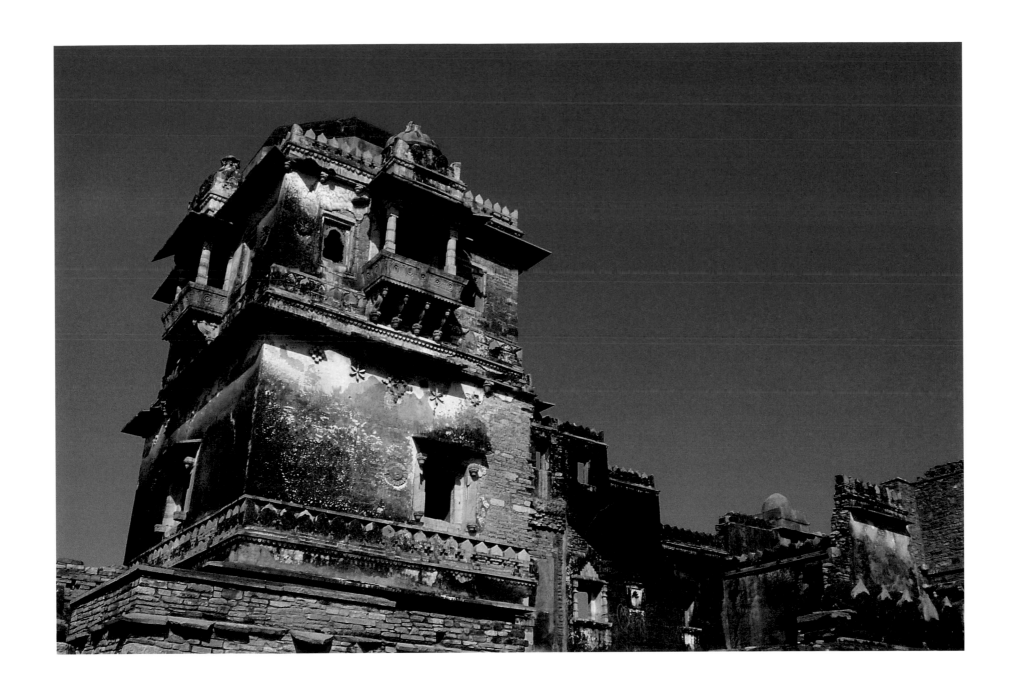

Ruins of the Rana Kumbha Palace.

UDAIPUR

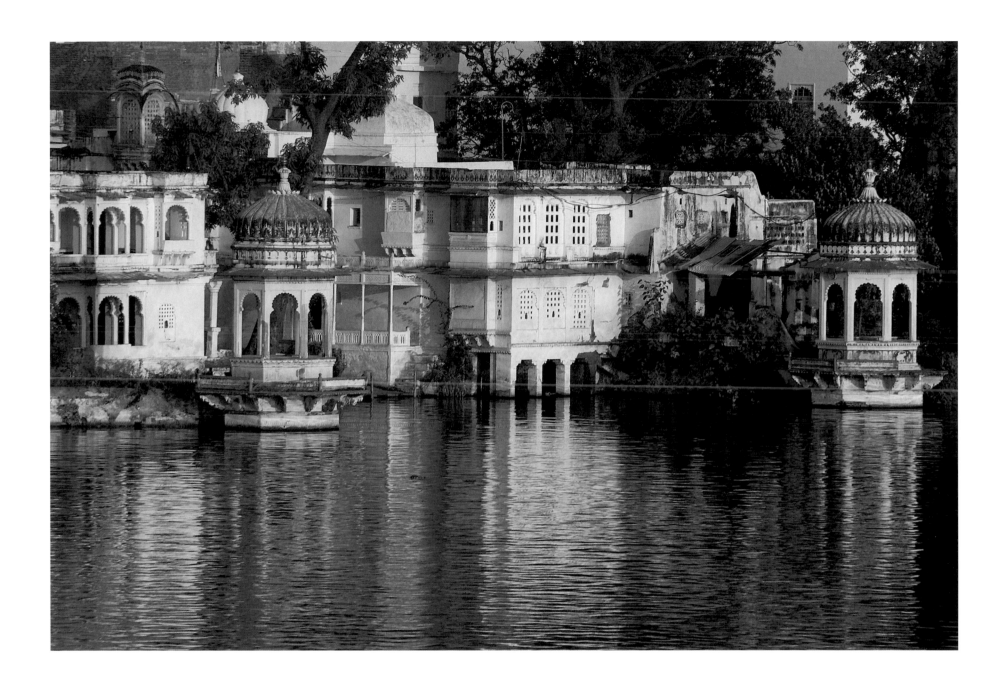

Buildings on Lake Pichola.

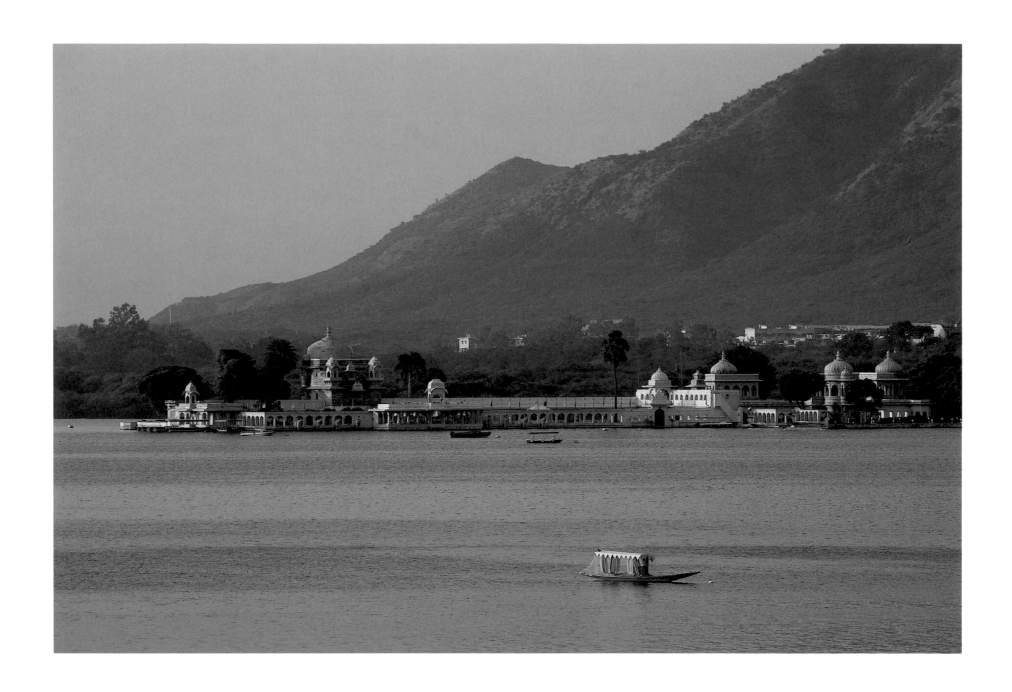

Jag Mandir Palace.

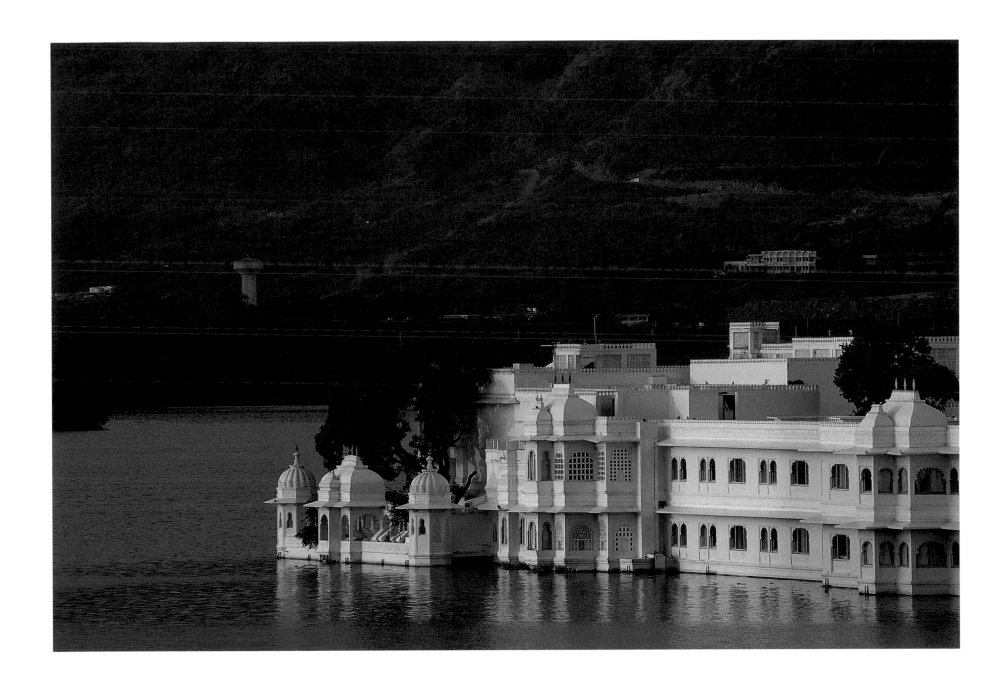

Jag Niwas or the Palace of the Lake.

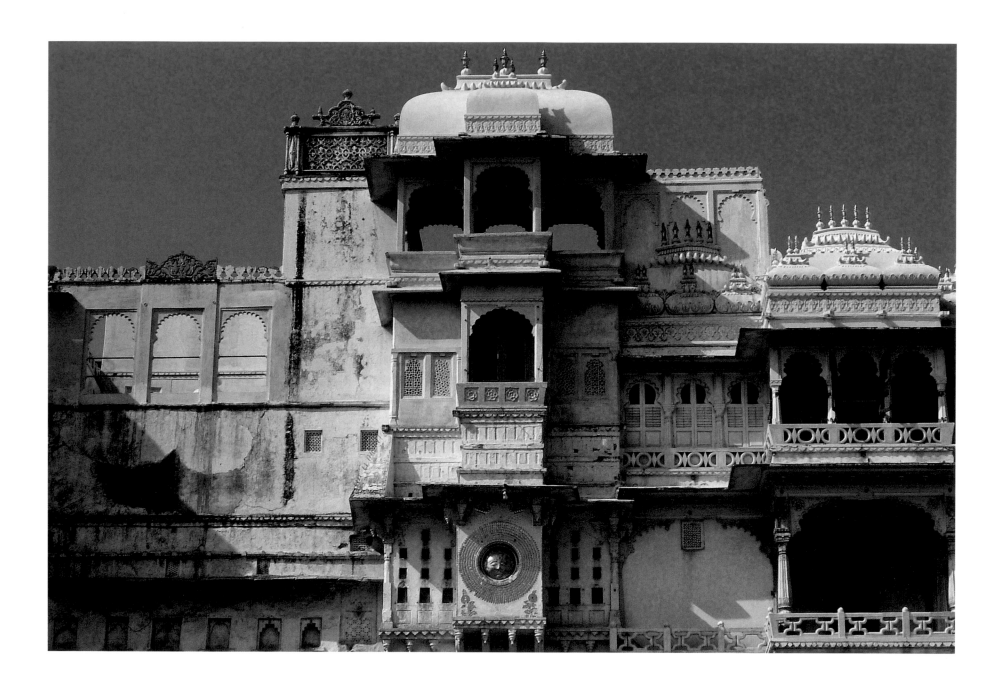

City Palace.

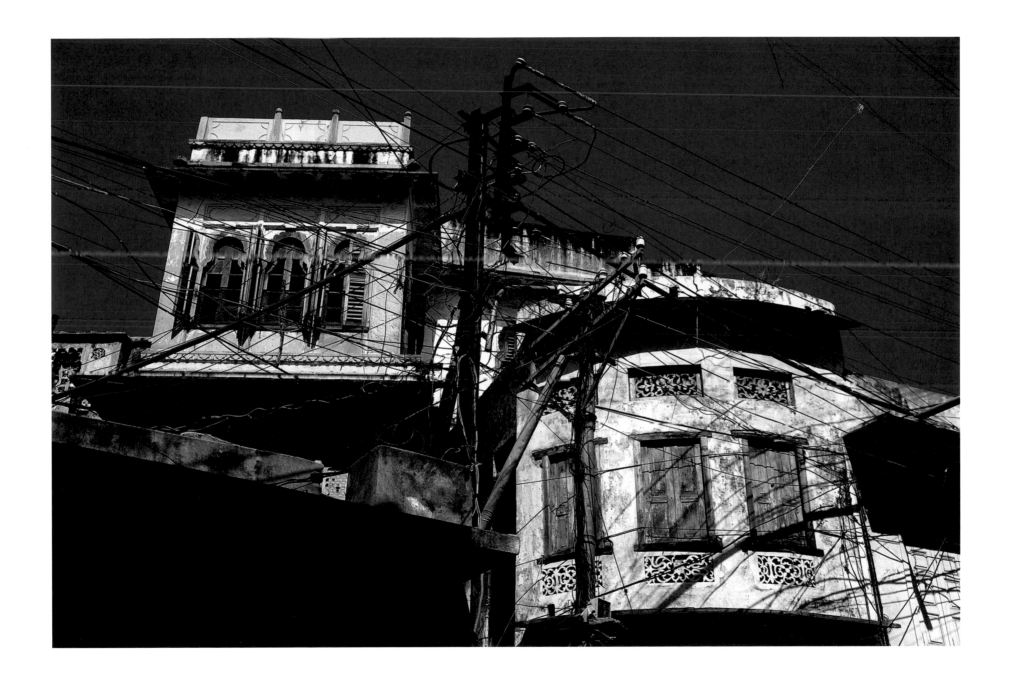

Moti Chohatta façades.

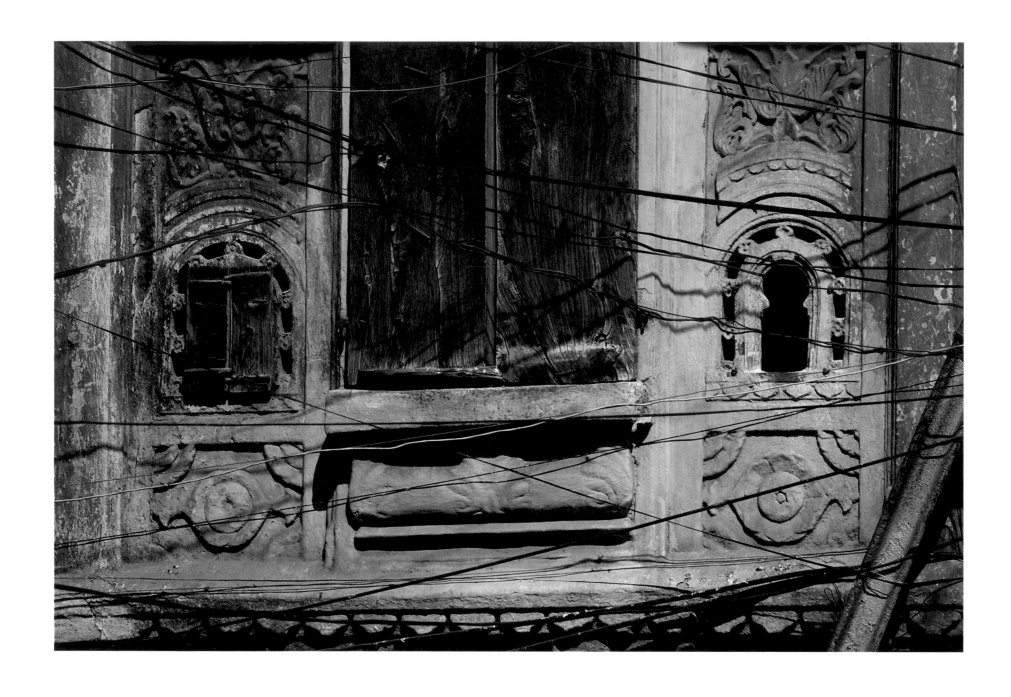

Façade near the temple of Jagdish.

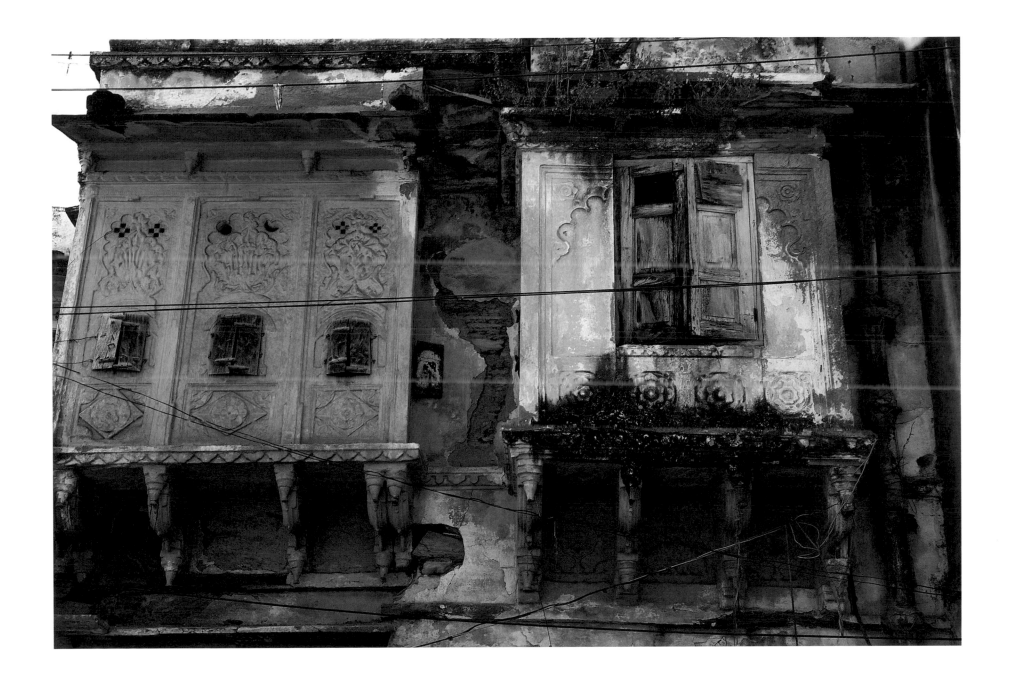

Façade next to the market.

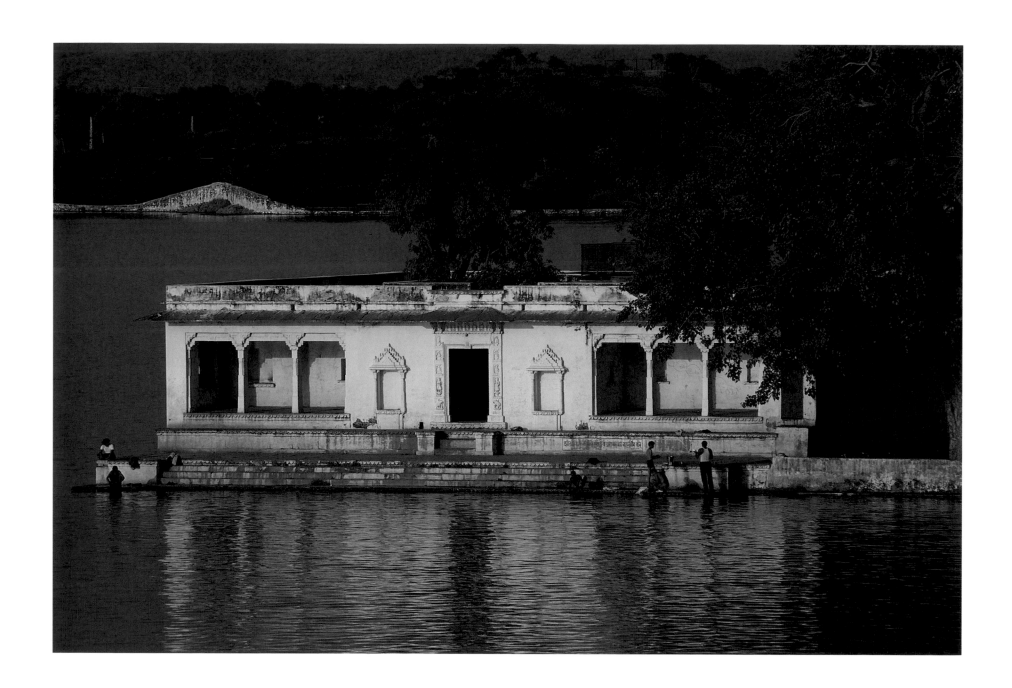

Jetty.

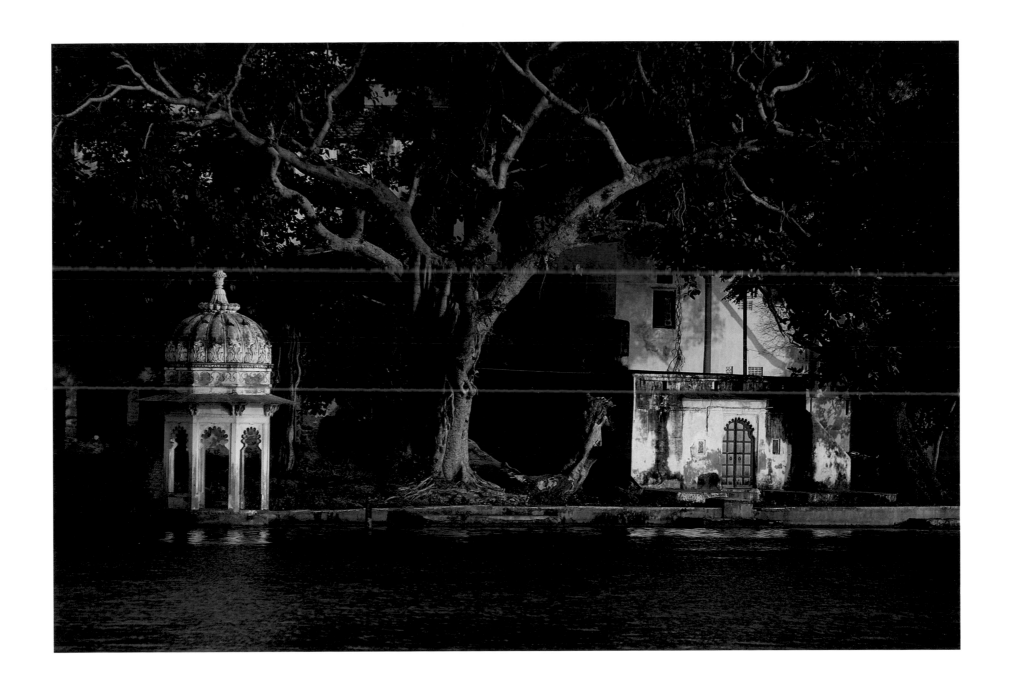

The lake beside the palace

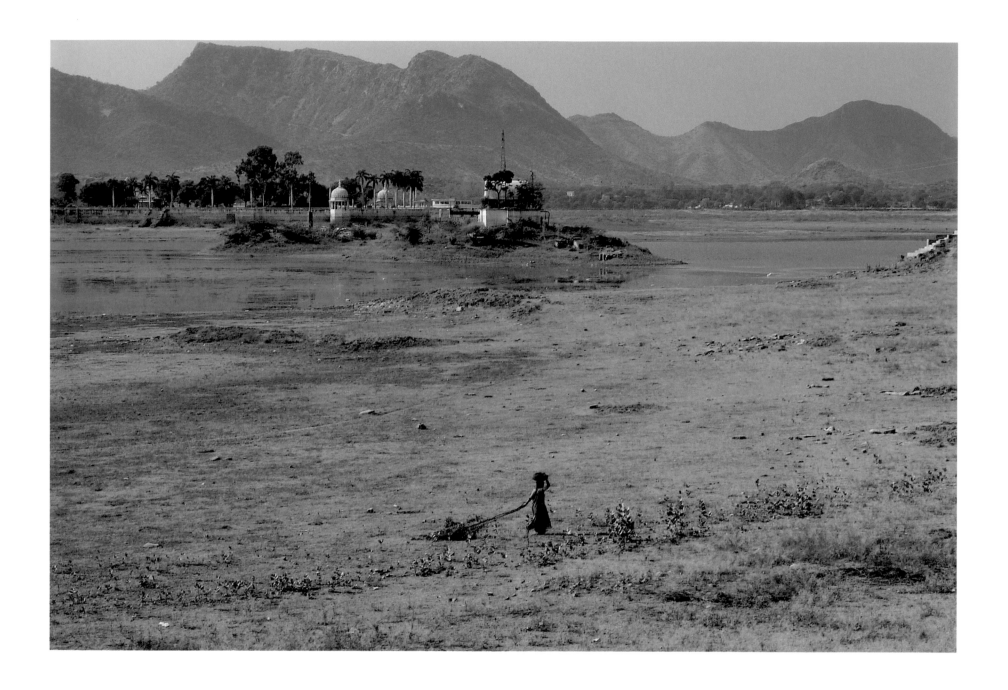

Lake Fateh Sagar in November 2004.

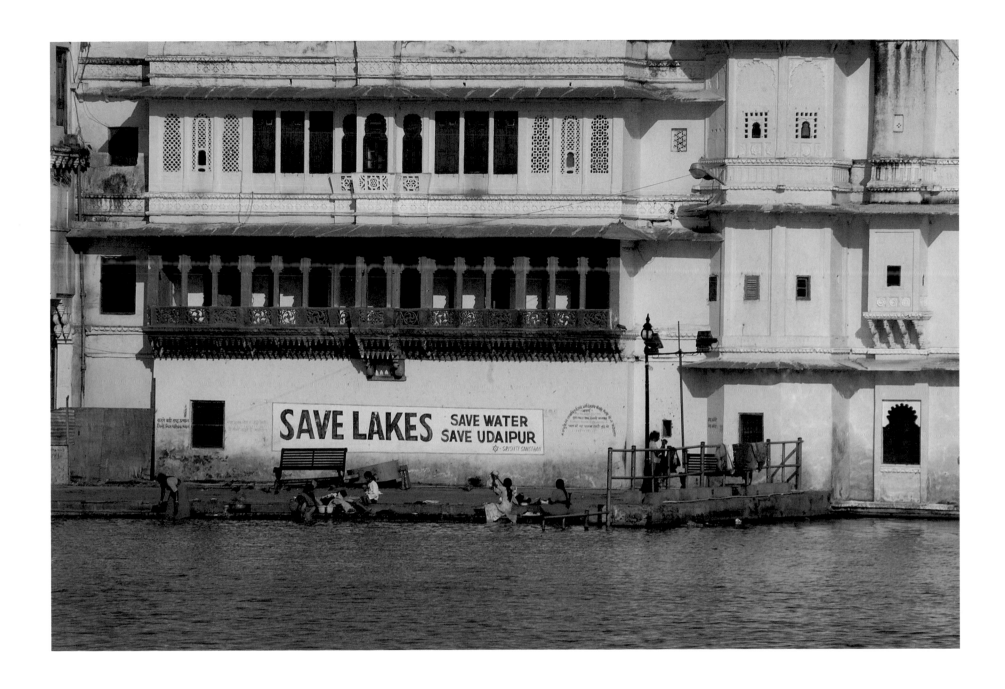

Women doing the washing from Gangaur Ghat.

FROM UDAIPUR TO JODHPUR

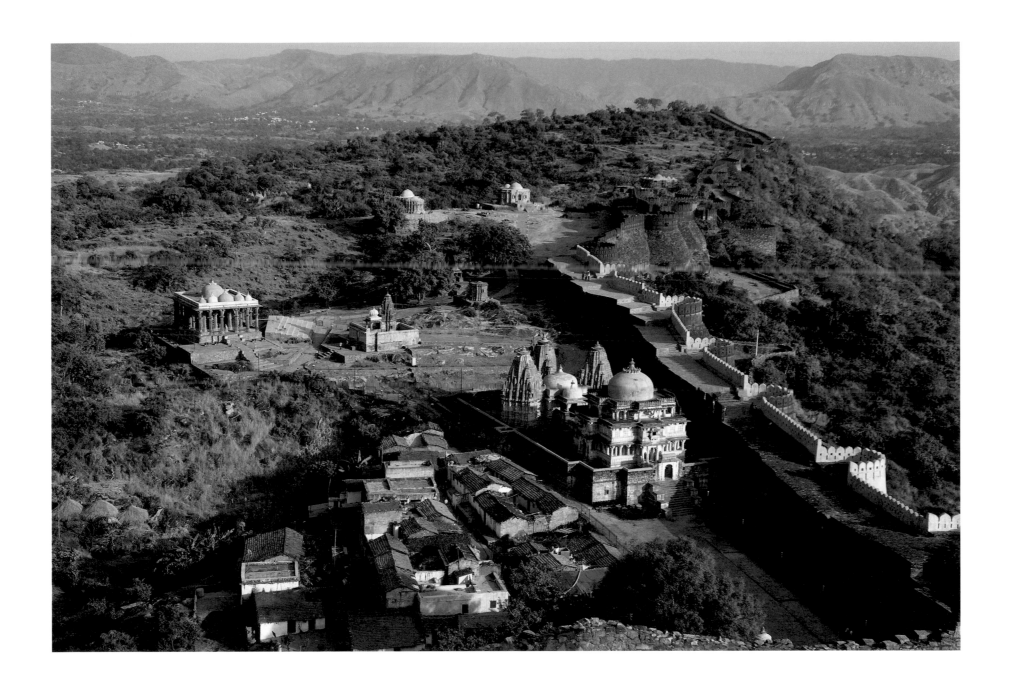

Fort Kumbhalgarh.

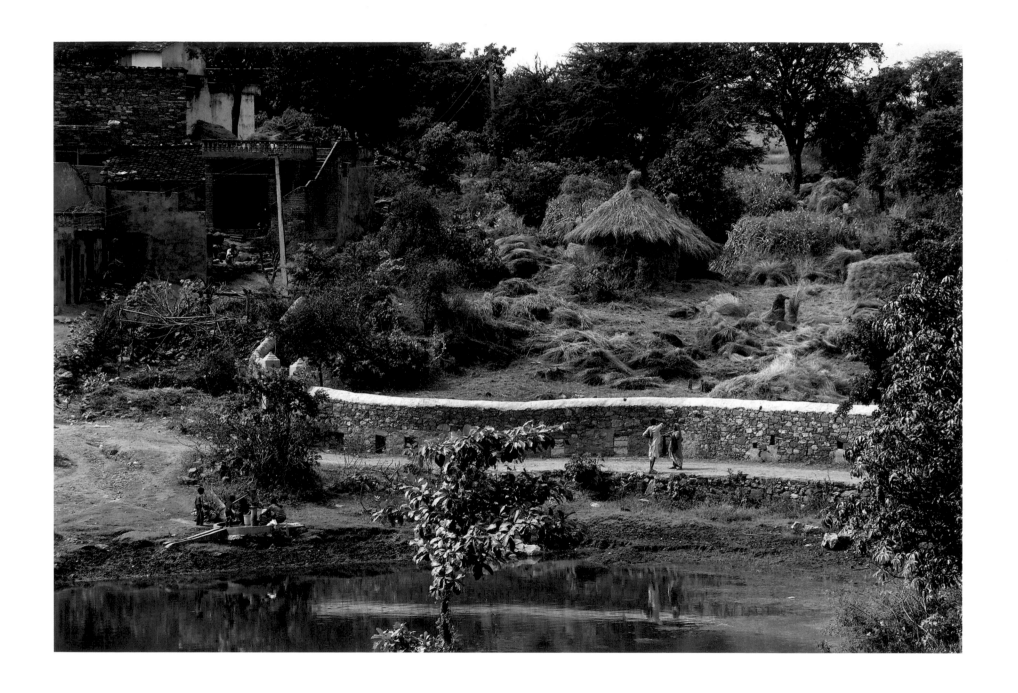

The road to Ranakpur.

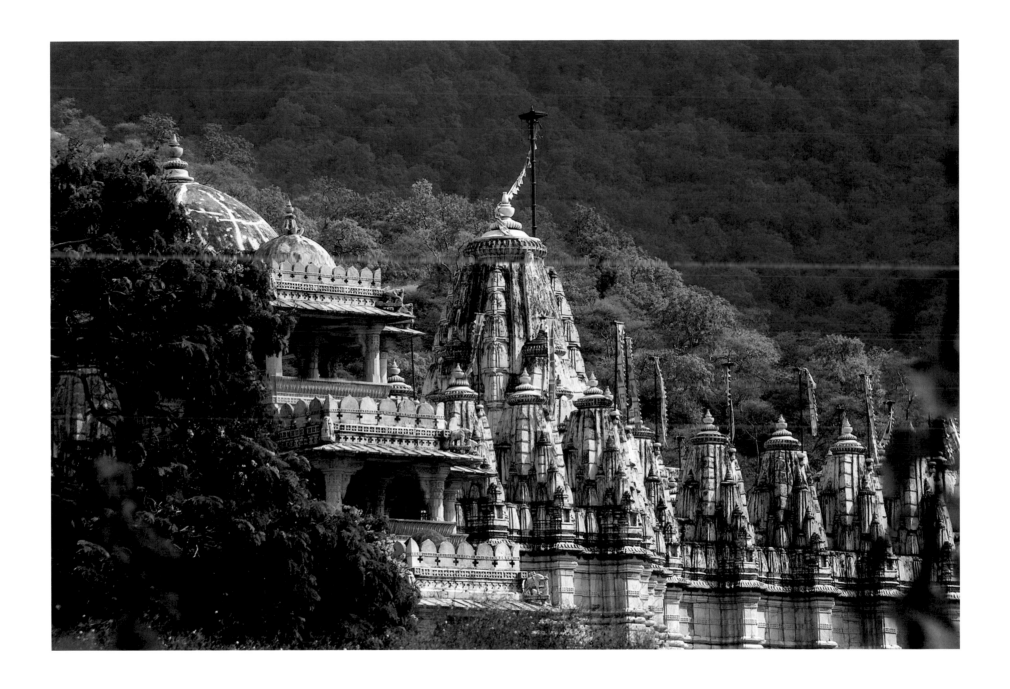

The temple of Ranakpur.

JODHPUR

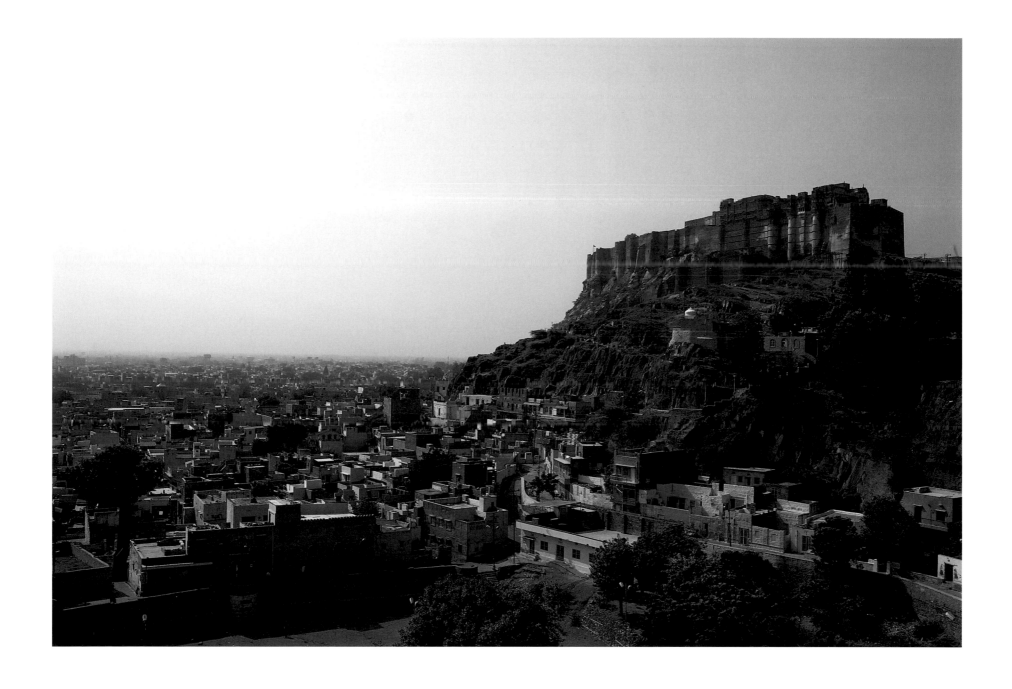

The city and fort of Mehrangarh.

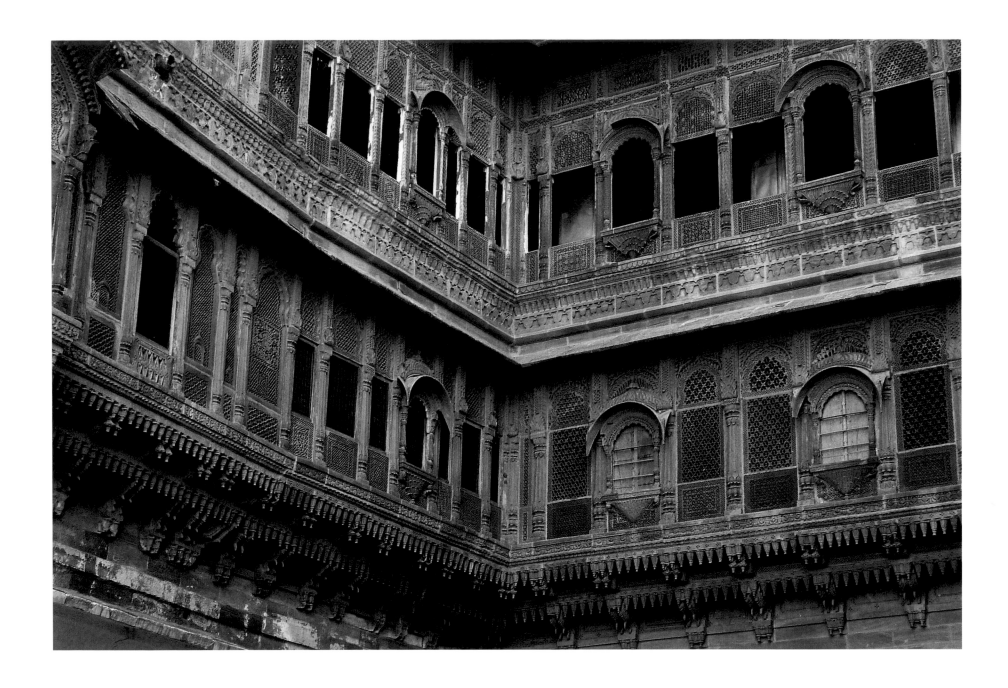

Fort Mehrangarh. The *zenana* or queens' palace.

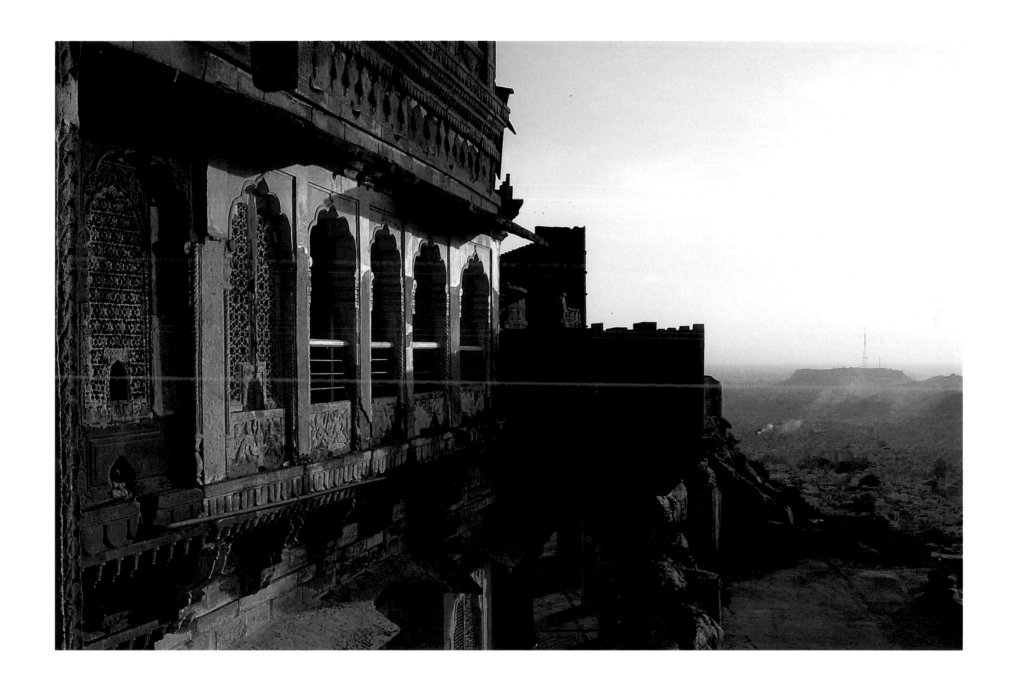

The city from Fort Mehrangarh.

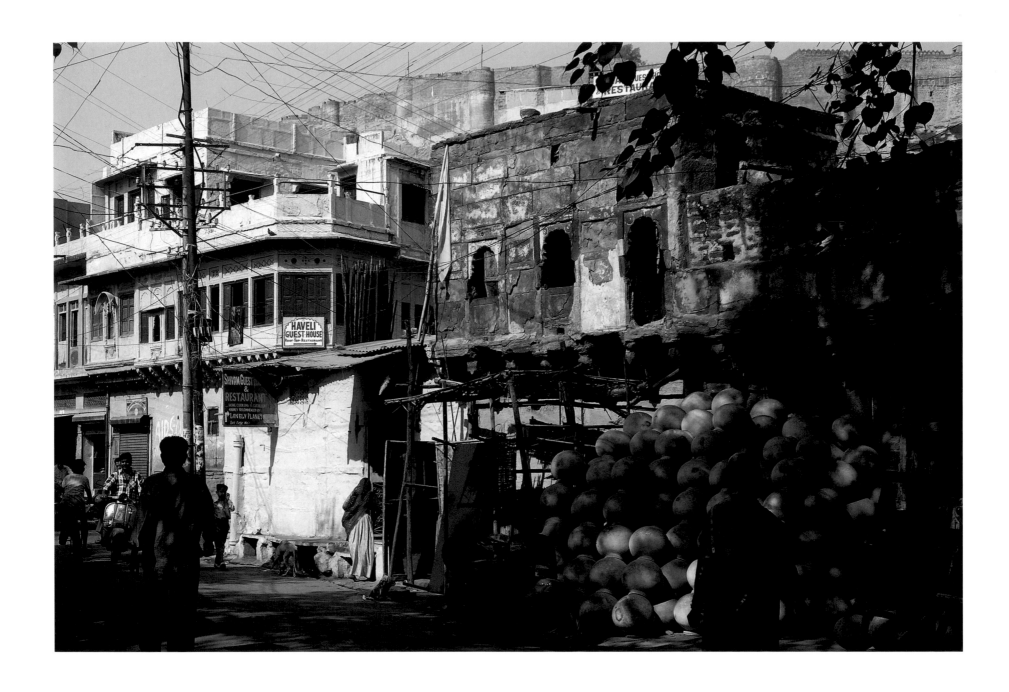

Houses beneath the fort.

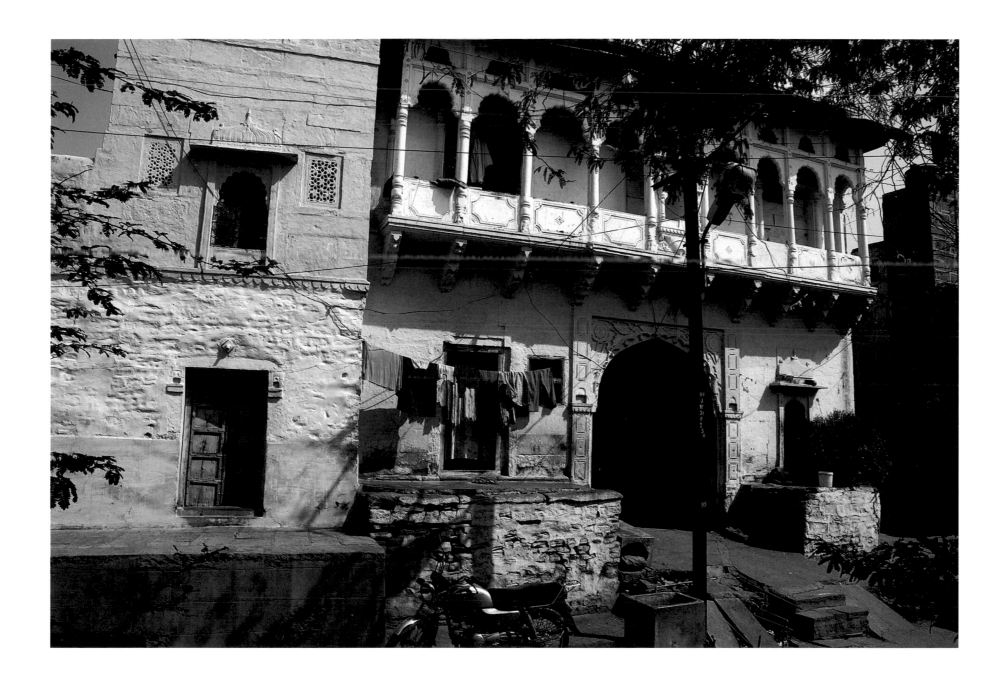

House beside Lake Gulab Sagar.

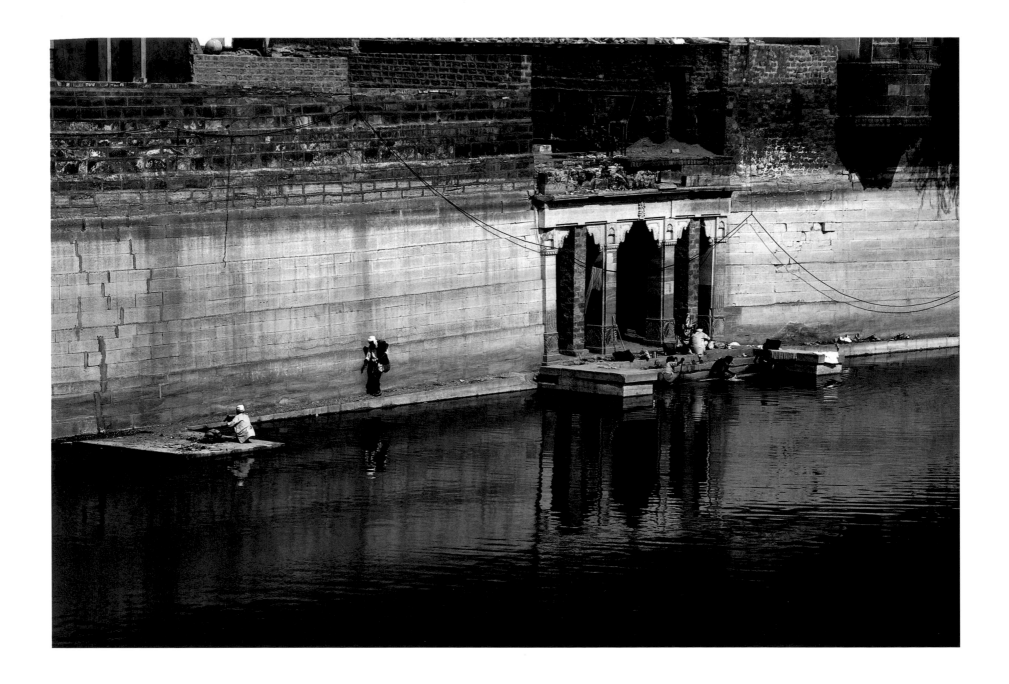

Lake Gulab Sagar.

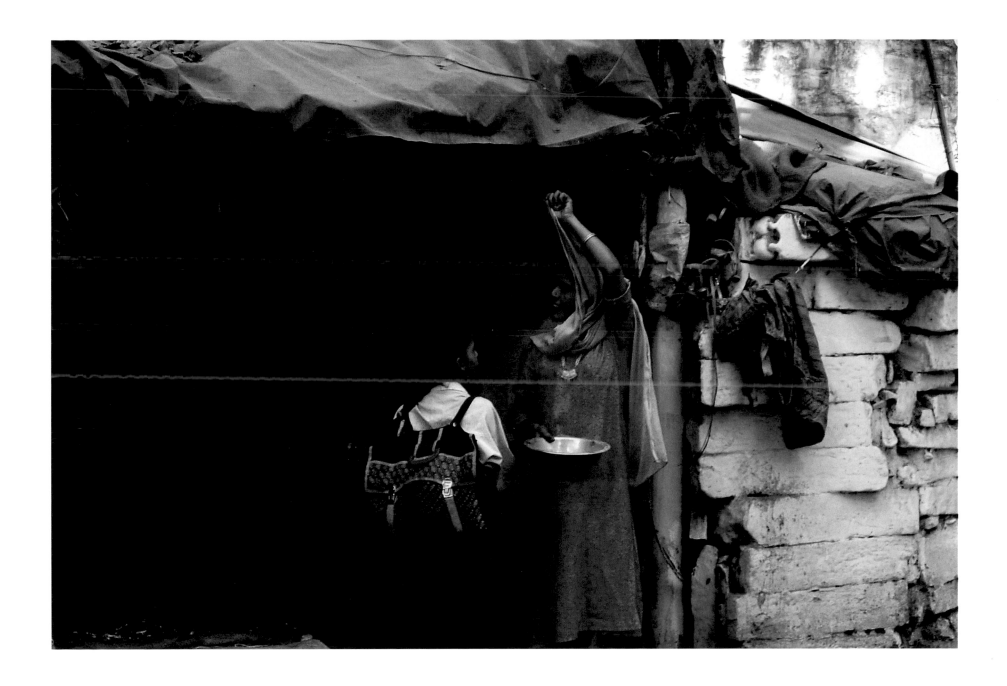

Leave-taking.

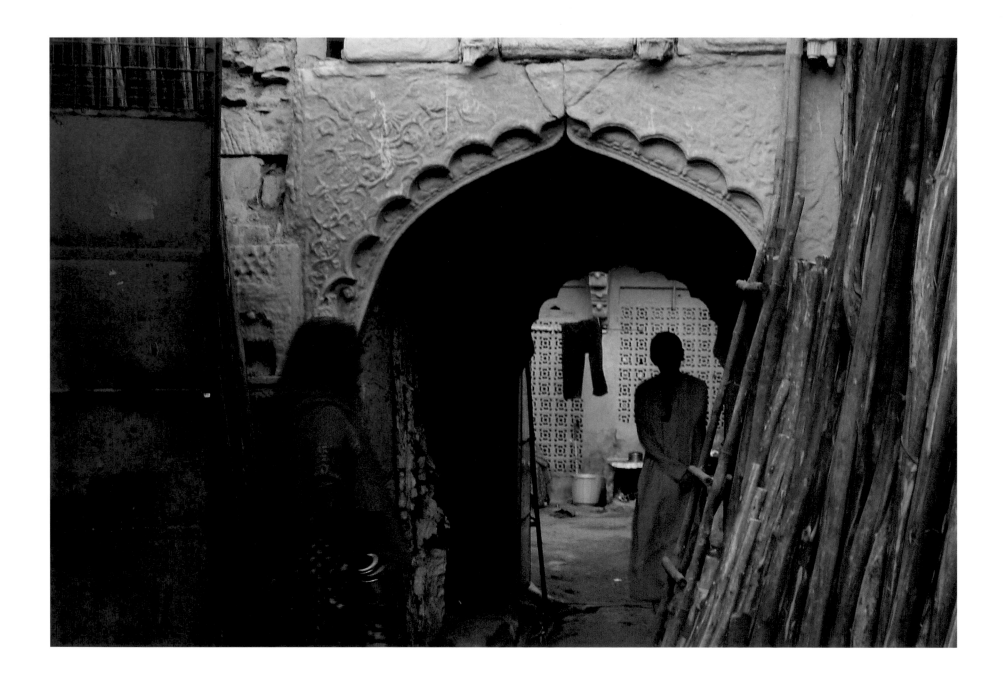

Patio.

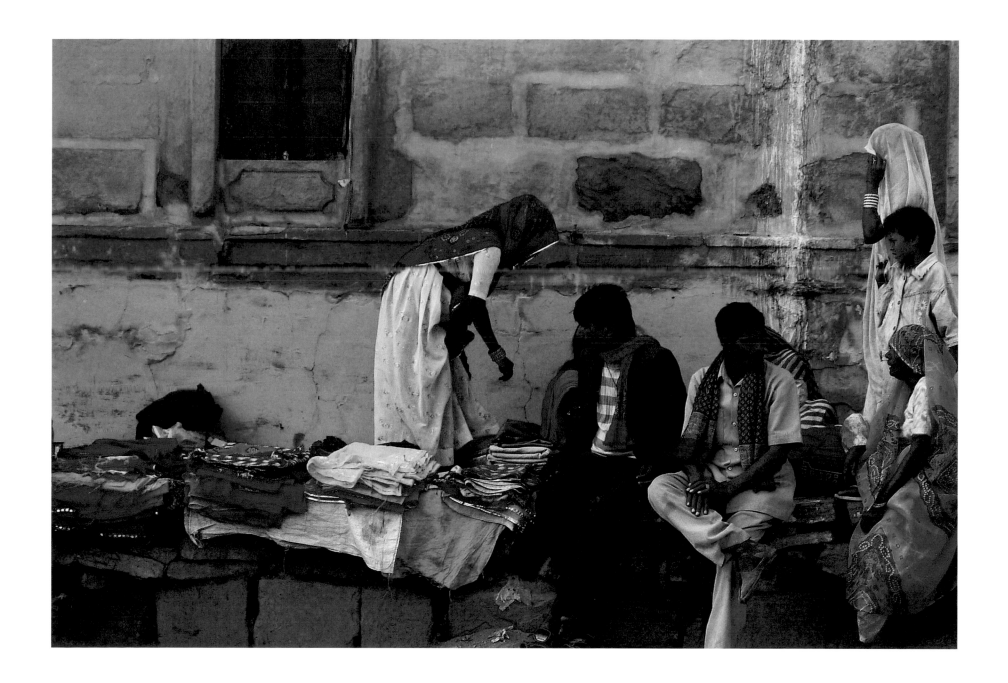

Nai Sarak.

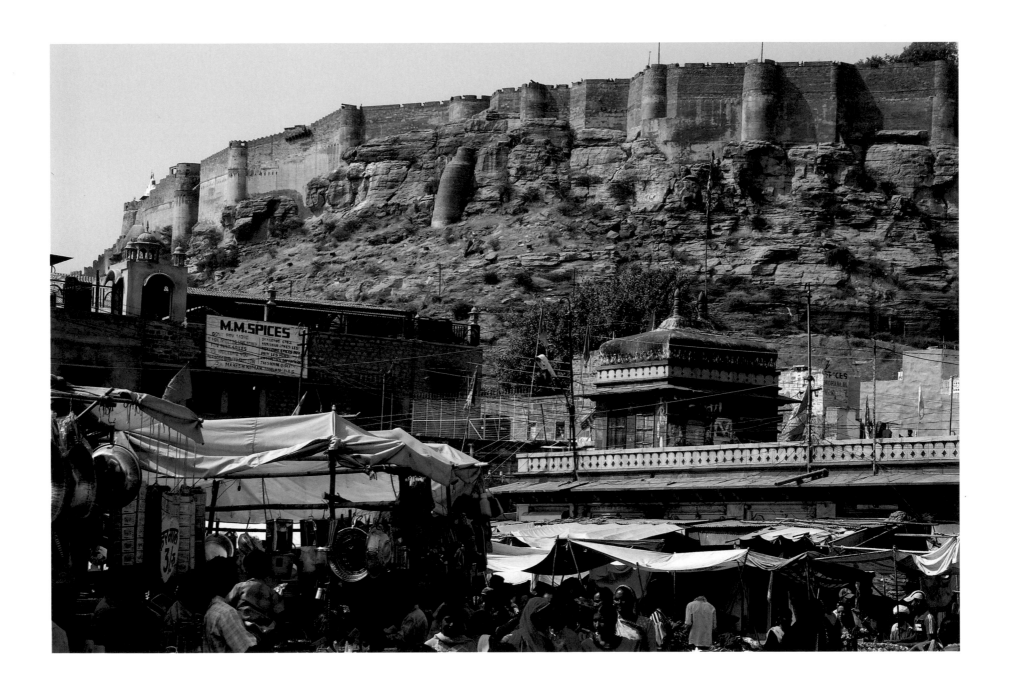

Sardar Market.

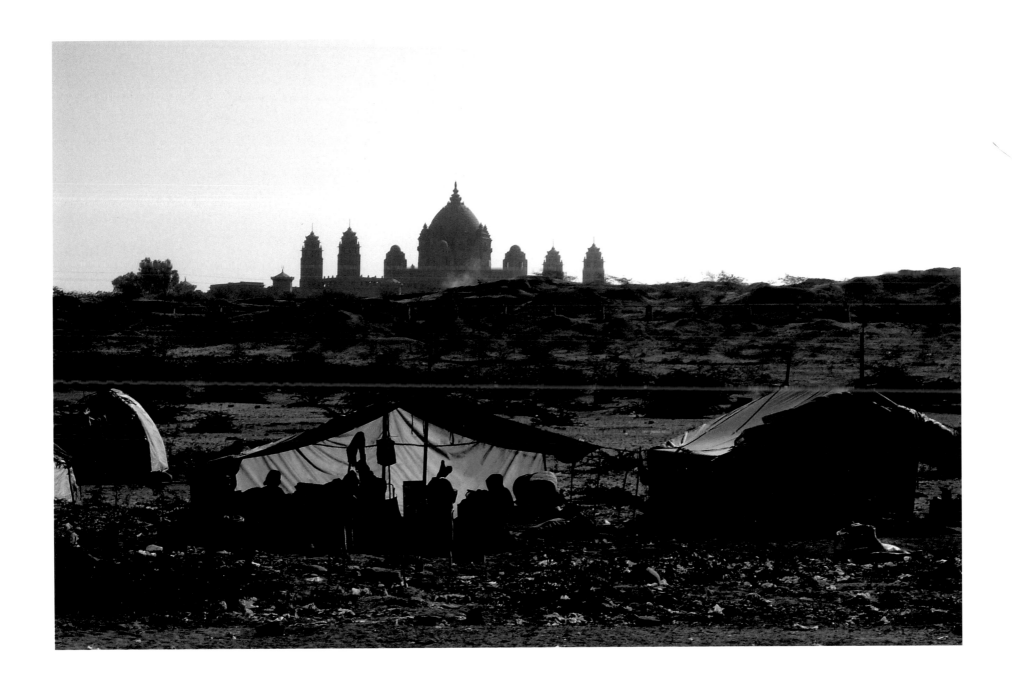

Umaid Bhawan Palace and the Lohars.

FROM JODHPUR TO JAISALMER

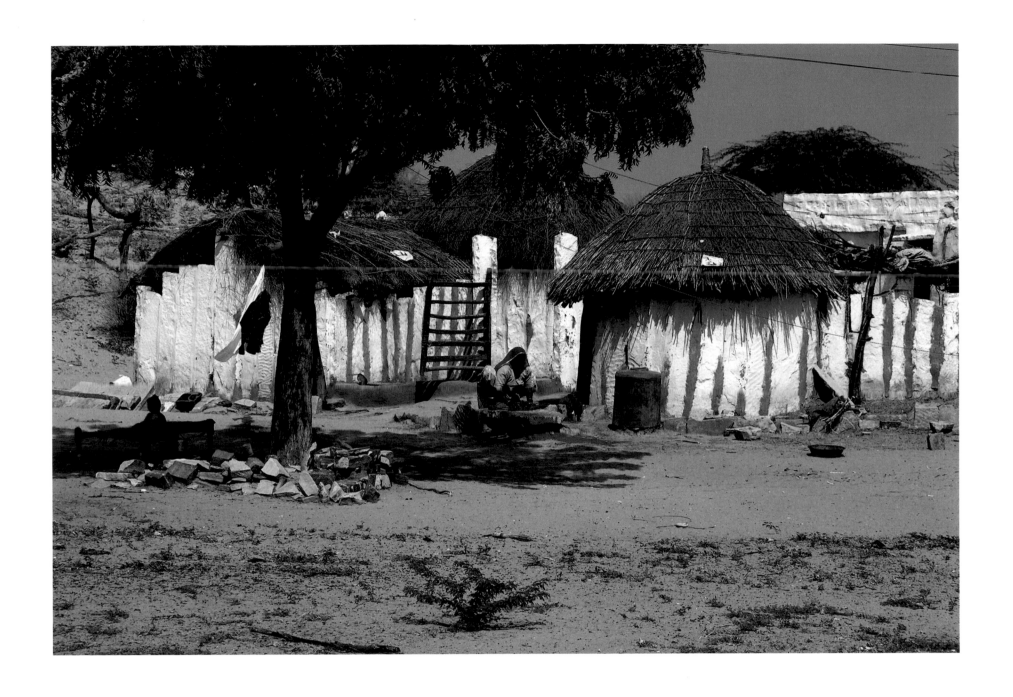

Village on the outskirts of Jodphur.

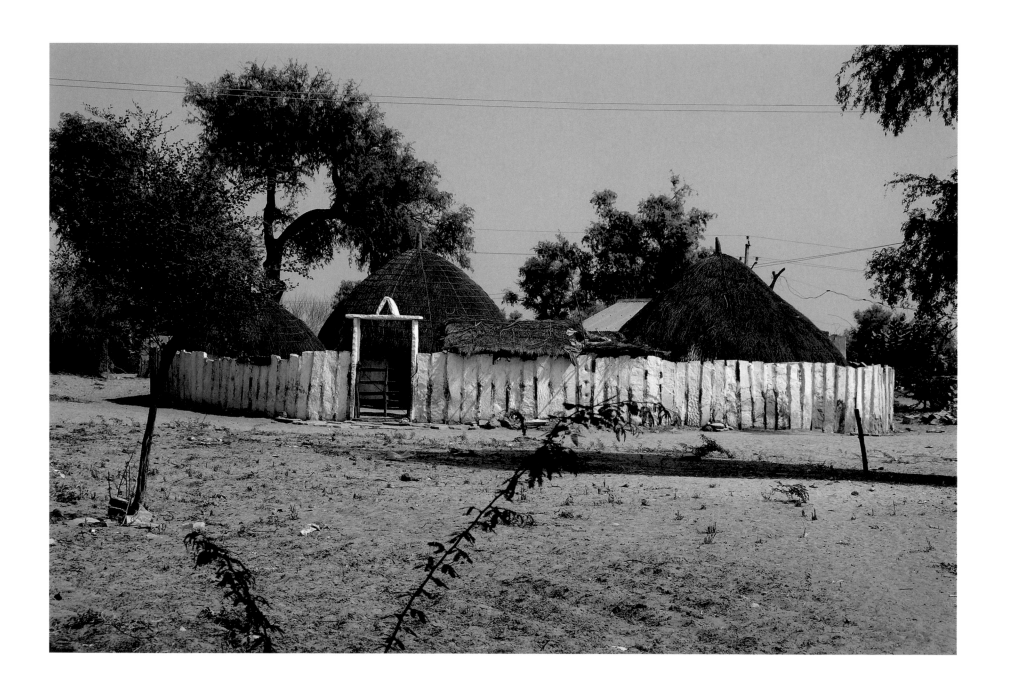

Village near Jodphur.

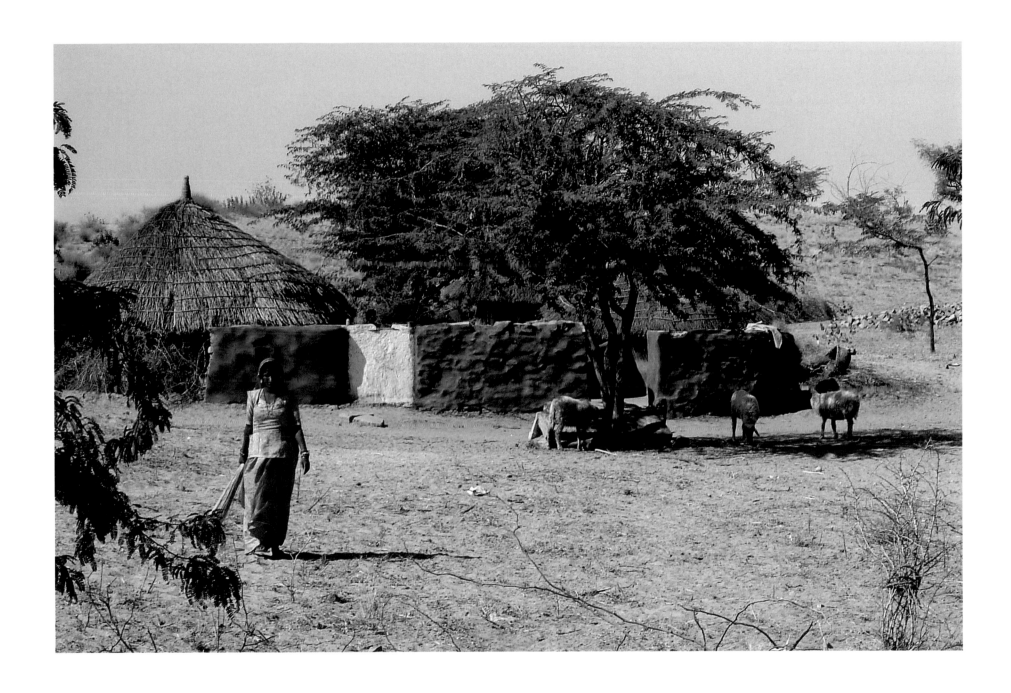

Halfway between Jodphur and Jaisalmer.

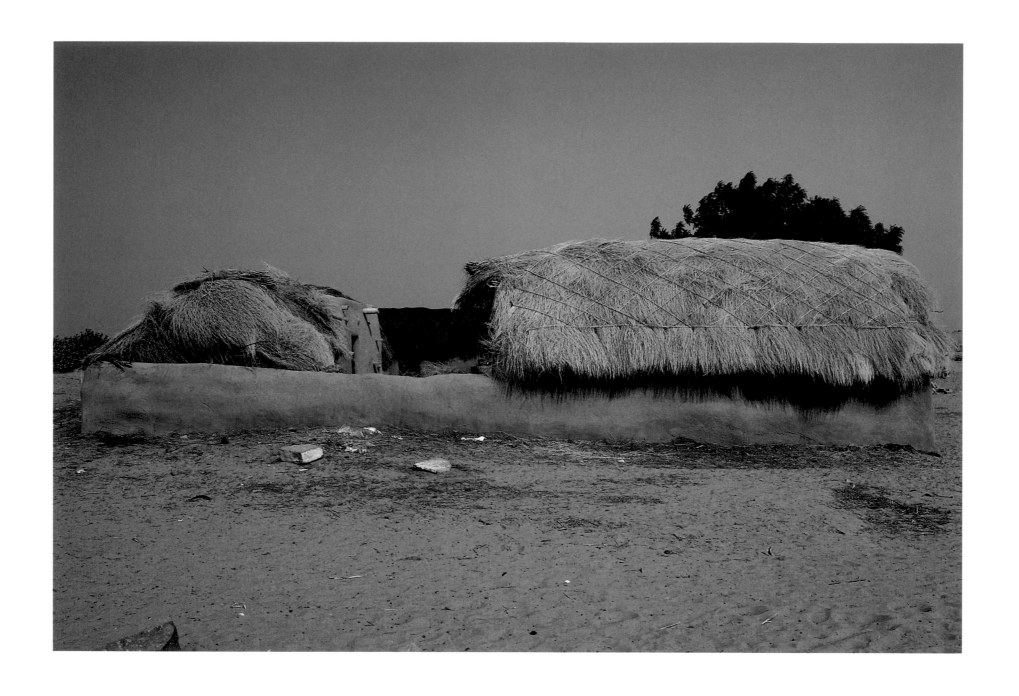

Village near Jaisalmer.

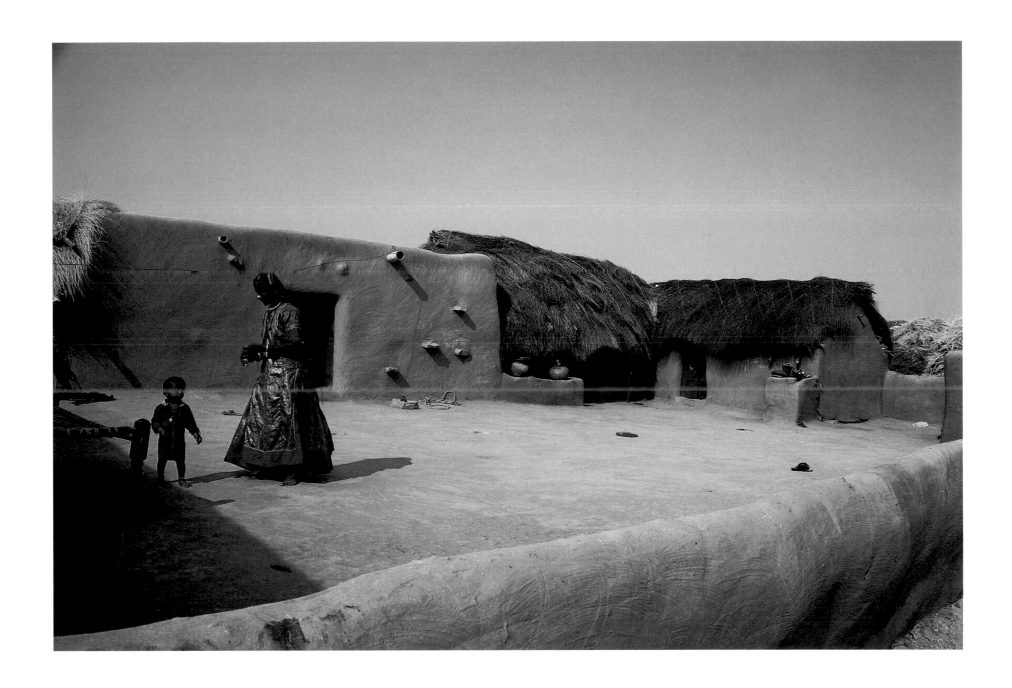

Woman in the patio.

FROM JODHPUR TO JAISALMER

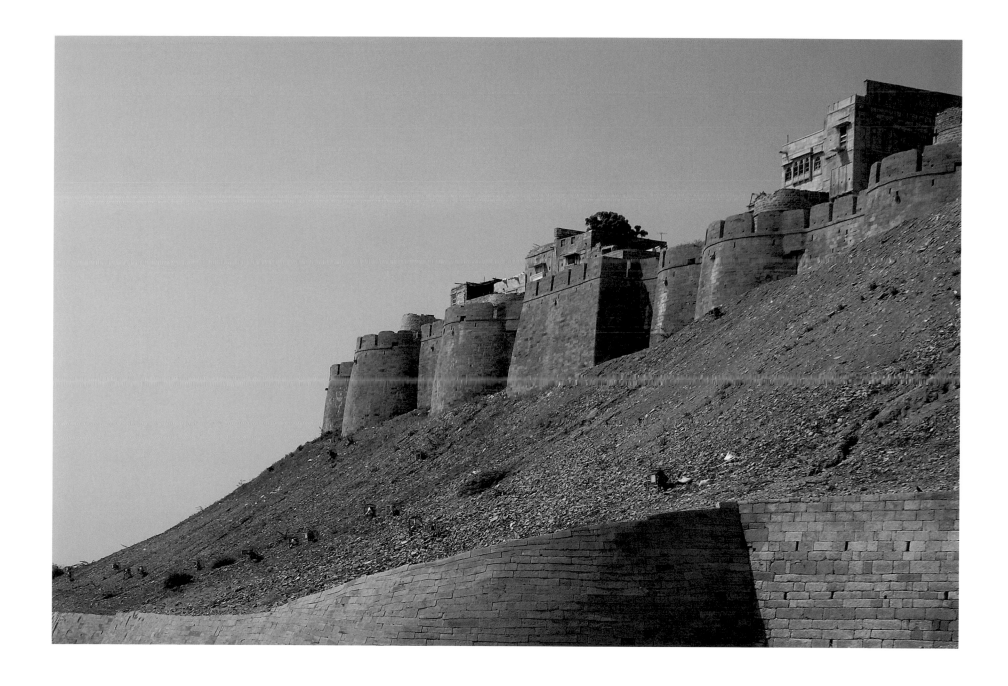

City walls.

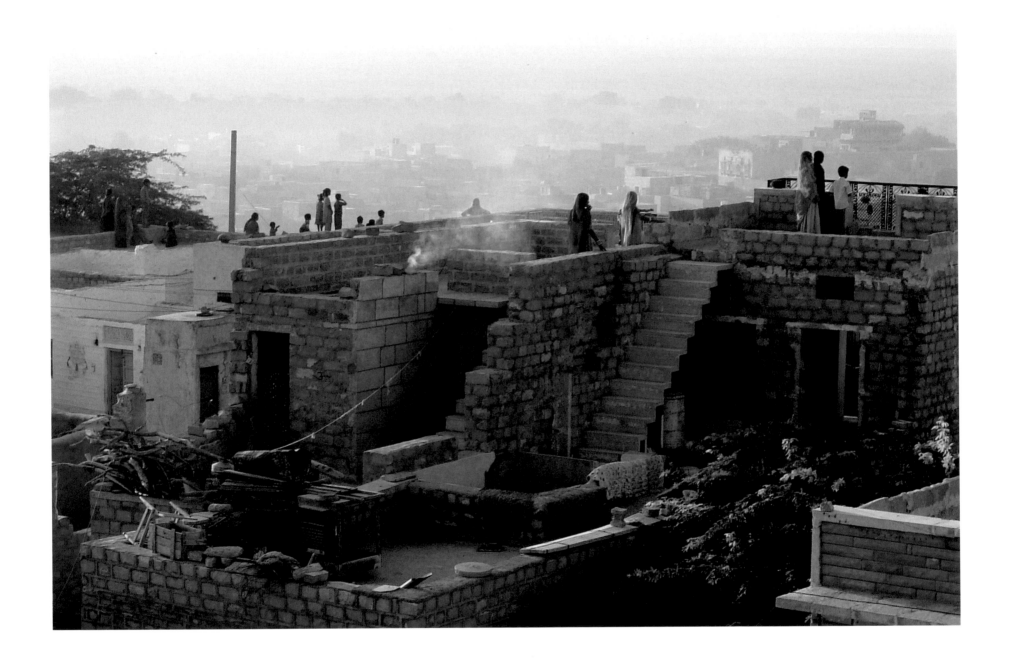

Dawn.

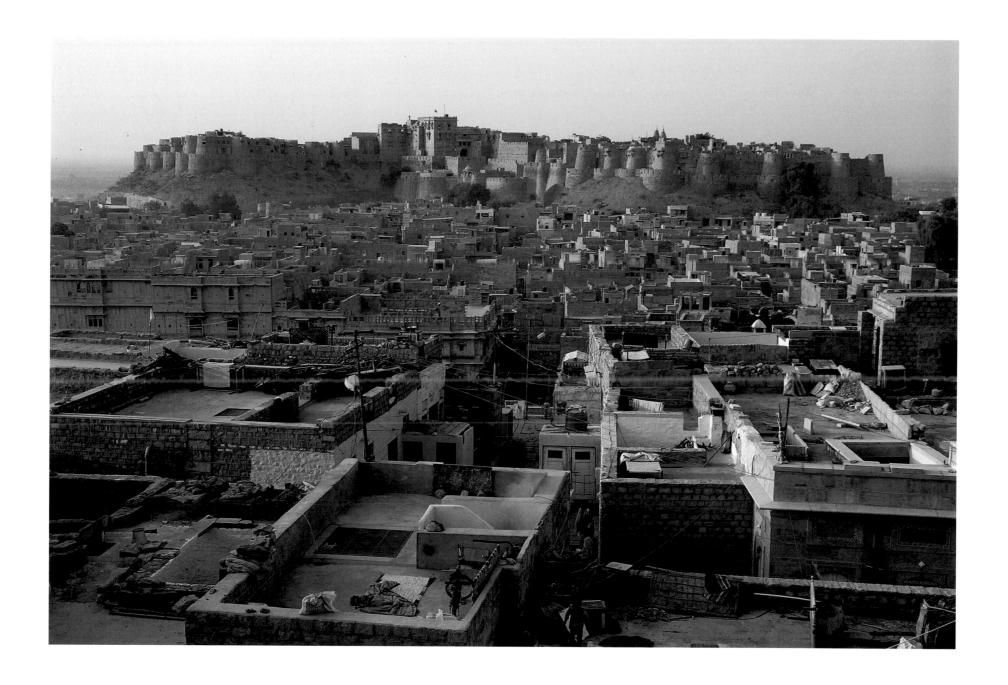

Flat roofs.

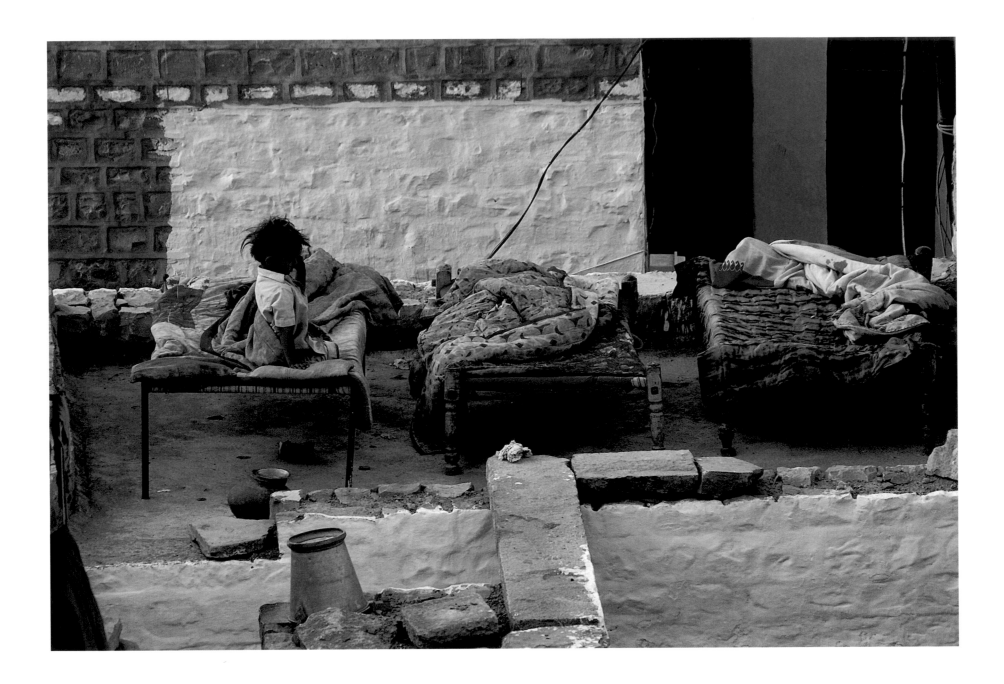

Awakening.

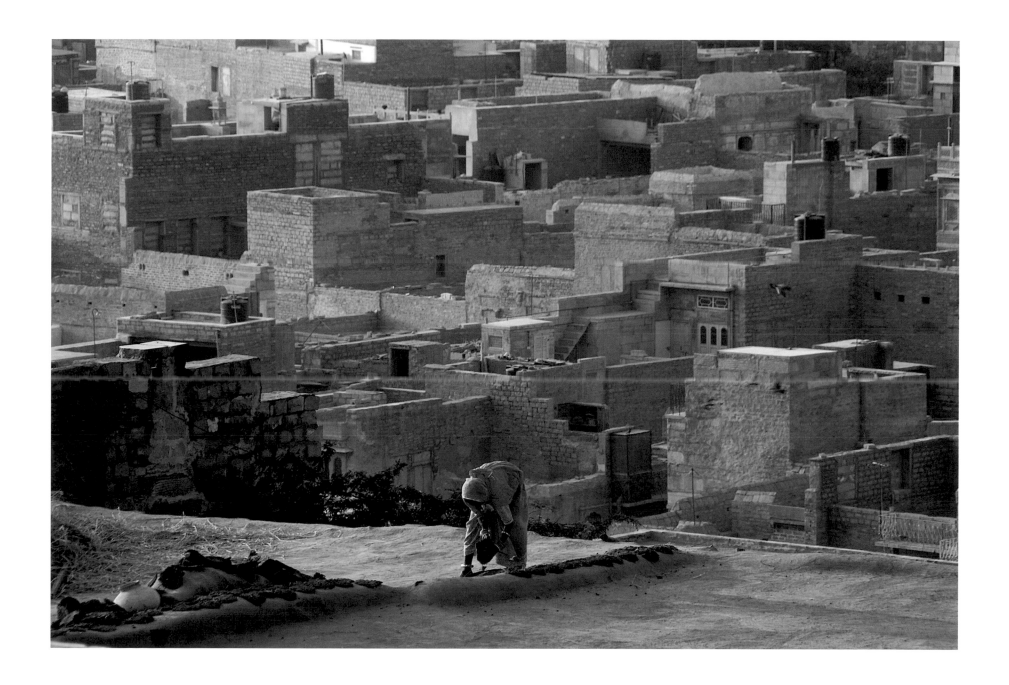

Preparing fuel.

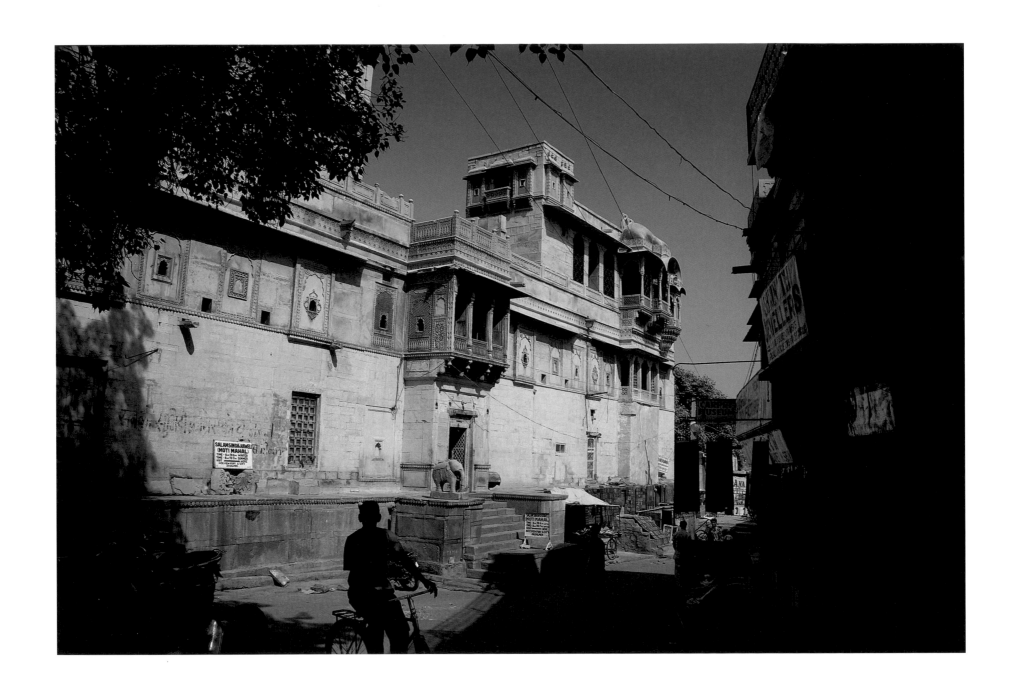

Jaisalmer. Salim singh ki haveli, 1815.

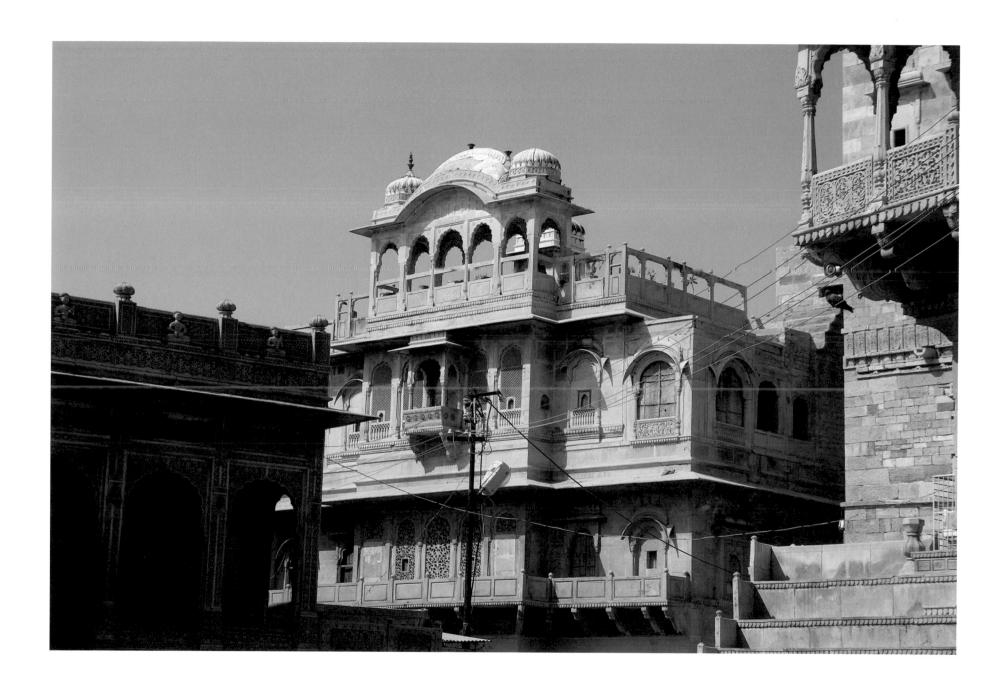

Jaisalmer. The palace of the Maharawals.

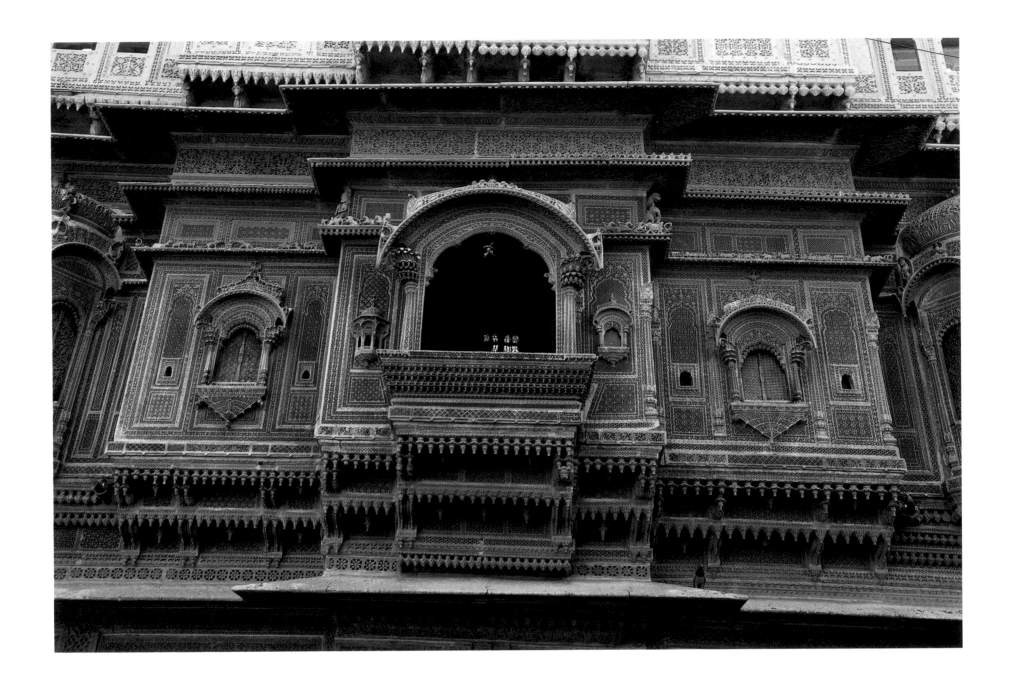

Jaisalmer. Nathmalji ki haveli, 1885.

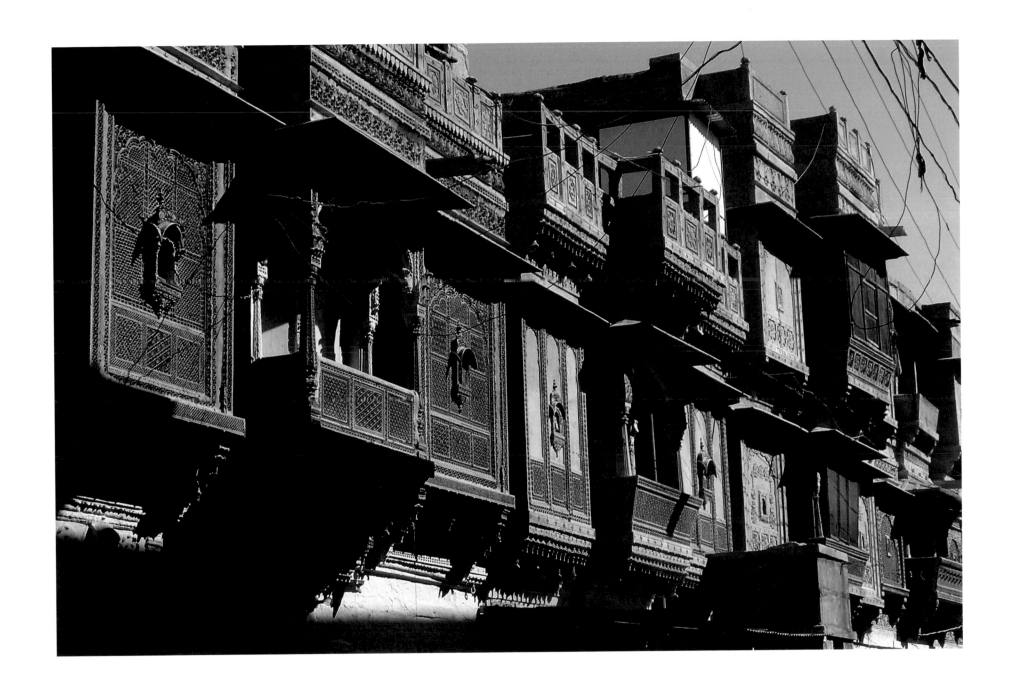

Zharookhas on a Jaisalmer street.

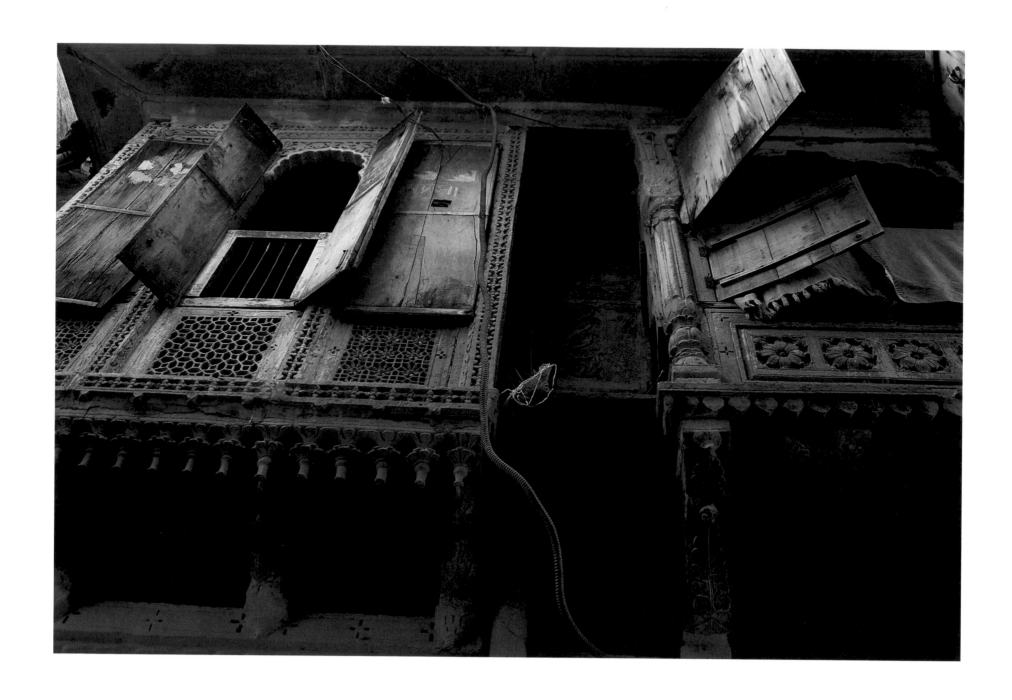

Jaisalmer. House façade in the fort.

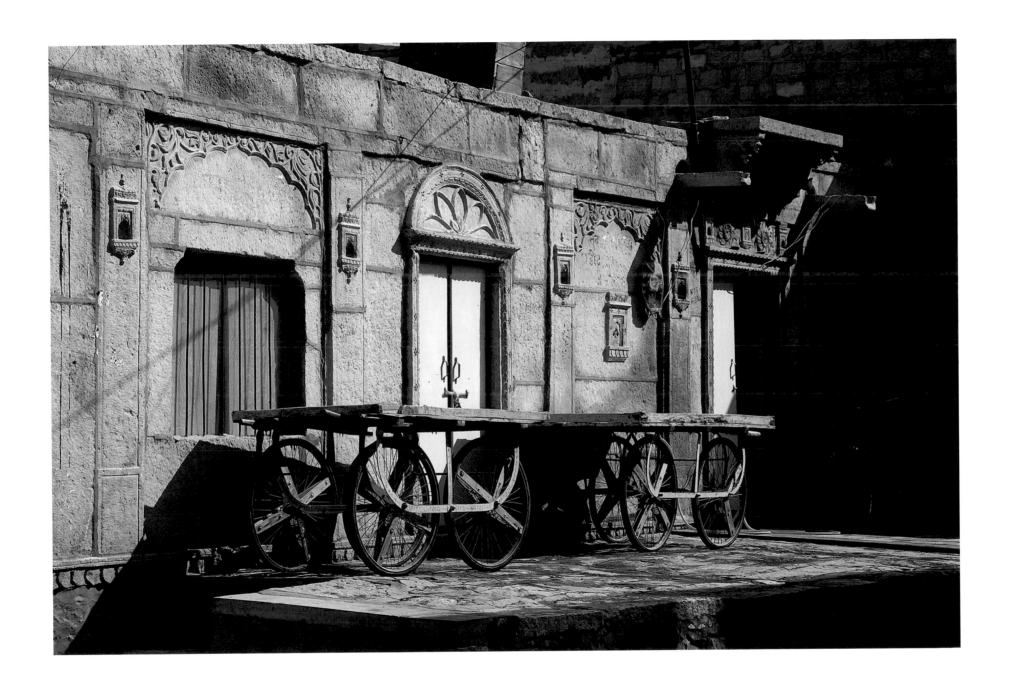

Jaisalmer. Façade in the old quarter.

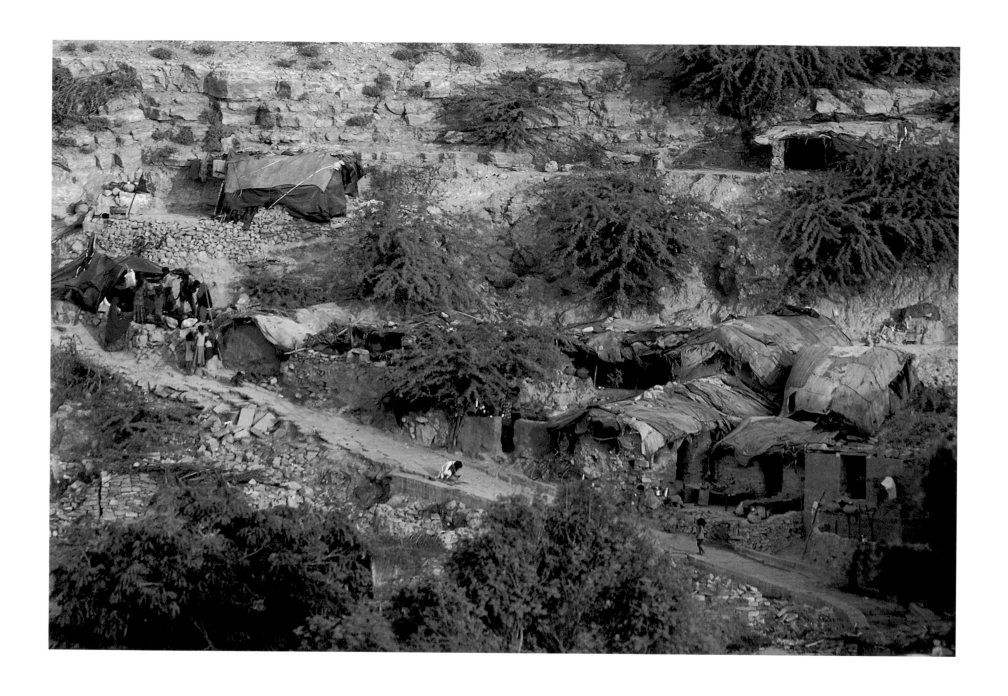

Jaisalmer. Camp of the Kalbeliyas, the gypsies of the desert.

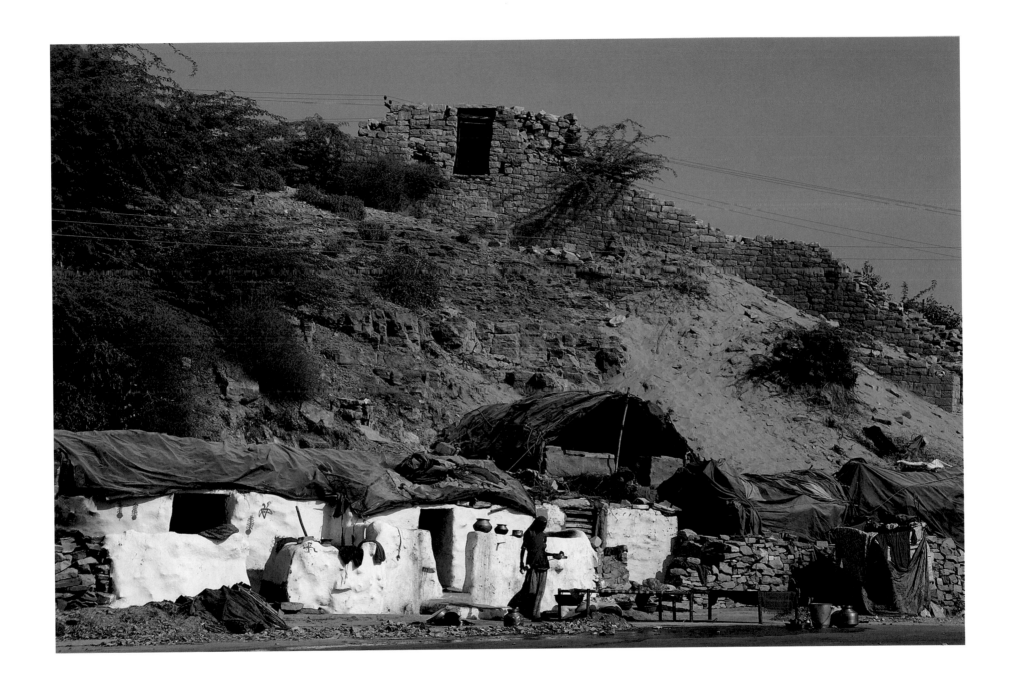

Base of the Kalbeliya camp at the foot of the walls.

DESERT VILLAGES

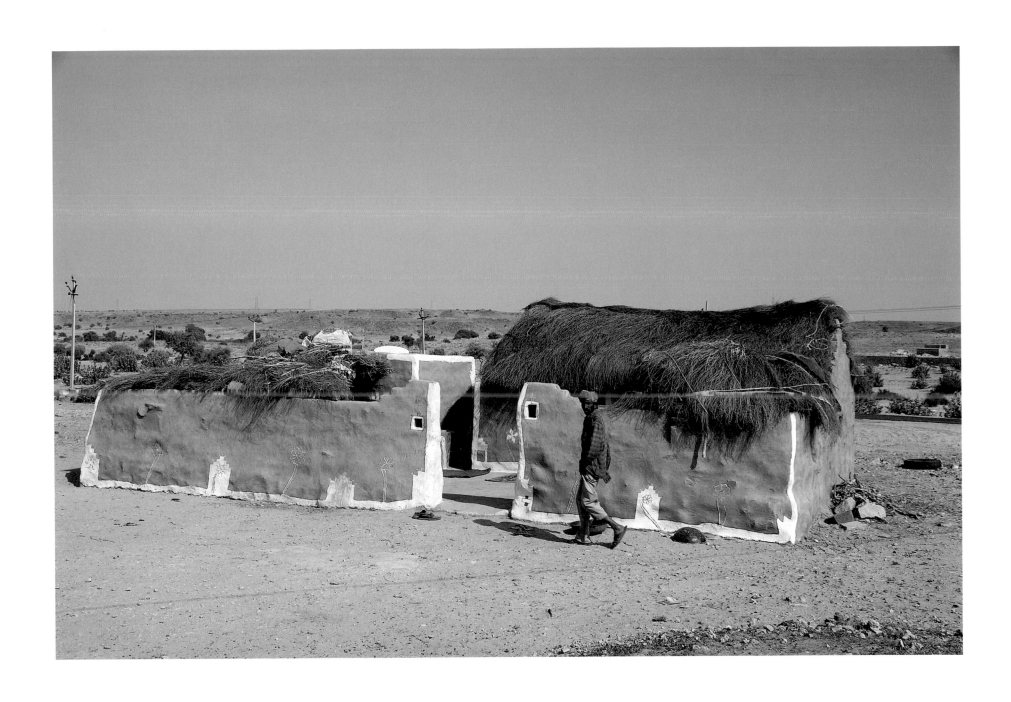

Village on the outskirts of Jaisalmer bordering on the desert.

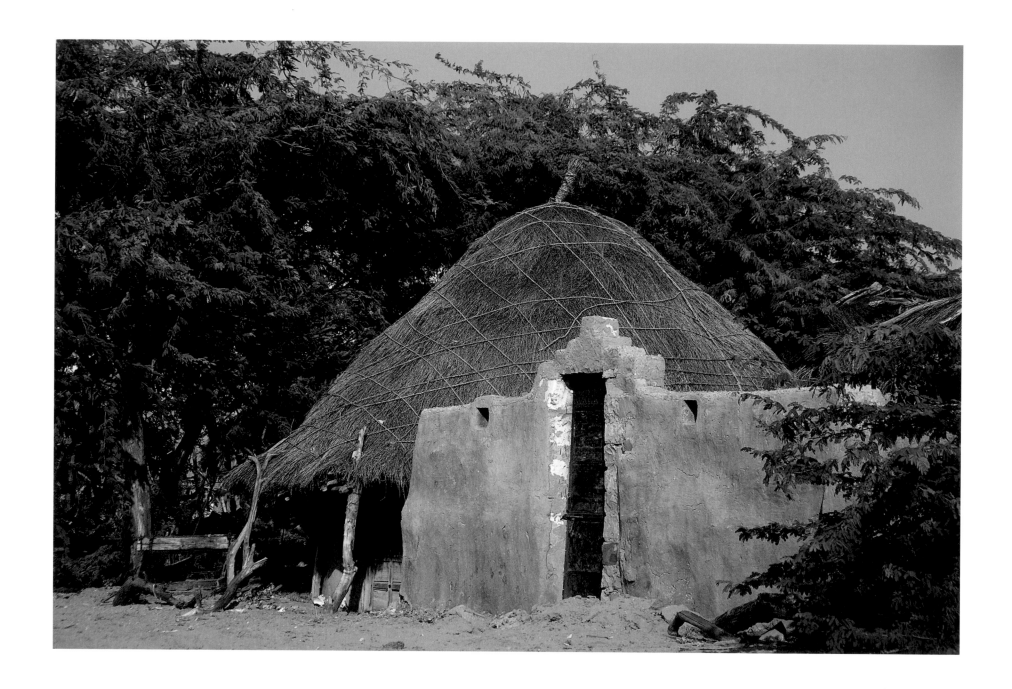

Khuri.

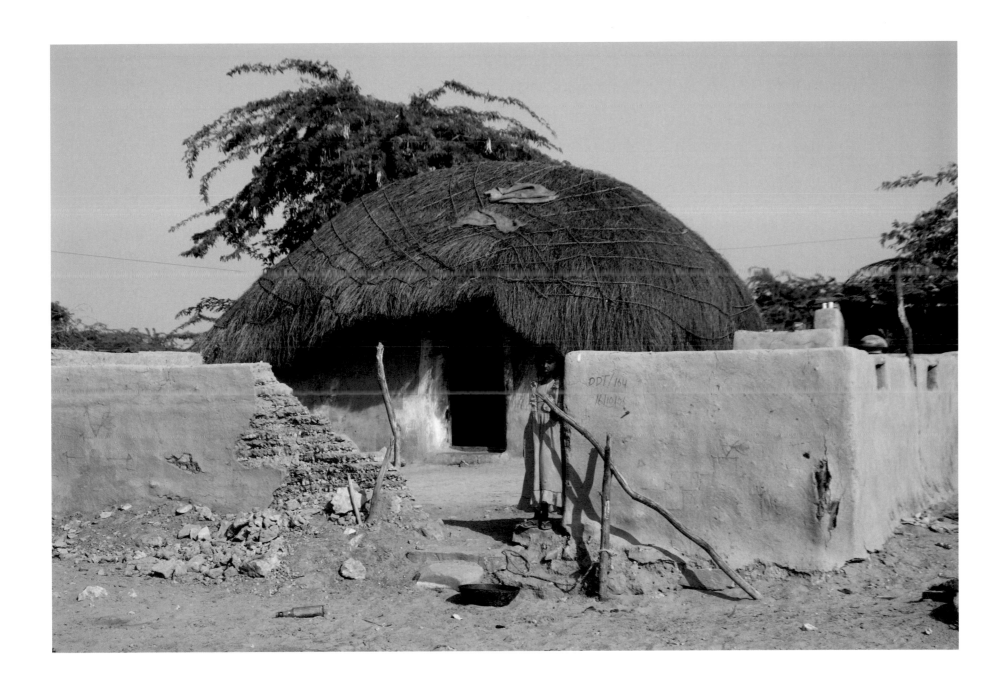

Khuri.

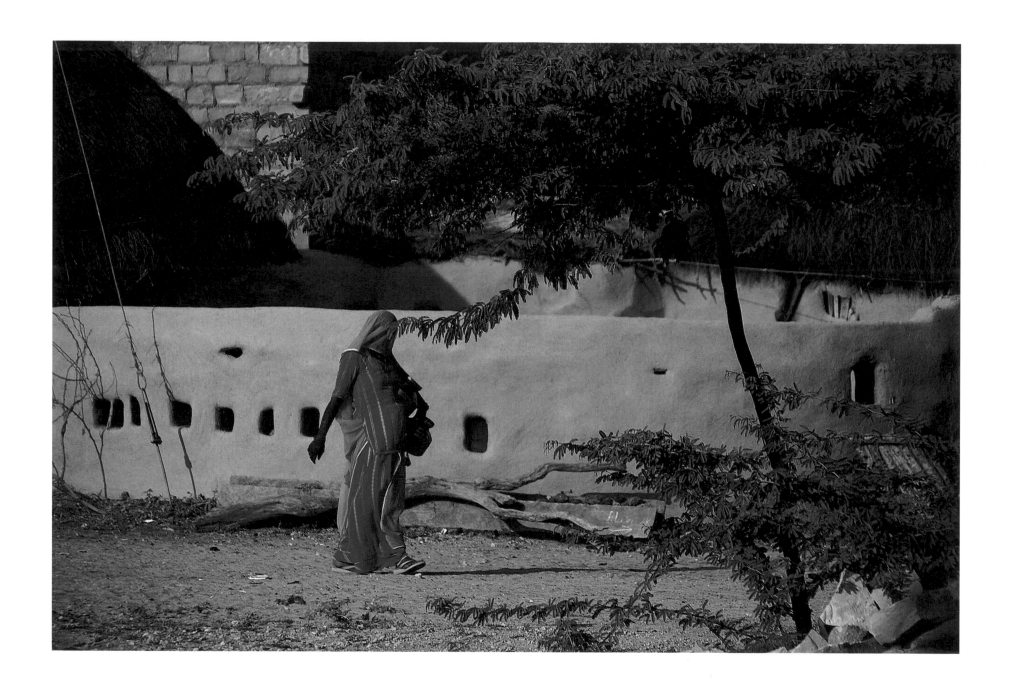

On the way to Megha.

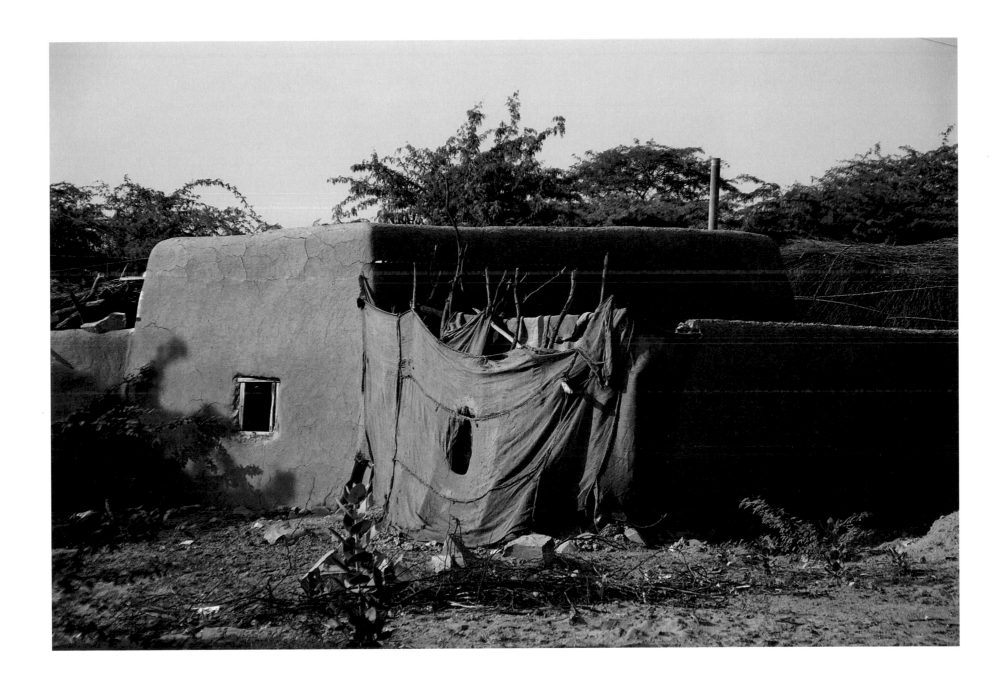

Megha.

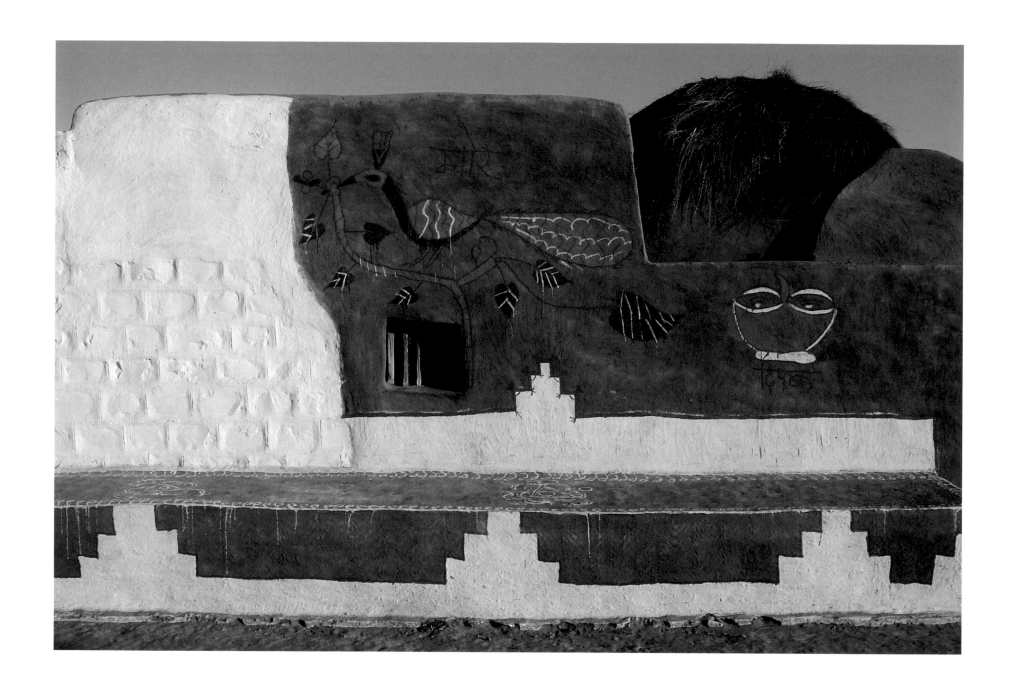

House in Sam.

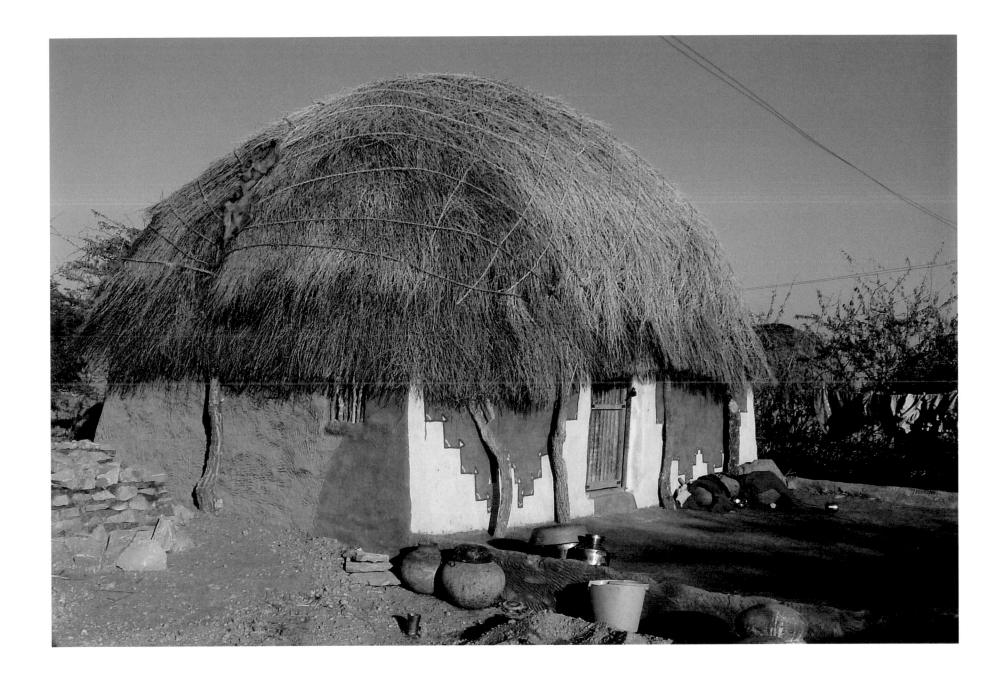

Sam.

BIKANER

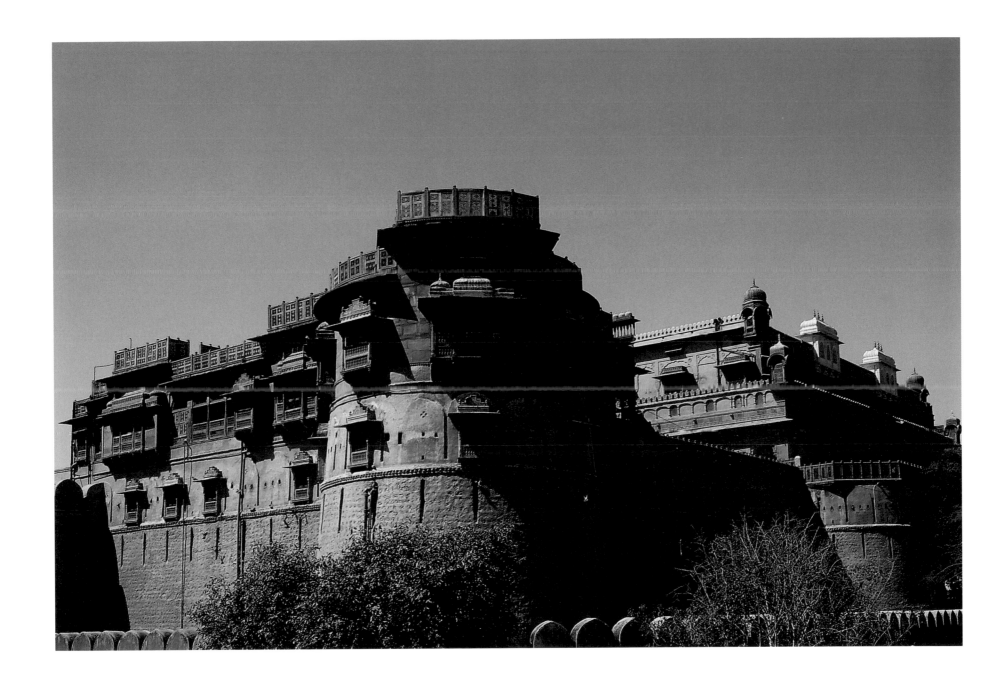

Bikaner. Fort Junagarh.

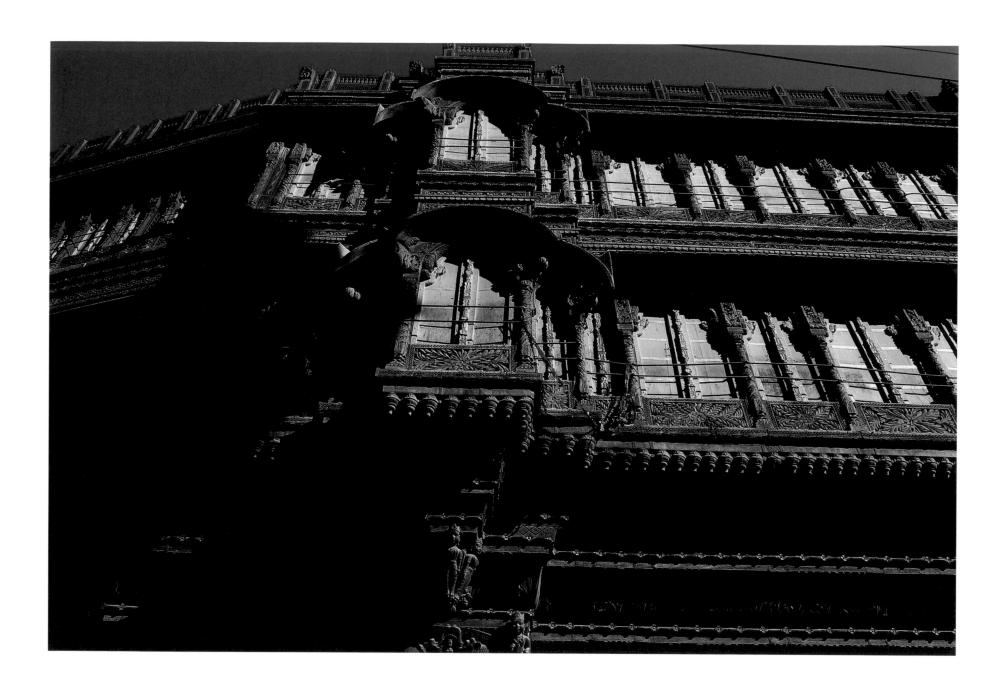

Bikaner. Haveli in the walled city.

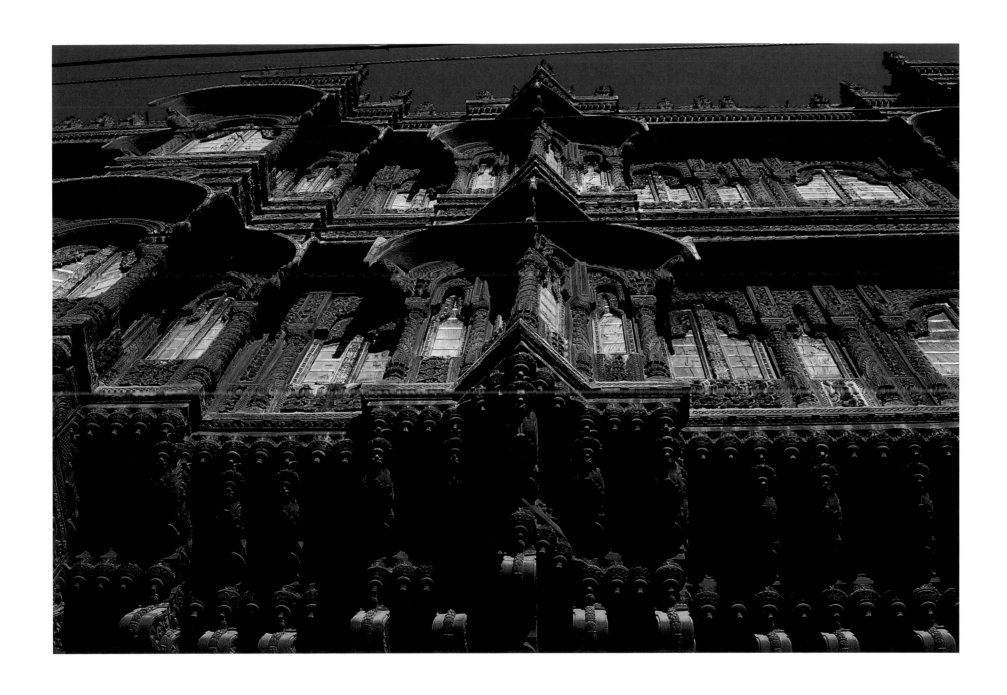

Bikaner. Profusely decorated haveli.

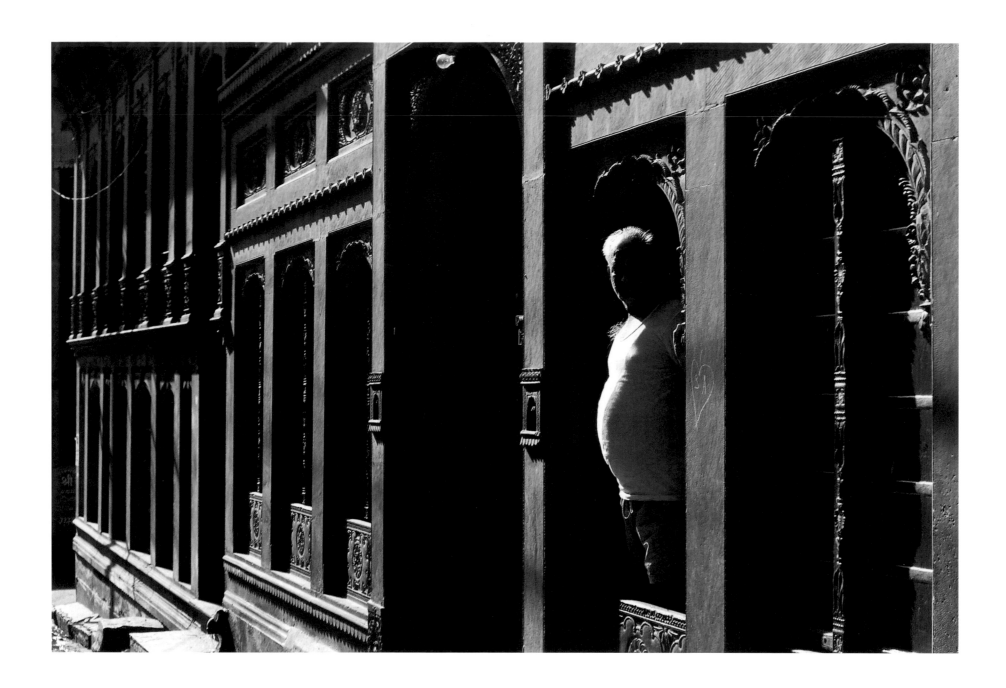

Bikaner. Observing the street.

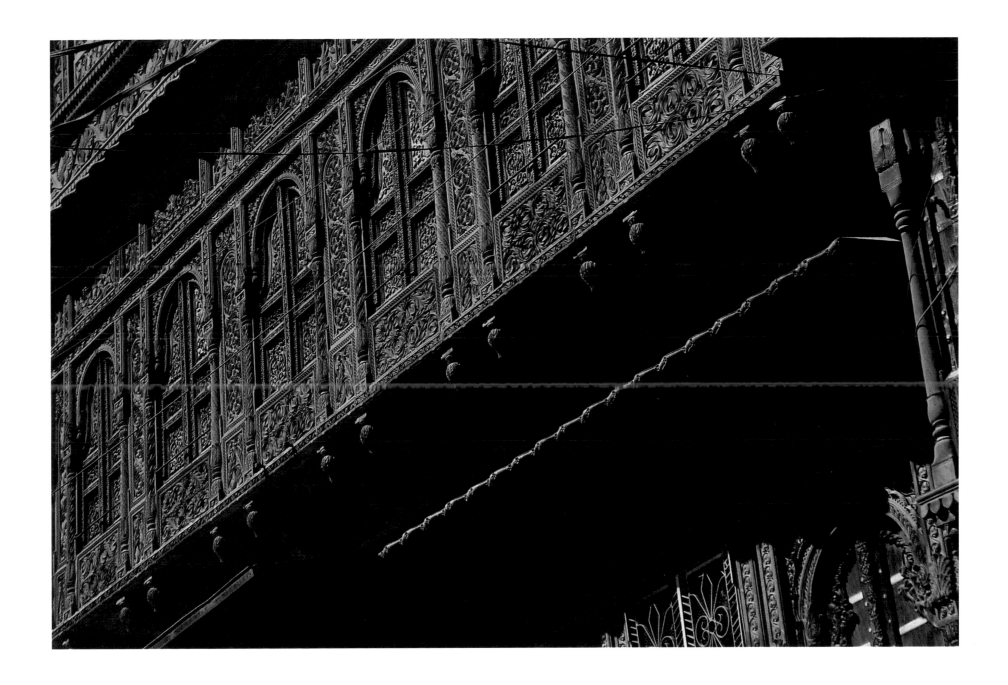

Bikaner. Sandstone façade.

THE ALWAR DISTRICT

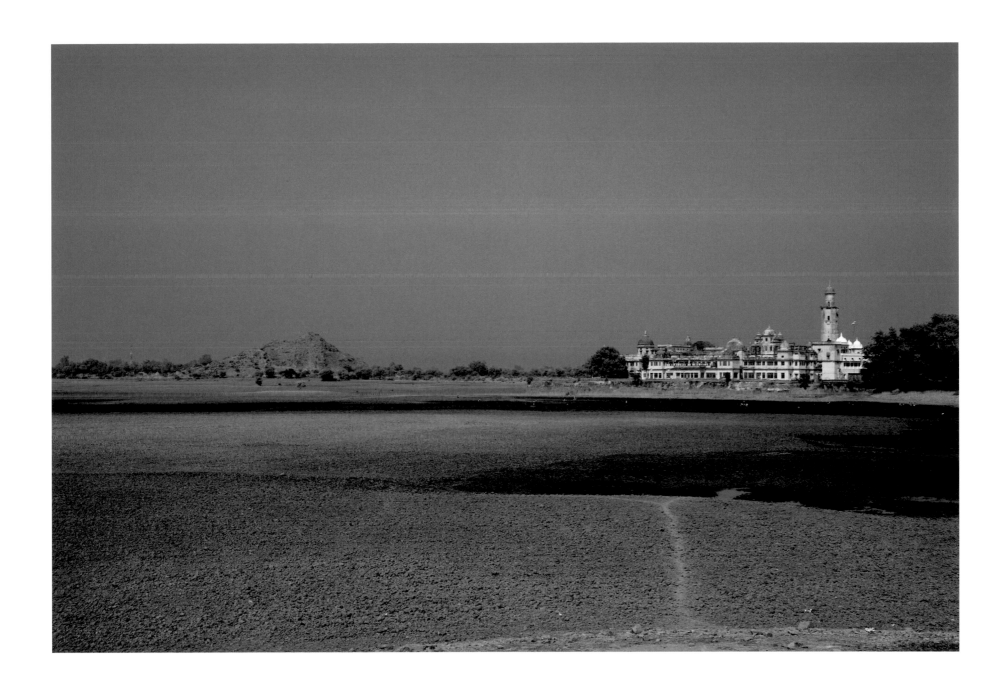

Near Alwar. The Vijay Mandir Palace and Lake Vijay Sagar.

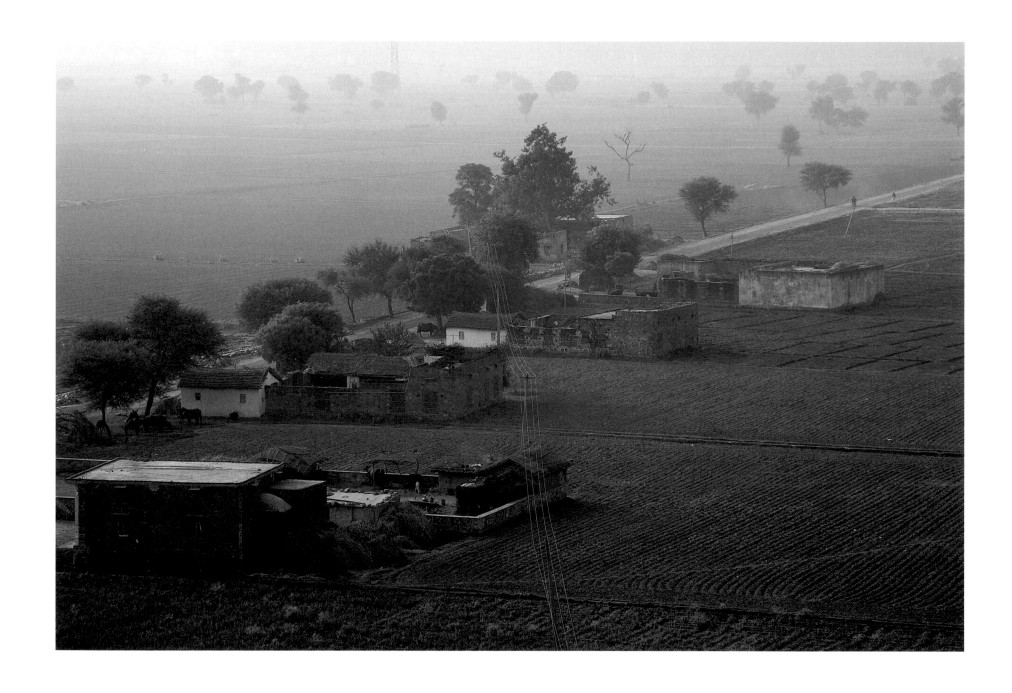

Fields of Alwar. Houses at the roadside.

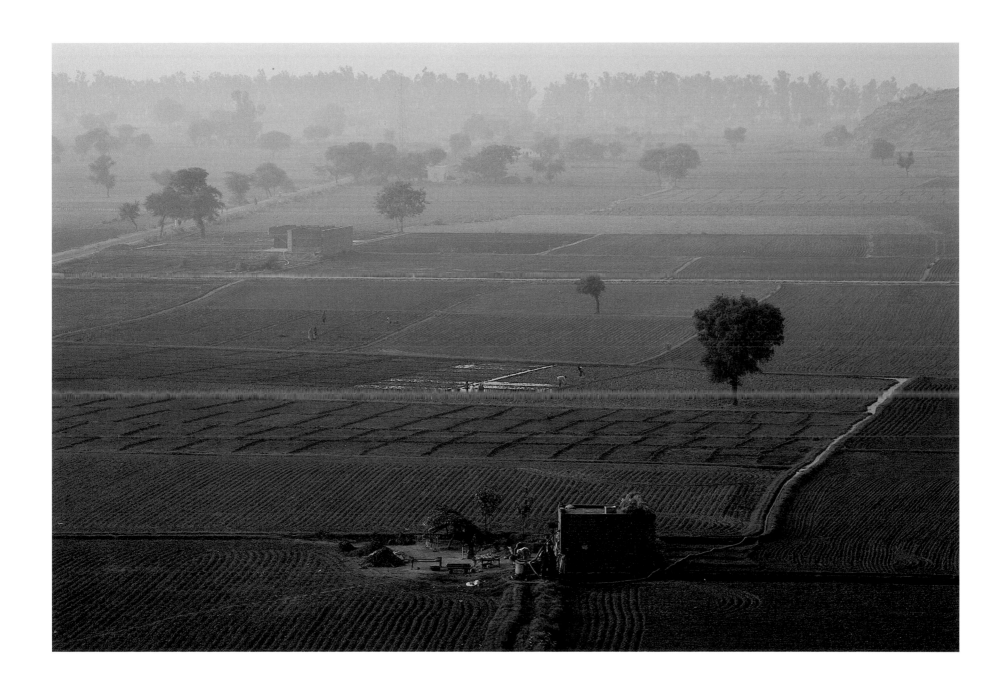

Fields of Alwar. The house of the well.

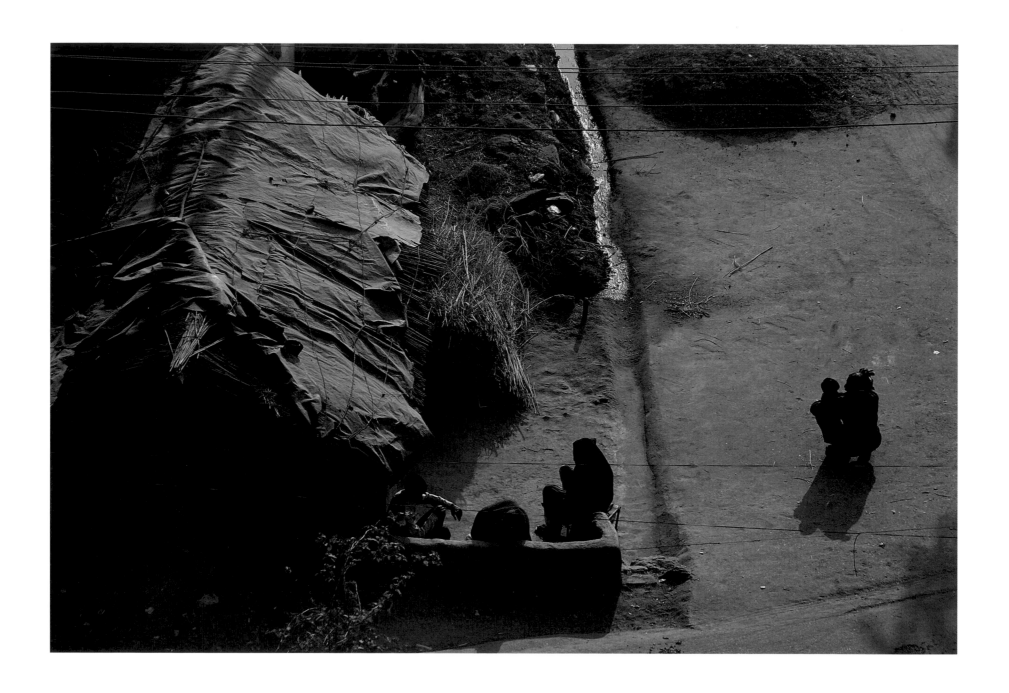

Kesroli village. The day begins.

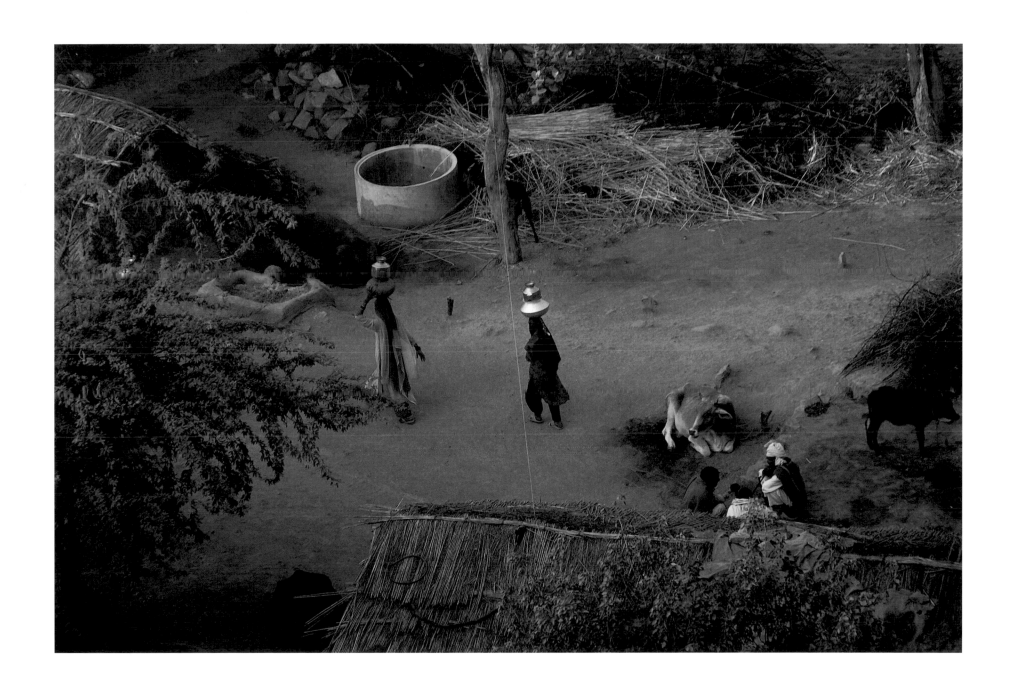

Kesroli village. Fetching water.

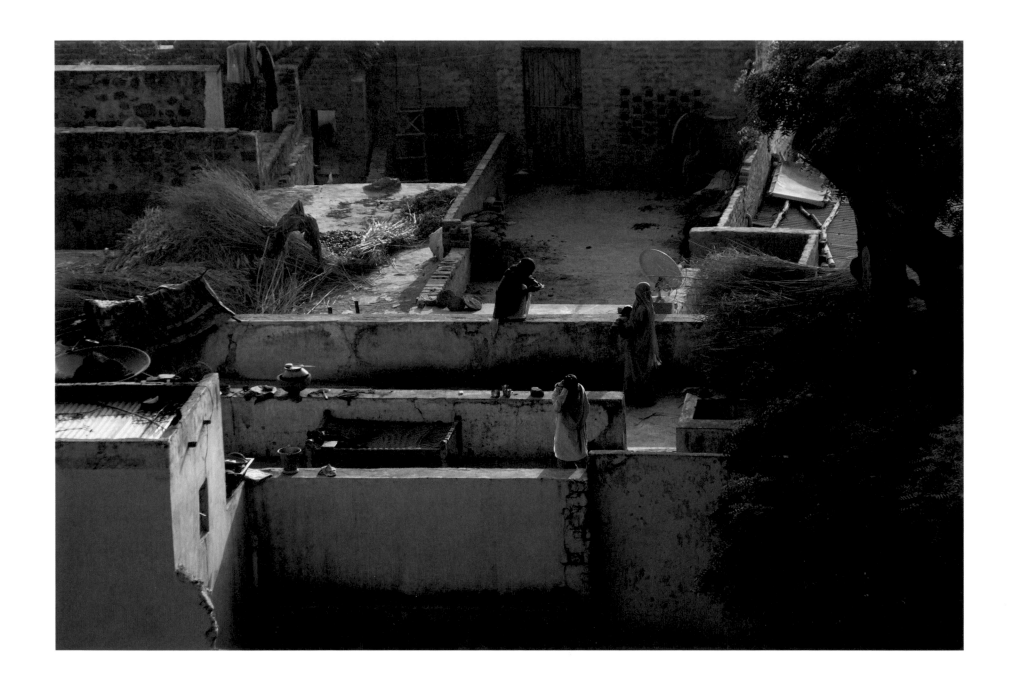

Kesroli village. Dawn.

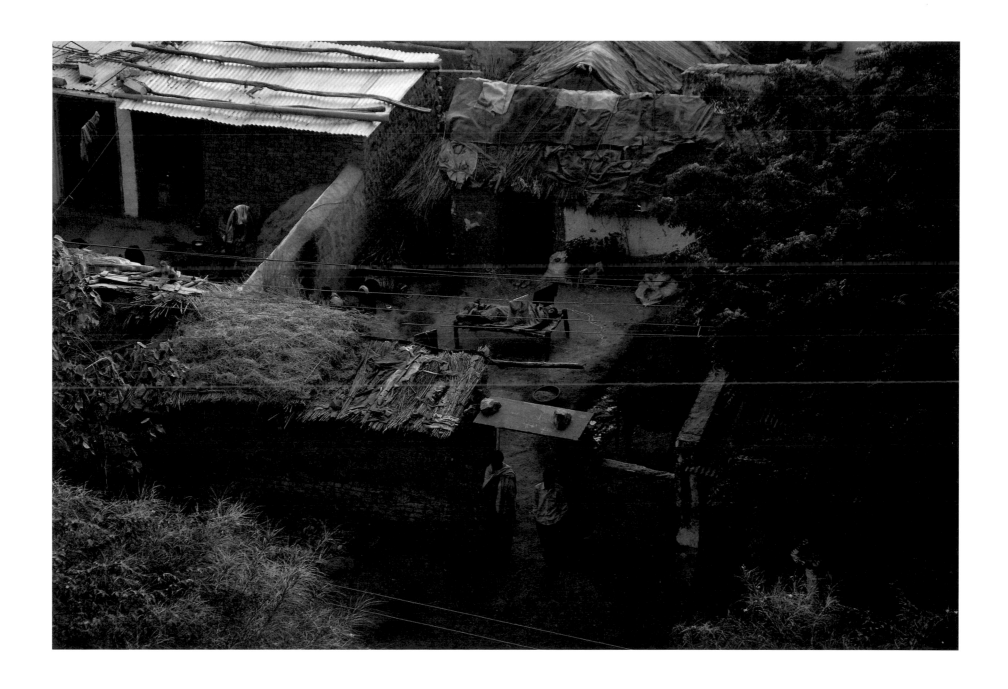

Kesroli village. Awakenings.

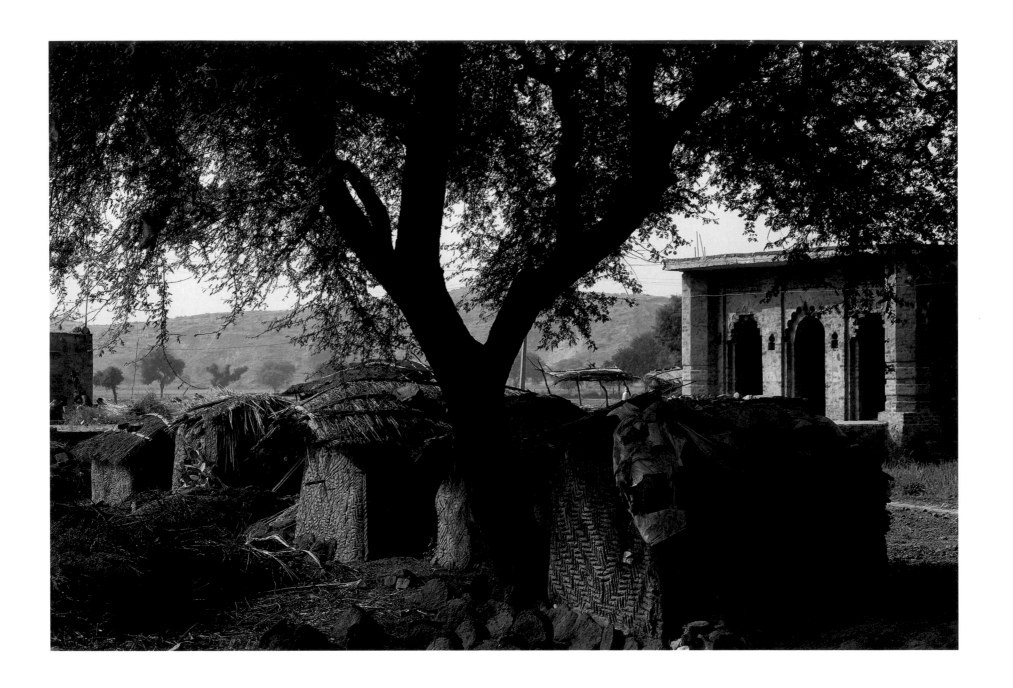

Fields of Alwar. Stables.

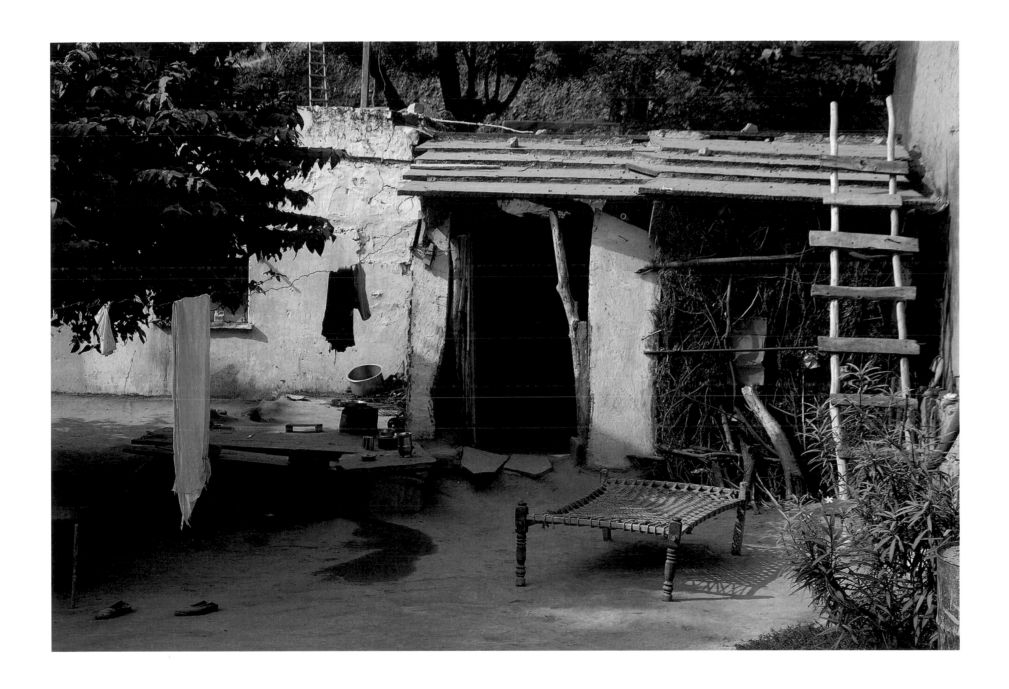

House near Lake Siliserh.

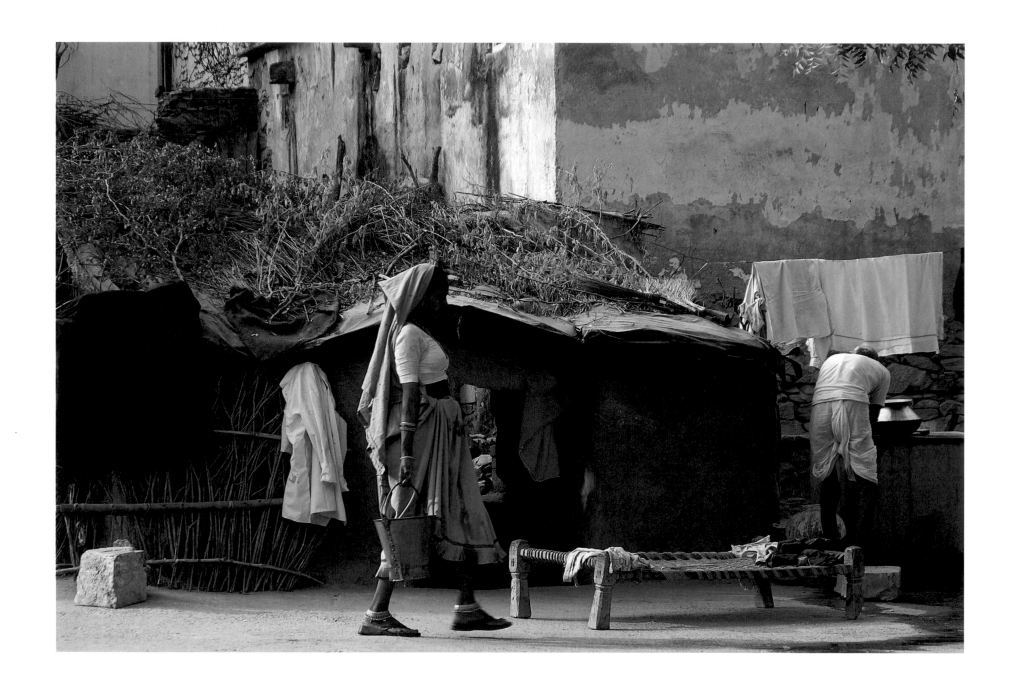

From Jaipur to Alwar.

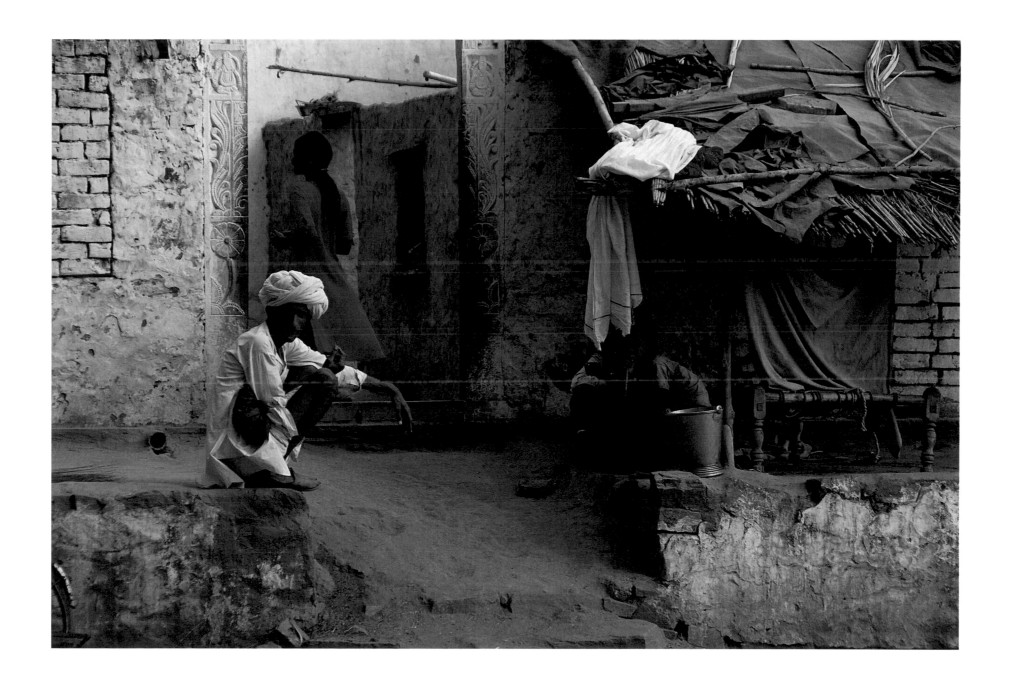

From Jaipur to Alwar.

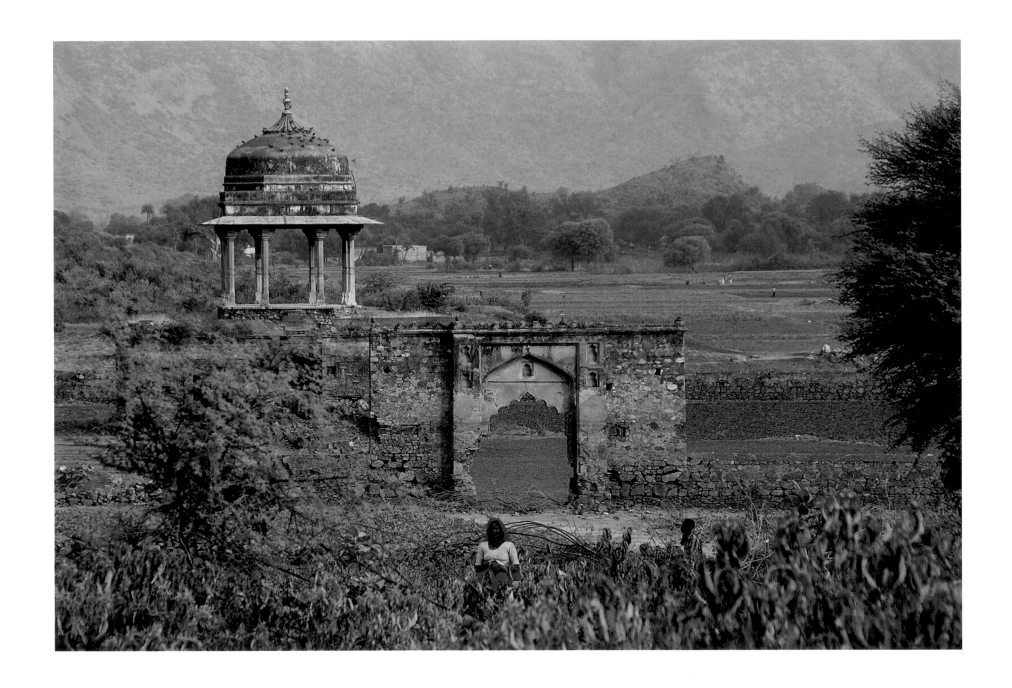

Bhangarh.

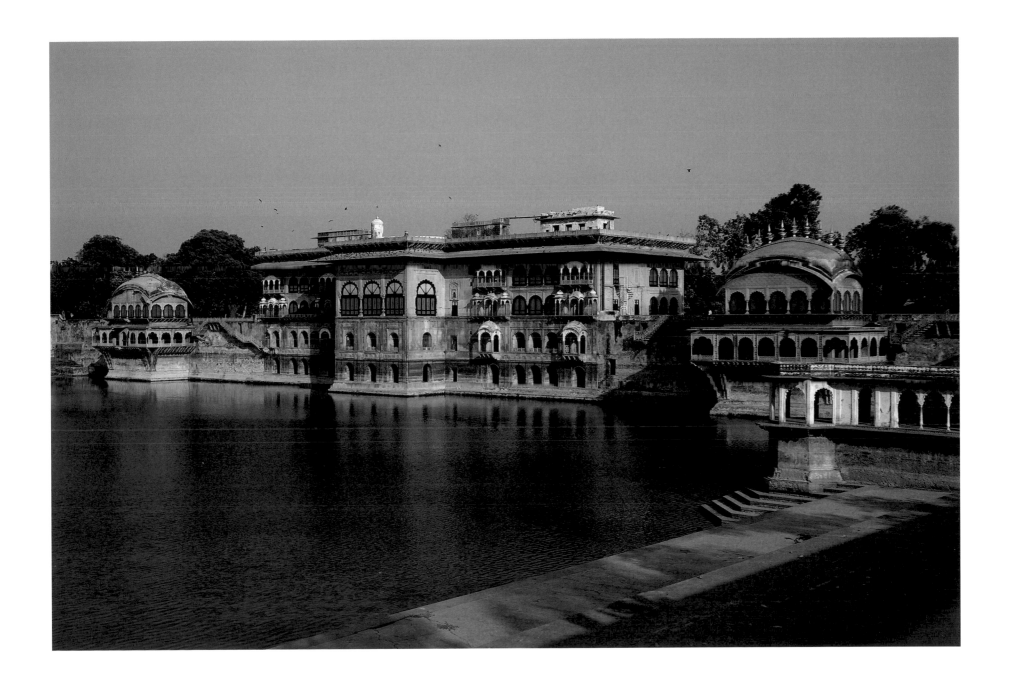

Deeg. The Suraj Mahl Palace.

SHEKHAWATI

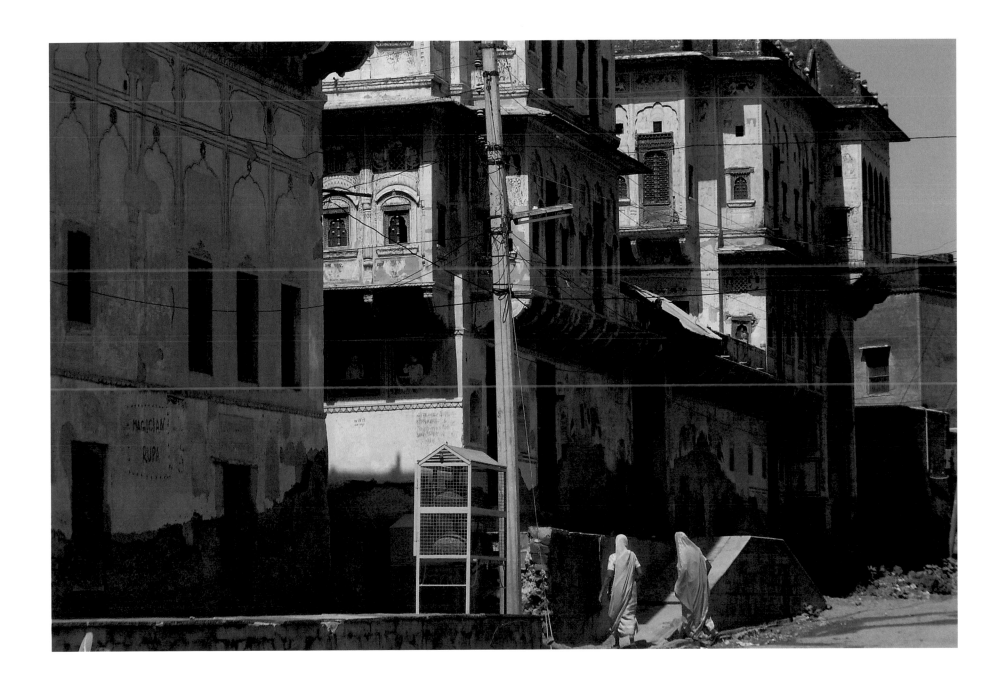

Mandawa. Gulab Rai Ladia Haveli.

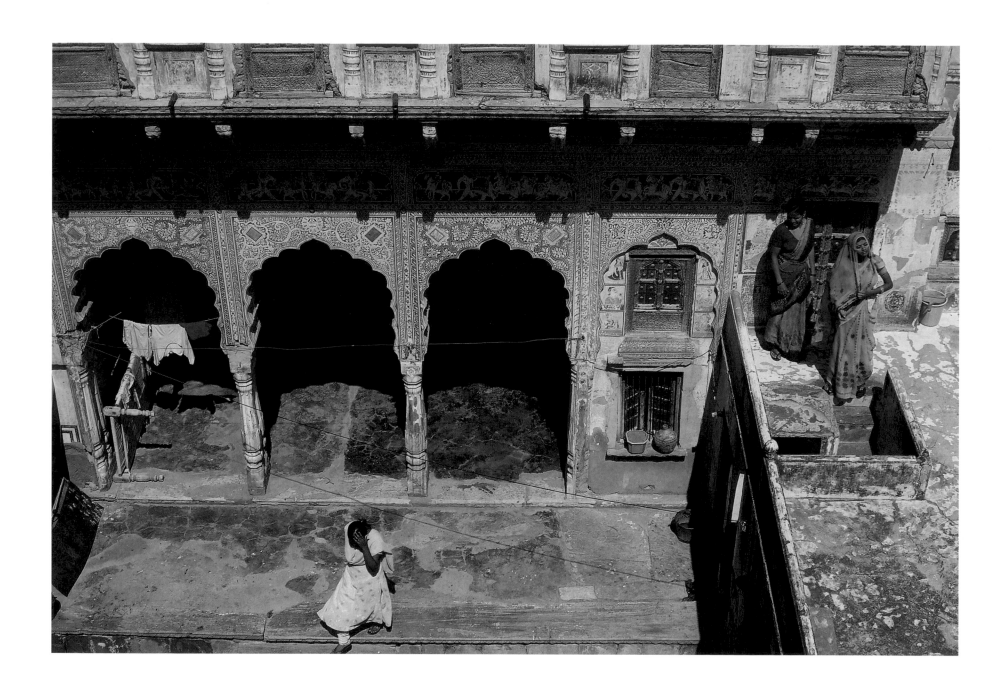

Mandawa. Inner patio.

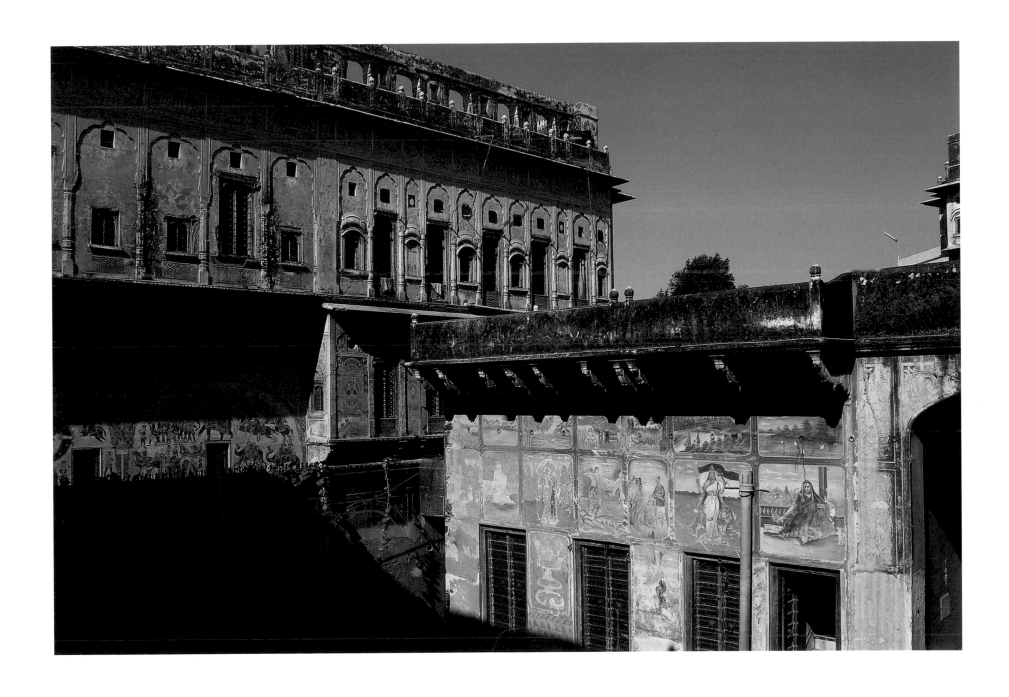

Mandawa. Goenka double Haveli from the Nandlal Murmuria Haveli patio.

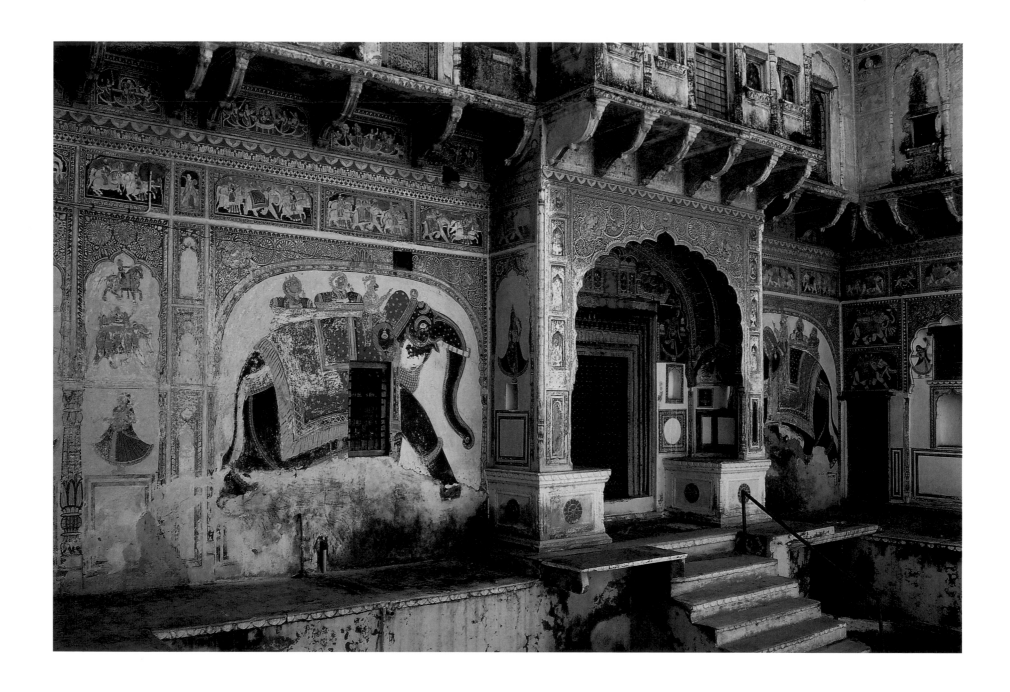

Mandawa. Lakshminarayan Ladia Haveli.

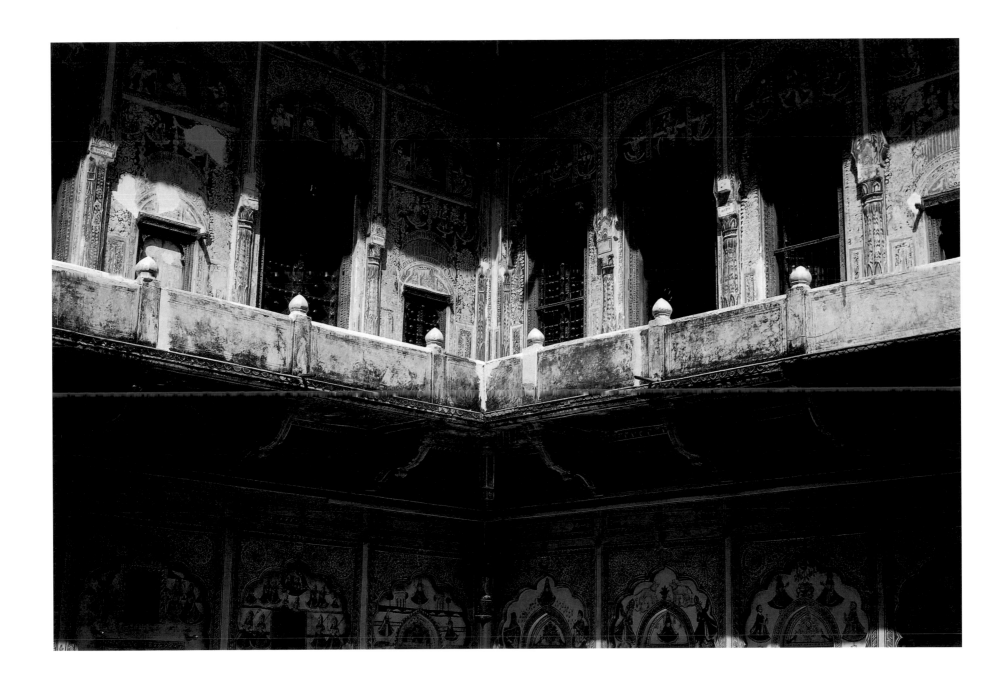

Hotel Mandawa Haveli.

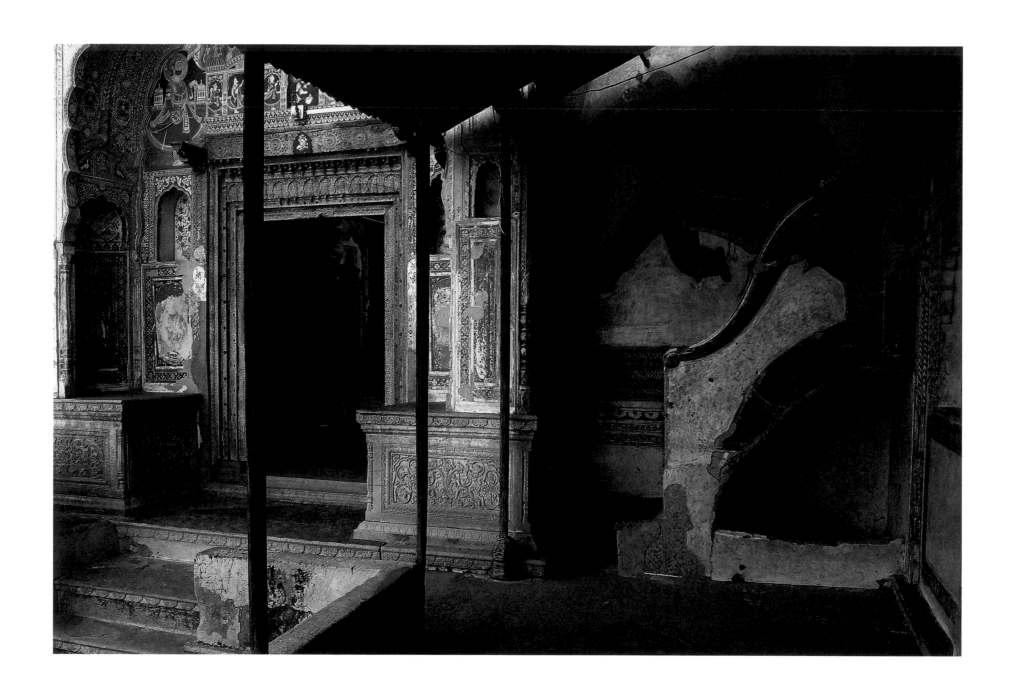

Bissau. Ramlalji Jainarayan Tibrewala Haveli.

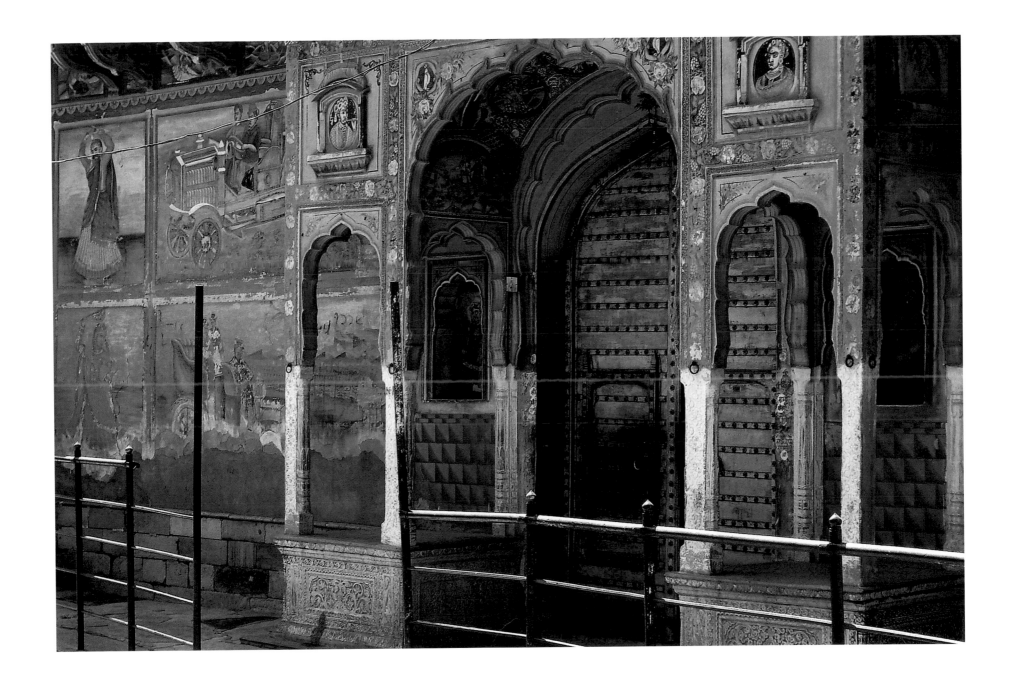

Nawalgarh. Mohanlal Saraogi Haveli.

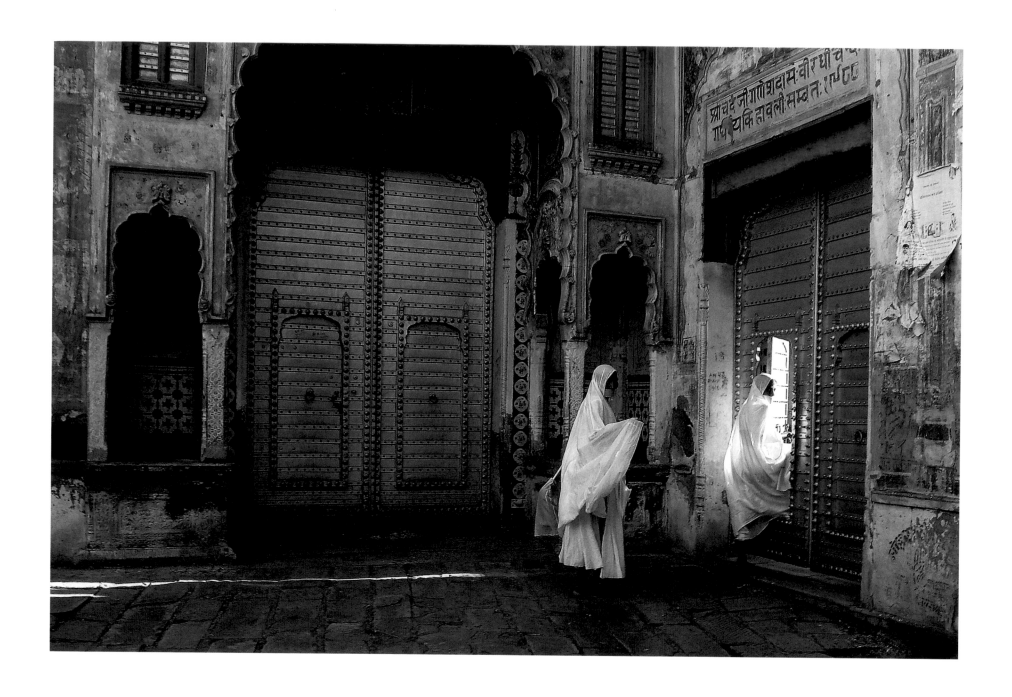

Sardarshar. Jain widows in Naimichand Sanpatmal Gadeya Haveli.

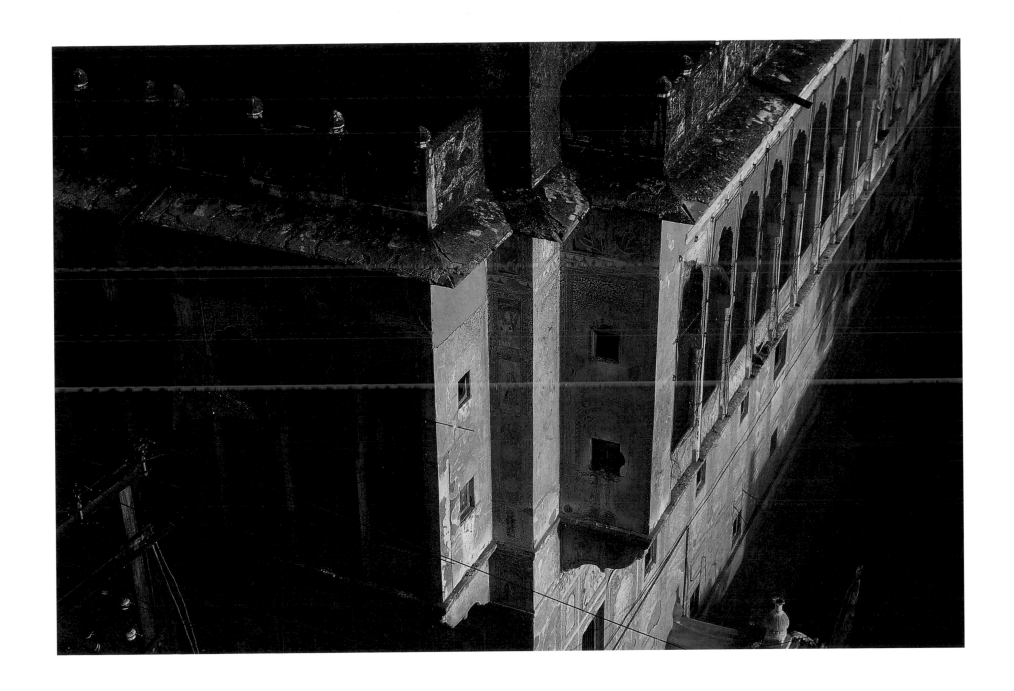

Dundlod. Goenka Haveli.

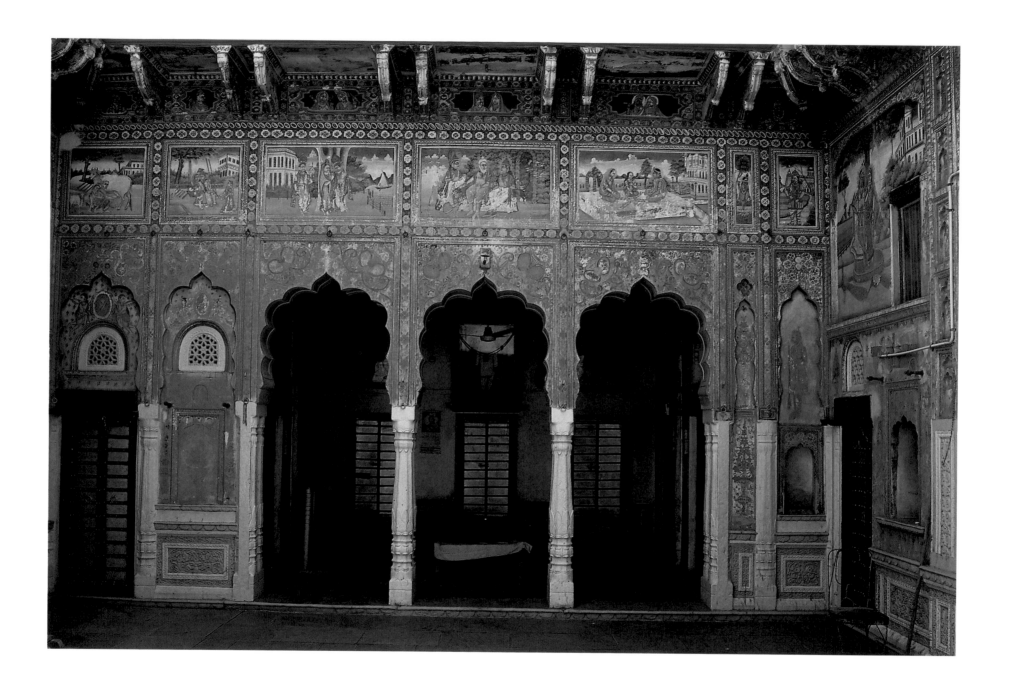

Fatehpur. Bishwan Kedia Haveli.

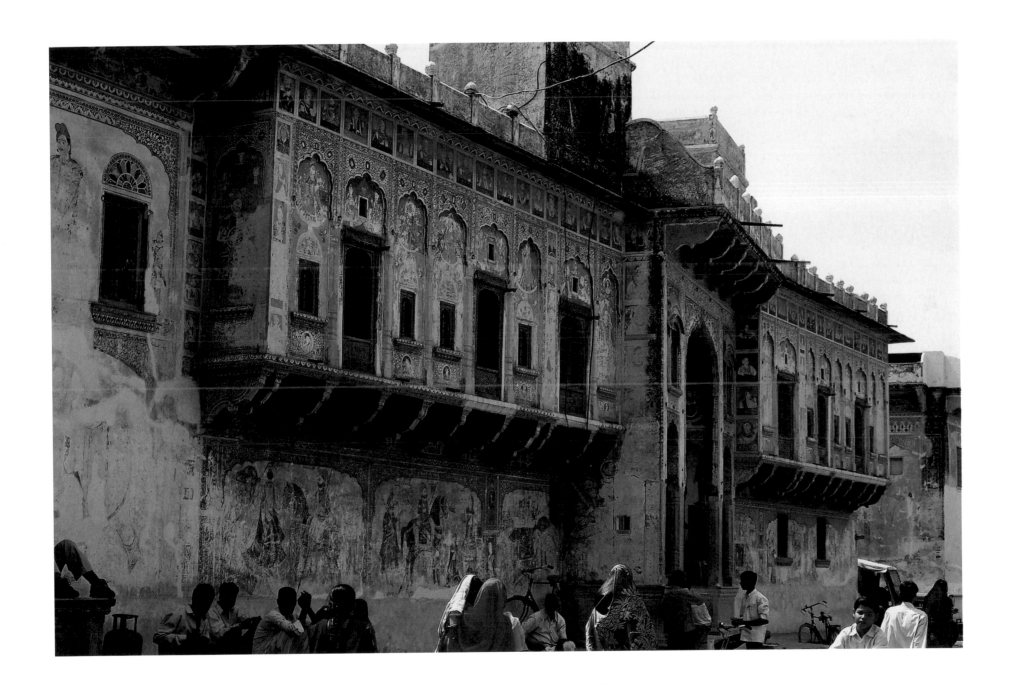

Nawalgarh Haveli next to Anandi Lal Poddar Haveli.

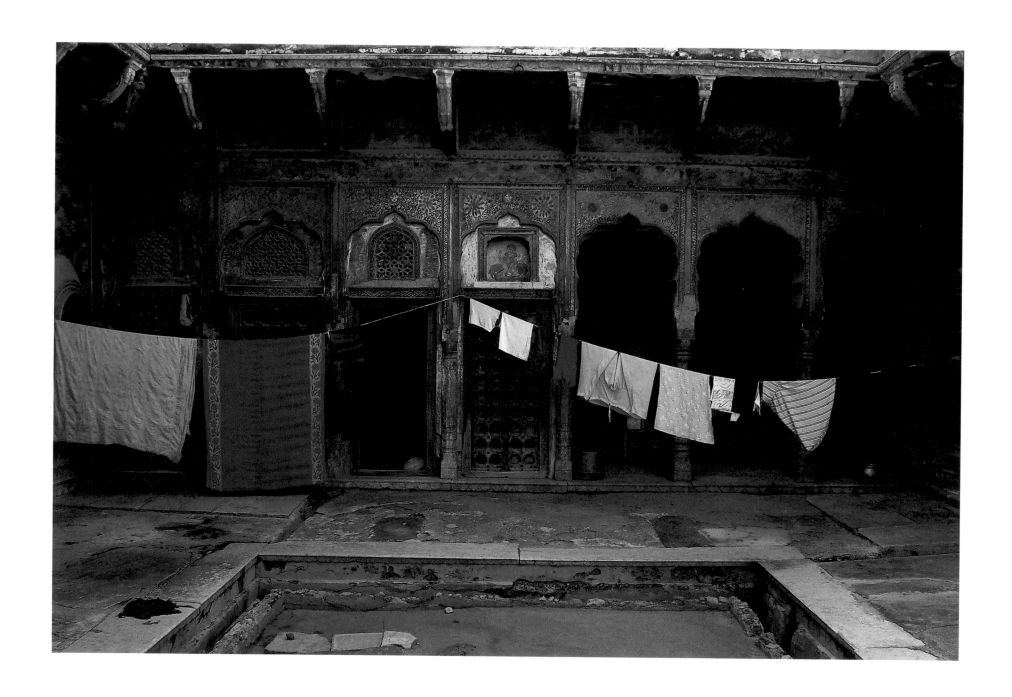

Bissau. House of Jugul Kishre Khawash.

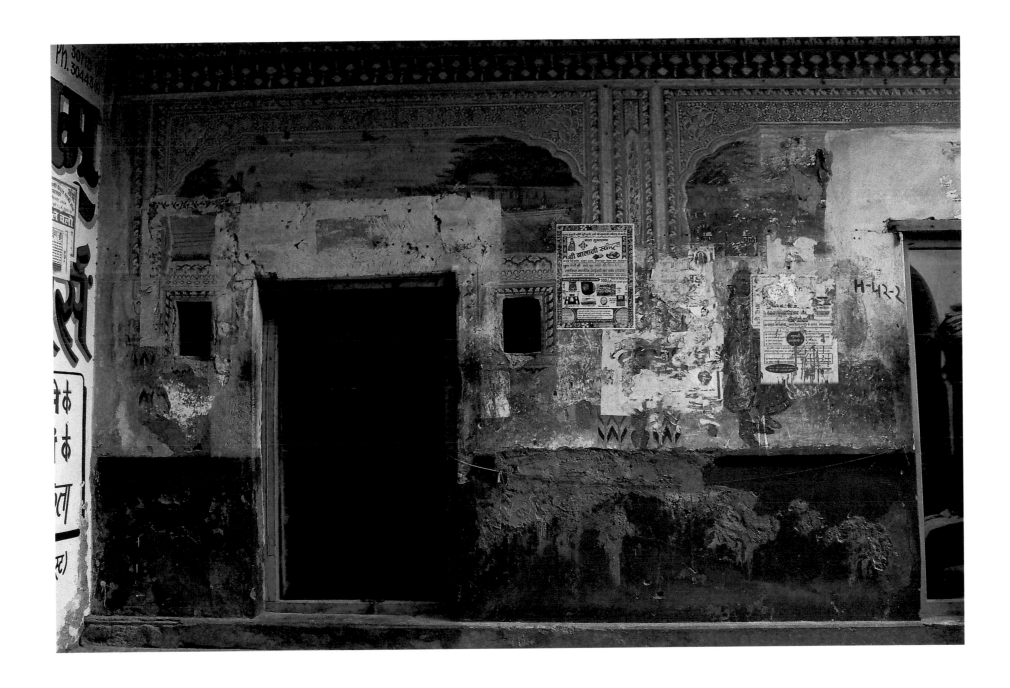

Sardarshar. Superimposed layers.

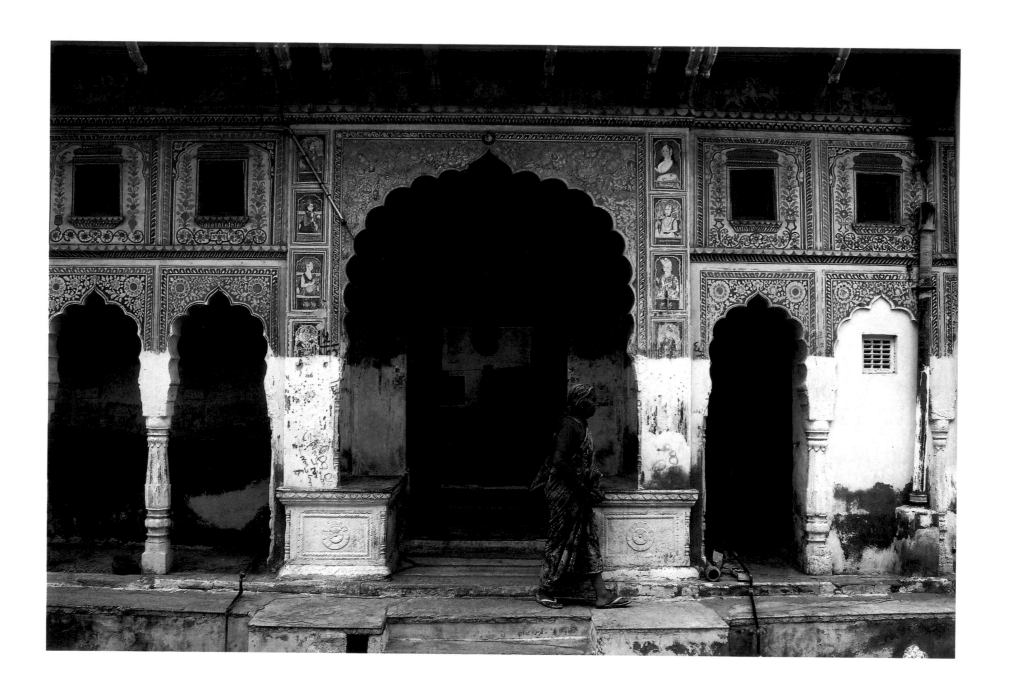

Nawalgarh. Mohanlal Mithuka Haveli.

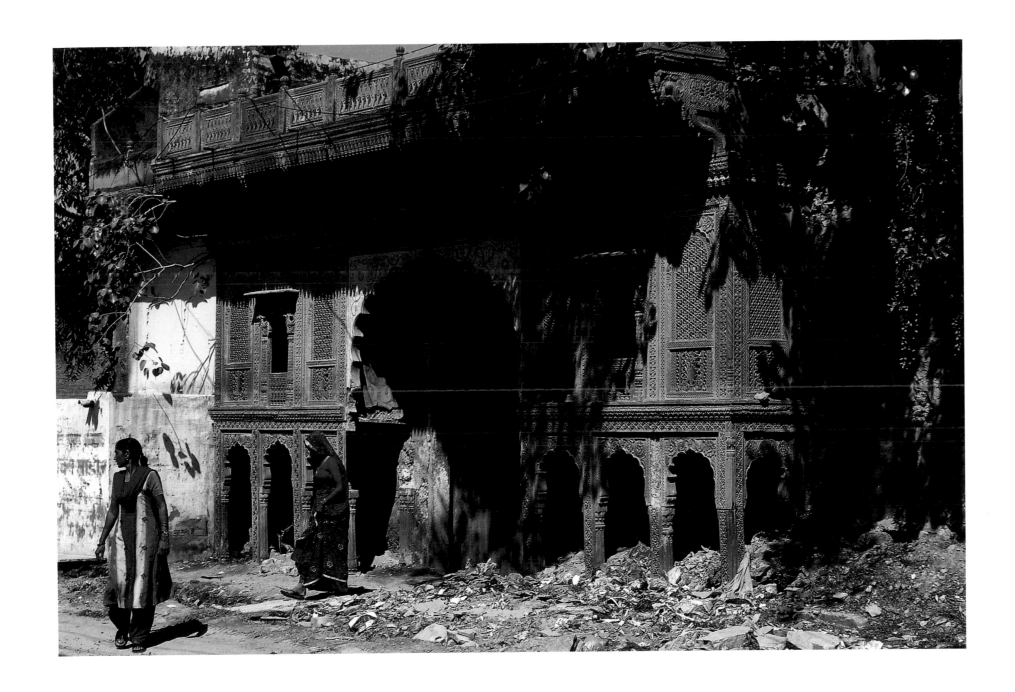

Fatehpur. Lal Patthar Haveli, the house of red stone.

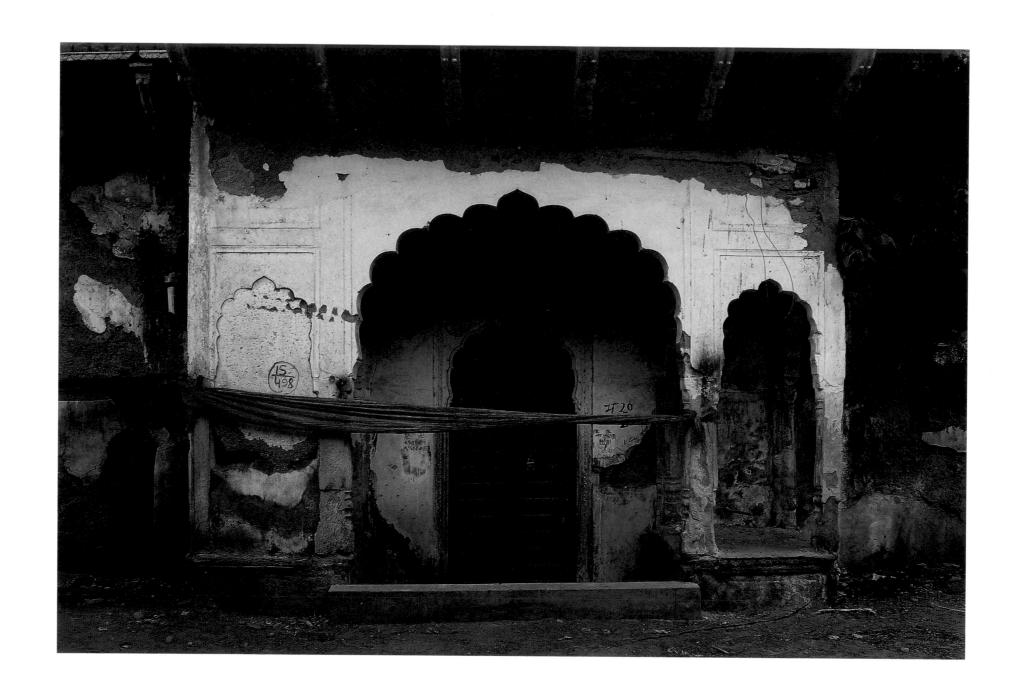

Laxmangarh. Haveli awaiting demolition.

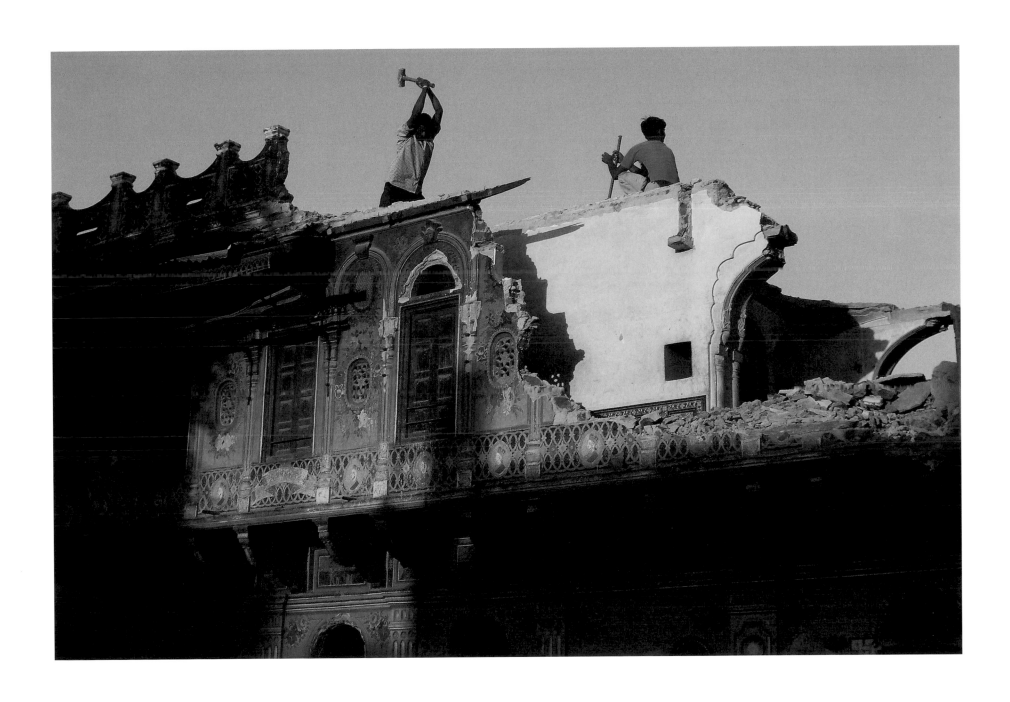

Laxmangarh. A haveli undergoing demolition in the city centre, September 2005.

TITO DALMAU

Born in Barcelona in 1948, Tito Dalmau obtained his degree in architecture from the Escuela de Arquitectura de Barcelona. He is a founding member of the BDM Arquitectos studio, at which he has executed numerous architecture and interior and industrial design projects. Some of these have been published, with his photographs, in books and international journals such as *A+U, WIND, A.D., Domus, Gran Bazaar, Interni, DDN, ON, Croquis, Diseño Interior, CREE, De Diseño, Ardi...* and has been awarded, amongst others, FAD, IPI, Llama de Bronce, Laus prizes, and other special mentions.

Besides his work as an architect, he also holds drawing and photography exhibitions, like "Paradigmas" (1982). Some suggest the idea of opposites, such as "Presencias" (photographs, 1994) and "Ausencias" (drawings, 1995), both at the Galeria H2O, while other photography exhibitions evoke the idea of a journey: "NYC" (1983), "Tokyoto" (1994) and "Nilo" (2002).

MAKA ABRAHAM

Born in Manila in 1950, Maka Abraham graduated in history and anthropology at Barcelona University. She is a regular contributor to art and architecture journals and also publishes travel articles. In recent years she has made numerous trips to Rajasthan.

BIBLIOGRAPHY

Ilay Cooper. *The painted towns of Shekhawati*. Mapin Publishing Pvt. Ltd., India, 1994

Shikha Jain. *Havelis. A living Tradition of Rajasthan*. Shubhi Publications, India, 2004

Kulbhushan & Minakshi Jain. *Architecture of the Indian Desert*. AADI Centre, Ahmedabad, India, 2000

Hans Silvester, Patricia Gautier. *Les Cavaliers du Shekhawati*. Éditions de La Martinière, Paris, 2001

James Tod. *Annals and Antiquities of Rajasthan*. Higgin Botham and co., Madras, India, 1873

ACKNOWLEDGEMENTS

To the team at Lunwerg Editores, particularly Andrés Gamboa,
who believed in and produced this project.

To Enrique Vila-Matas, who after his mysterious encounter with the Hindu in Soria
wrote the foreword, which deeply moved us.

To Ajit Bansal from Jaipur, who oriented us on our travels

To Rais, Manohar, Subaj, Raj... the drivers who patiently took us wherever we wanted to go.

To all those who, on the way, opened up their houses to us with a smile.

And to all of you who have taken the trouble to peruse this book.

Printed in Spain, March 2007